NEW FORMS

The Avant-Garde Meets the American Scene
1934–1949

Selections from the University of Iowa Museum of Art

Erika Doss

Kathleen A. Edwards

Emily A. Kerrigan

Joni L. Kinsey

This volume is published
on the occasion of an exhibition organized by
Kathleen A. Edwards and Joni L. Kinsey for
the University of Iowa Museum of Art,
September 14 – December 4, 2013.

The New Forms exhibition is sponsored in part by
Janet Y. & Richard V. M. Corton, M.D.,
Alan F. & Ann B. January, Jeanne S. & Richard S. Levitt,
Carrie Z. Norton, Craig N. & Nancy B. Willis, and
multiple donors to the Members Special Exhibition Fund

Cover image:
Philip Guston (American,
born in Canada, 1913–1980)
The Young Mother, 1944
Oil on canvas
39 7/16 x 29 1/2 in.
(100.17 x 74.93 cm)
Gift of Dr. Clarence Van Epps
© The Estate of Philip Guston

Edited by Kathleen A. Edwards

With essays by Erika Doss, Kathleen A. Edwards, and
Joni L. Kinsey, and catalogue entries by Emily A. Kerrigan.

Copy Editor: Gail Zlatnik
Design: Meng Yang

Unless otherwise noted, UIMA collection photographs
were taken by Steve Erickson.

University of Iowa
Museum of Art

1840 Studio Arts
1375 Highway 1 West
Iowa City, Iowa 52242

uima.uiowa.edu

THE UNIVERSITY
OF IOWA

This catalogue is published in partnership with
University of Iowa Press.

Library of Congress Control Number: 2013937090

ISBN: 9780934656009

TABLE OF CONTENTS

107

Exhibition List

Acknowledgements

An exhibition of this range and depth, and the accompanying catalogue, results from the efforts of not only the co-curators and catalogue authors, but students and staff affiliated with the University of Iowa School of Art and Art History and the Museum of Art.

The laudable work accomplished by curatorial research assistant Sarika Sugla is uppermost in our minds. Art history graduate student Emily A. Kerrigan is to be commended for her research and writing. We are grateful to Erika Doss, University of Notre Dame art historian and chair of American Studies, for her willingness to write one of the essays and for doing it so efficiently and effectively.

David McCarthy and Kathryn Hodson, UI Archives and UI Special Collections, and Rijn Templeton, UI Art Library, provided their expertise and access to files.

Our fantastic copy editor, Gail Zlatnik, worked through the text. Our thanks also go out to Jim McCoy, director of the University of Iowa Press.

Museum staff Betty Breazeale, Steve Erickson, Catherine Hale, Pat Hanick at the UI Foundation, Lexi Janezic, Jeff Martin, catalogue designer Meng Yang, Diane Scott, Elizabeth Wallace, and Katherine Wilson proved yet again that they know what it takes to get the job done.

Marissa Bourgoin and staff at the Archives of American Art, Smithsonian Institution, as well as Naomi Kuromiya and staff at the Museum of Modern Art Archives, were of tremendous assistance. Marianna Kistler Beach Museum of Art curator Elizabeth Seaton, and Deborah Wythe of Brooklyn Museum Digital Collections and Services, also provided assistance.

Last but not least, our thanks go out to UIMA director Sean O'Harrow, who has turned the ship around.

Kathleen A. Edwards

Joni L. Kinsey

1

Preface

In early 2014, precisely 70 years after his oil painting was inaugurated in Peggy Guggenheim's Manhattan duplex, Jackson Pollock's monumental masterpiece *Mural* will be unveiled to the public at the J. Paul Getty Museum, outside of Los Angeles. The significance of the Getty event is that, for the first time in decades, the work will be seen as it would have at the opening in early 1944, with its swirling waves, its contrasting matt and glossy colors, the occasional paint splatters, all stampeding across the 20-foot-wide canvas. The Getty conservators will have removed years of dirt, varnish, and old touch-up paint to return this work to its former glory.

Pollock started *Mural* in 1943, the year when Guggenheim gave him his first commission. The patron and her artist planned carefully for this to be a major contribution to American art, and must have felt vindicated when renowned critic Clement Greenberg famously proclaimed Pollock to be "the greatest painter this country has produced."

It shocked the art world when it was created, it shocked many at the University of Iowa when they took possession of the painting in 1951, and it continues to shock people today. In Iowa, as elsewhere, many politicians, cultural commentators, and internet trolls still cannot come to terms with it as great art; they see the market value, but not the artistic value. And they are not alone in this country. It does not help that Pollock's paintings are often associated with the derisive notion that Modern art is equivalent to art that children can do.

However, this all seems par for the course when it comes to the discussions about abstract and figurative art, and the direction(s) of art in America. In this book *New Forms: The Avant-Garde Meets the American Scene, 1934-1949, Selections from the University of Iowa Museum of Art* and the accompanying art exhibition, you will see and understand in fascinating detail the debate that has raged in Iowa and across the country for generations, and particularly during the 1930s and 1940s.

The University of Iowa's great Pollock masterpiece perfectly illustrates this. Pollock was notoriously eclectic and influenced by many other artists and artistic styles. Although *Mural* can be viewed as trumpeting the beginning of the American Abstract Expressionist art movement because of its ground-breaking "non-objective" qualities, some aspects of the work stylistically resemble that of his teacher, Thomas Hart Benton, the great Midwestern Regionalist painter. *Mural* is the Omega and the Alpha, in that order. To a certain degree, it was rejected by the Art Establishment but appreciated by progressive college art professors, and thus ended up at the University of Iowa, where it was used for teaching new approaches to painting and composition. Stuart Edie, a studio art professor at Iowa, advocated for this painting in 1951 because he knew that his students needed to see what nationally-recognized Avant-Garde artists were producing.

Several years later in 1961, Peggy Guggenheim offered to trade a 1926 picture by Georges Braque for *Mural*. The director of the Iowa art program, Frank Seiberling, rejected the proposition, stating that it was important for the Iowa collection to emphasize new American art and not "the French market." The Iowa professors wanted their students to understand and be part of current and future trends, not past movements. The university art collection was created for this purpose and gives people a glimpse into the approach to art at the time at Iowa.

In this book, you find out how the development of American art and its audience, the history of the University of Iowa's Art and Art History program, and the university's Museum of Art collection are all intertwined and interdependent, their timelines twisted and sometimes knotted, often forming one entity during the 1930s and 1940s. Erika Doss of the University of Notre Dame, Joni Kinsey of the University of Iowa, and Kathleen Edwards of the University of Iowa Museum of Art, use significant examples from the University of Iowa Museum of Art collection to tell the intriguing story of how the Avant-Garde collided with the American Scene, and how many of the battles that took place happened in America's rural heartland.

We truly appreciate the contributions of museum members who support our exhibition projects: Janet Y. & Richard V. M. Corton, M.D., Alan F. & Ann B. January, Jeanne S. & Richard S. Levitt, Carrie Z. Norton, Craig N. & Nancy B. Willis, and multiple donors to the Members Special Exhibition Fund.

Sean O'Harrow, PhD
Director
University of Iowa Museum of Art

John Beldon Scott, PhD
Elizabeth M. Stanley Professor of the Arts
Director, School of Art and Art History
University of Iowa

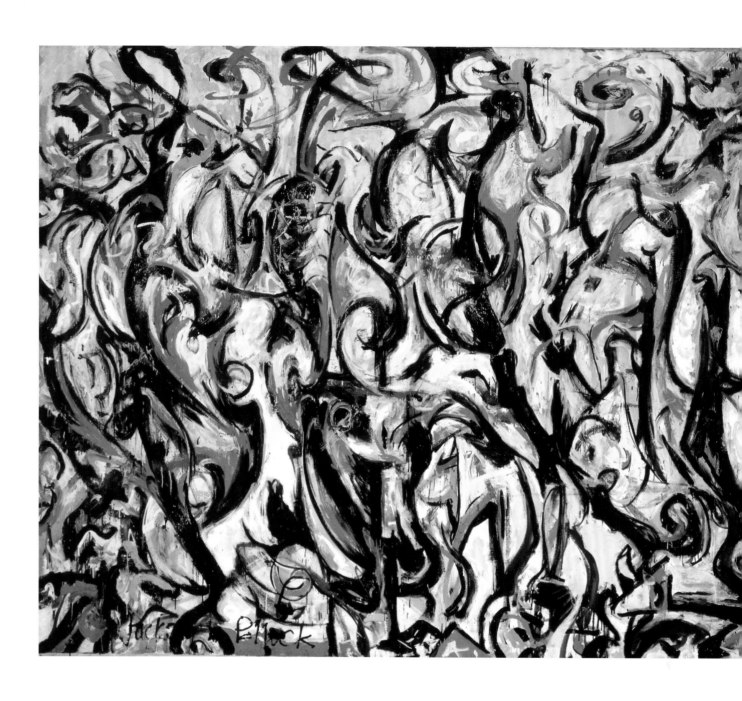

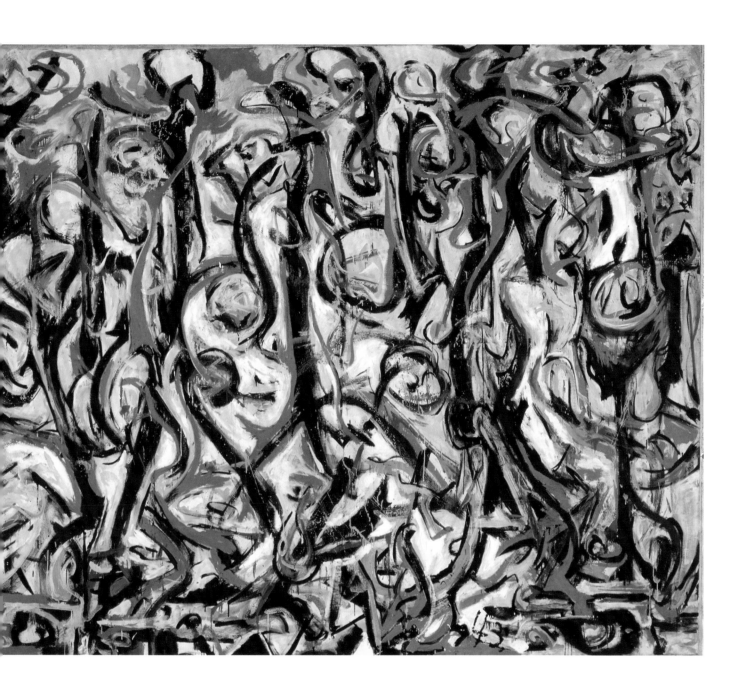

American Moderns in the 1930s and 1940s

The Triumph Of Diversity

Erika Doss, PhD

Professor and Chair
Department of American Studies
University of Notre Dame

In 1943, the Museum of Modern Art in New York City published *What Is Modern Painting?*, a slim booklet "written for people who have had little experience in looking at paintings, particularly those modern paintings which are sometimes considered puzzling, difficult, incompetent or crazy." The art historian Alfred H. Barr Jr., MoMA's first director, explained that the guide was "intended to undermine prejudice, disturb indifference and awaken interest so that some greater understanding and love of the more adventurous paintings of our day may follow."[1] Writing in an upbeat manner aimed at convincing skeptics that modern art was worth looking at, and taken seriously, Barr cast the modern painter as a cultural pioneer, and modern art itself as an aesthetic adventure. Over the course of forty-four pages, he introduced novice viewers to what he admitted was a "bewildering variety" of modern paintings, focusing especially on the various styles—impressionism, cubism, expressionism, surrealism, social realism, regionalism, and more—pursued by European artists such as Renoir, Van Gogh, Kandinsky, Miró, and Picasso, and American moderns ranging from

Arthur Dove and Stuart Davis to Charles Burchfield, Edward Hopper, Loren MacIver, Matta, Ben Shahn, and Grant Wood.

Barr's comprehensive understanding of modern art, and his interest in modern art education, were common in the 1930s and 1940s. His 1943 booklet was preceded, for example, by *Art in America in Modern Times* (1934), a survey text that he and Holger Cahill edited on behalf of the American Federation of Arts (AFA).[2] Founded in 1909 (and still operating today), the AFA was instituted to facilitate greater public access to art, especially American art—to provide opportunities for Americans living in rural areas and smaller cities, in places that might not have galleries and museums, to see and learn about the visual arts, past and present. In addition to organizing traveling exhibitions and publishing art journals (*Magazine of Art* was published from 1936 to 1953), the AFA sponsored a weekly radio show, *Art in America*, broadcast in the mid-1930s by radio station WJZ (New York) on Saturday nights and carried by more than three dozen affiliates coast-to-coast.[3] Radio was widely used as an art education tool at this time; different

programs originating from stations in Kansas, Kentucky, New York, and Pennsylvania "featured radio talks supplemented with photographs of the art works published in local newspapers."[4] In the same vein, *Art in America in Modern Times* was paired with a similarly named radio show. Like *What Is Modern Painting?*, the book cast a wide net in its inclusion and assessment of diverse styles of modern American art.

These twinned impulses—an expansive understanding of American modernism and broadly shared convictions that modern art should be accessible to all Americans—shaped the collecting practices of many American institutions during the interwar era, including the University of Iowa. Despite assumptions that Americans became interested in, and informed about, modern American art only during the postwar era of the 1950s, when artists like Jackson Pollock and Mark Rothko gained widespread popular, critical, and media attention, American appetites for cultural modernism were actually honed earlier, especially during the years of the Great Depression and the 1940s.

New forms of mass media, including radio, movies, television, and large-circulation picture magazines like *Life* and *Look* (launched in 1936 and 1937, respectively) played their part in cultivating these cultural appetites, as did multiple New Deal art projects initiated in the mid-1930s. So did new programs in American studies, an academic field of inquiry and scholarship that emerged during the interwar era, and new classes in the field of art history that focused especially on American art and on questions like "What's American about American art?" If only nine courses on American art were offered

in American colleges and universities in 1925, that number jumped to forty between 1933 and 1940.[5]

Correspondingly, American artists and audiences alike were receptive to new methods of marketing American art. These included the mail-order campaigns of outfits like Associated American Artists, a gallery that started in 1934 and commissioned original etchings and lithographs by well-known American artists—from the regionalists Thomas Hart Benton, John Steuart Curry, and Grant Wood to American moderns such as Ivan Albright, Yasuo Kuniyoshi, and Federico Castellon, among others. Their prints were sold for just five dollars each and shipped to customers all over America. Buying ad space in magazines like *Time* and *Art Digest*, the AAA beckoned potential art consumers with copy that read "*This is the moment you have waited for!* Through this vital new Art Project you now can get museum-perfect Originals, personally signed by the artists, from the selfsame collection from which the Metropolitan Museum of Art, Chicago Art Institute, United States Library of Congress, Yale University and 74 other famous museums and galleries have acquired them."[6]

And while many older, well-established art galleries struggled during the depression, harnessed by high-priced inventories of "old masters" and a small number of elite patrons, a surprising number of new galleries sprang up that focused on showing emerging artists. In New York these included Herman Baron's ACA Galleries (American Contemporary Arts, established 1932), Mark Perper's Forty-Fourth Street Gallery (1940–51), and Peggy Guggenheim's Art of This Century Gallery (1942–47). In 1933, Mark

Rothko had his first solo exhibition at the Contemporary Arts Gallery; in 1937, the Museum of Non-Objective Painting (later, the Guggenheim Museum) opened its doors. Despite the devastating economic conditions of the 1930s—or perhaps because of them—American moderns were both innovative and prolific, and American audiences, captivated by new approaches to showing, selling, and buying modern art, were enthusiastic. *New Forms: The Avant-Garde Meets the American Scene, 1934–1949, Selections from the University of Iowa Museum of Art* amply demonstrates the diversity of American modernism during an era framed by the Great Depression and the years immediately following the Second World War.

Until relatively recently, the critical and historical construction of what was considered modern American art was confined to the post–World War II years, and the "triumph" of nonobjective strains of nascent styles of avant-garde painting like abstract expressionism.[7] The "standard history of American modernism," the critic Peter Wollen recounts, has been viewed as a stylistically progressive march from representational to abstract art, or from infancy to maturation, that "begins with the Stieglitz circle . . . peaks prematurely in the 1920s . . . [and goes] into recession during the 1930s (seen as a period of realist reaction)." For a while, Wollen adds, "nothing much happens" until the mid-1940s, when "the whole climate changes completely [and] soon afterwards, Abstract Expressionism is launched."[8]

This narrow understanding of modern American art, and its particular emphasis on nonobjective art, was cultivated by the influential critic Clement Greenberg, who

championed the abstract paintings of American artists like Jackson Pollock as the necessary—and inevitable—cultural equivalents of the nation's new postwar position as a global economic and political superpower. In a 1945 review in *The Nation* of Pollock's second one-artist show at Art of This Century Gallery, which included his *Portrait of H.M.* (probably named after one of Pollock's friends, either Herbert Matter or Helen Marot, or perhaps an homage to Herman Melville), Greenberg declared Pollock "the strongest painter of his generation."[9] Three years later, he pronounced: "The level of American art has risen in the last five years, [and] with the emergence of new talents . . . [such] as Jackson Pollock, the main premises of western art have at last migrated to the United States, along with the center of gravity of industrial production and political power."[10] Sweeping aside other modes of modern art in Europe and the United States—from French styles of cubism and surrealism to American styles of

precisionism, regionalism, and social realism, Greenberg elevated abstract expressionism as the only credible form of American modernism.[11]

Grounded in post-1945 notions of American exceptionalism, Greenberg's critical mission hinged on advancing American styles of modern art that meshed with Cold War political pronouncements of the nation's supposedly unique alignment with attributes like freedom, individualism, and self-expression; these values were contrasted with their opposites in communist Russia and with similarly disparaged political cultures such as New Deal liberalism and Popular Front radicalism.[12] Modern art, Greenberg insisted, was media-specific (engaged only in the properties and techniques of specific media, such as painting or sculpture) and hence "pure." It was untainted by popular, folk, or mass cultures; "uninflated," he stated in 1949, "by illegitimate content—no religion or mysticism or political certainties." However

facile, Greenberg's theories defined modern American art in terms of the abstract painting of a small band of heroic—and mostly male—postwar artists such as Pollock, Rothko, and Charles Seliger.[13]

Reductive and exclusionary, this notion of American modernism was at odds with much of the modern art that was actually produced by postwar American artists. It also marginalized many earlier twentieth-century artists who considered themselves American moderns. As the historian Daniel Joseph Singal explains, a primary motivation guiding twentieth-century American modernists was a yearning to integrate art and life, to recover an intensity of experience and an expansion of consciousness that premodern institutions had aimed to prohibit or to tightly control. Challenging perceived Victorian-era limitations ranging from fixed and idealized notions of truth and knowledge (such as unyielding natural laws and an

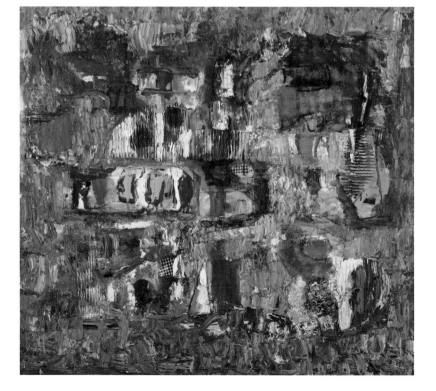

Fig. 2
Lil Picard (American, born in Germany, 1899–1994)
Crossing, 1947
Oil on canvas with collaged elements
32 x 36 in. (81.28 x 91.44 cm)
Lil Picard Collection
© University of Iowa Museum of Art

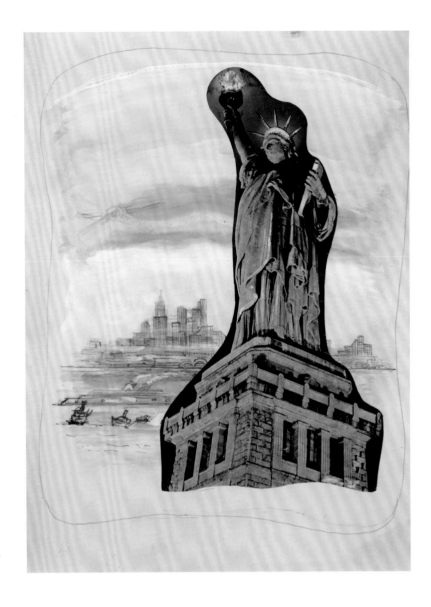

absolute God) to sharply separated spheres of social interaction, American modernists sought liberation, release, and redefinition in cultural projects that emphasized authenticity, change, diversity, and synthesis. American modernism was fundamentally "integrative," Singal maintains, a paradoxical blend of resistance and reconciliation that aimed at accommodating art and life, culture and experience.[14]

Embracing wide-ranging interests, ceaseless experimentation, the authenticity of lived or "felt" experience, and the innovative aesthetic discoveries of other artists in Europe and elsewhere, American moderns employed new pictorial strategies of montage, collage, overlapping, frenzied pacing, spatial flattening, inconsistent light sources, spontaneity, and highly saturated color to convey modernism's fragmented, uncertain, inconsistent, and unstable conditions, and to simultaneously propose new ideas about nature, knowledge, themselves, the nation, and art itself. A dynamic continuum of flux and irresolution, American modernism was essentially processual, a culture of becoming rather than being—not unlike the modern nation itself. As pictures ranging in stylistic diversity from Philip Guston's *The Young Mother* (1944) (fig. 38) to Lil Picard's *Crossing* (1947) (fig. 2) suggest, American moderns were typically more inclined to pose questions than to provide answers.

Nor were they especially interested in framing American modernism within stylistically limiting parameters. The art historian Janet Wolff explains that realistic and abstract approaches to painting—and, by extension, other modes of visual culture—were not considered oppositional by many twentieth-century artists, who tended to evade critically manufactured labels, and narrow ideas about media, in favor of simply being artists of modern life.[15]

Frederick Kiesler is a prime example of the eclectic, unclassifiable modern artist. Trained as an architect in

9

Austria, he emigrated to the United States in 1926 and was active as a sculptor, set designer, window dresser (designing window displays for the department store Saks Fifth Avenue in 1928), exhibition designer, furniture maker, theorist, teacher, and author.[16] In 1934, Kiesler joined the Juilliard School, where for several decades he designed sets for some sixty different music productions. His sketch featuring a collaged image of the Statue of Liberty (fig. 3) may stem from his work on the three-act opera *Maria Malibran*, which premiered at Juilliard in April 1935 and was based loosely on the life of a popular nineteenth-century Italian mezzo-soprano who had toured New York a century earlier. Kiesler's

set designs for the production included collages and photomontages featuring images culled from glossy picture magazines, with little interest in "historical accuracy."[17] The author Anaïs Nin, describing a farewell party for the surrealist artist André Breton that she, Kiesler, Matta, Arshile Gorky, Max Ernst, and Marcel Duchamp attended in New York in 1945, noted in her diary: "Frederick Kiesler, the modern architect, kissing ladies' hands. But as he is four feet tall, it makes a woman feel like the Statue of Liberty."[18]

Kiesler was a prominent figure (if a small man) among similarly inventive surrealist artists. He collaborated with Duchamp for several decades

on various exhibition designs and other projects, and in 1937 published an article on the artist's enormous work *The Large Glass* (1915–23) in *Architectural Record*, observing that this extraordinary example of modern art, made with unorthodox materials and ostensibly focusing on the relationship between the sexes, "will not fit any descriptions such as abstract, constructivist, real, super—and—surrealist without being affected. It lives on its own eugenics. It is architecture, sculpture and painting in ONE."[19]

Kiesler worked with other interwar surrealists as well, among them Max Ernst, the peripatetic German-born surrealist who pioneered a number of inventive pictorial techniques, including collage, frottage, decalcomania, and oscillation. From the late 1920s through the mid-1930s, Ernst developed a series of "collage novels," taking Victorian-era woodcuts printed in popular dime novels, natural science journals, sales catalogues, and travel magazines, cutting them apart and then precisely reorganizing them to deny his intervention and to suggest their plausibility— and thereby to create new, often hallucinatory visual situations that challenged conventional expectations of certain scenes and subjects. Ernst's *The Lover* (1934) (fig. 4) is comparable to the 184 collages he created for his surrealist novel *A Week of Kindness*, which he worked on during the summer of 1933.

Fig. 4
Max Ernst (German, 1891–1976)
L'Amoureux (The Lover), 1934
Collage
5 x 3 3/4 in. (12.7 x 9.53 cm)
University acquisition
© 2013 Artists Rights Society (ARS), New York /
ADAGP, Paris

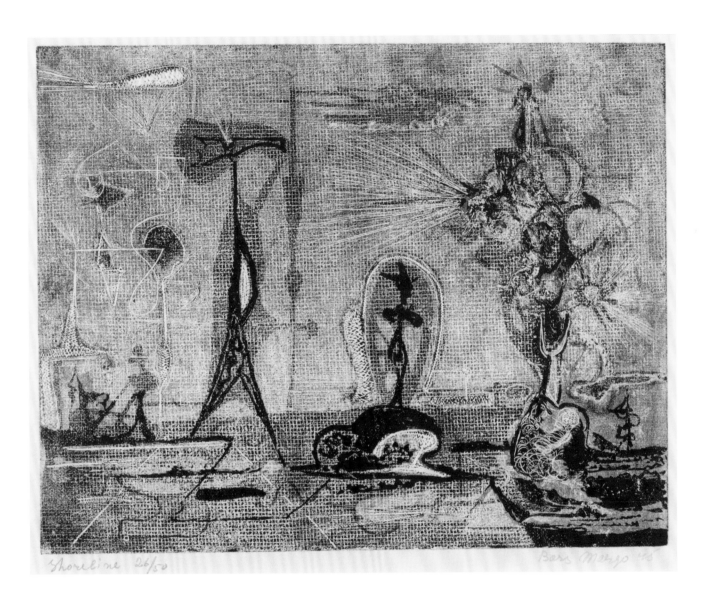

Fig. 5
Boris Margo (American, born in Russia, 1902–1995)
Shoreline, 1945
Etching
Image: 7 x 9 in. (17.8 x 22.9 cm); sheet: 9 3/4 x 12
in. (24.77 x 30.48 cm)
Gift of the Betty Parsons Foundation
© Courtesy of Michael Rosenfeld Gallery LLC,
New York, NY

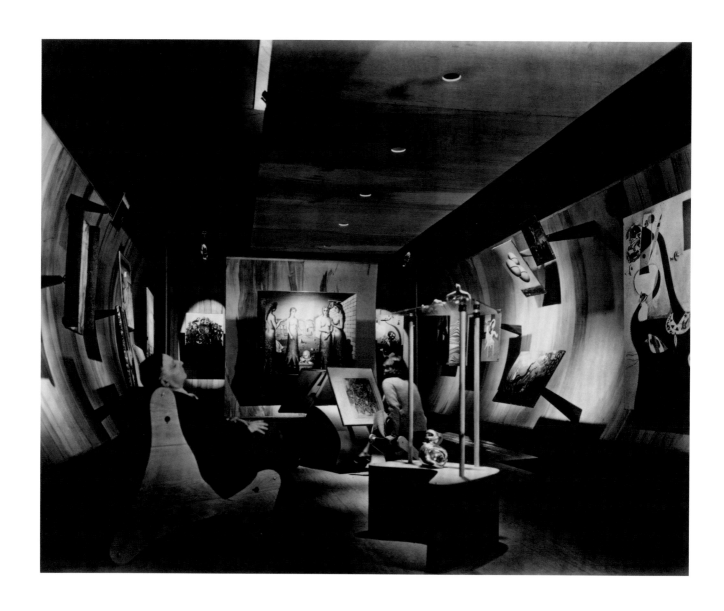

Fig. 6
Frederick Kiesler
Surrealist Gallery with Frederick Kiesler sitting in a Correalist instrument
Art of This Century, Installation view looking south
New York, 1942
Photo by Berenice Abbott
© 2013 Austrian Frederick and Lillian Kiesler Private Foundation, Vienna/
Berenice Abbott/Getty Images

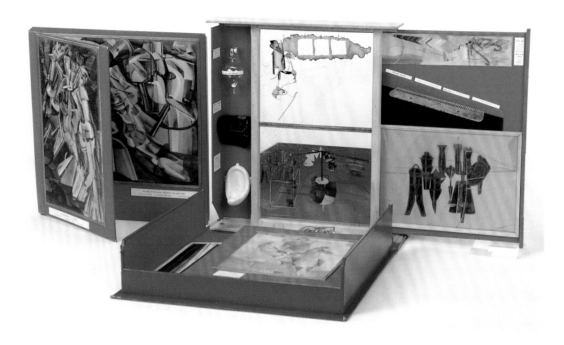

Fig. 7
Marcel Duchamp (French, 1887–1968)
Boîte-en-Valise (de ou par Marcel Duchamp ou Rrose Sélavy) (Box-in-a-Valise), 1941/1966
Replicas and reproductions of 80 works encased in red leather box
15 1/8 x 16 1/4 x 3 5/8 in. (38.42 x 41.275 x 9.21 cm)
Museum purchase with funds from the Philip D. Adler Fund
© Succession Marcel Duchamp / ADAGP, Paris / Artists Rights Society (ARS), New York, 2013

In 1942, Peggy Guggenheim—who was married to Ernst from 1941 to 1946—asked Kiesler to design the rooms for her Art of This Century Gallery. A haven for European moderns fleeing the war and for American artists working in abstract and surrealist styles, Guggenheim's gallery, which was located at 30 West Fifty-seventh Street, exhibited both the art she collected (several pieces of which she later donated to the University of Iowa) and some of the most original art produced during the 1940s. This included work by Jean Arp, Ernst, Giorgio de Chirico, Robert Motherwell, Pollock, Rothko, and Boris Margo, a pioneering printmaker who produced surrealist-inspired etchings such as *Shoreline* (1945) (fig. 5) and invented the cellocut, a high-relief process involving solidified

plastic. Spurning the staid interior of the average midcentury art salon, Kiesler outfitted Art of This Century Gallery with biomorphic furniture, undulating walls, and free-floating easels with suspended frames that displayed canvases and prints (fig. 6).[20] Rejecting the separation of interior and exterior space, and general distinctions between art and architecture, Kiesler wrote: "We, the inheritors of chaos, must be the architects of a new unity. These galleries are a demonstration of a changing world in which the artist's work stands forth as a vital entity in a spatial whole, and art stands forth as a vital link in the structure of a new myth."[21] Considered radical at the time, Kiesler's visceral and theatrical installation aesthetic is practiced today by artists and architects alike.

In one of the rooms for Guggenheim's gallery, Kiesler designed a special kinetic peephole mechanism that allowed visitors to view the sixty-nine miniature works of art included in Duchamp's "portable museum," *Box-in-a-Valise* (1941/1966) (fig. 7).[22] The miniatures, each a reproduction of Duchamp's own art—from his 1912 painting *Nude Descending a Staircase (No. 2)* to doll-house-sized replicas of his various Readymades—were originally collected in a collapsible leather suitcase; later versions were assembled in fabric-covered volumes and featured different numbers of items. As a critique of standard notions of artistic originality and authenticity, as well as of market-directed assumptions about artistic value, Duchamp's conceptual art was central to the modernist project.

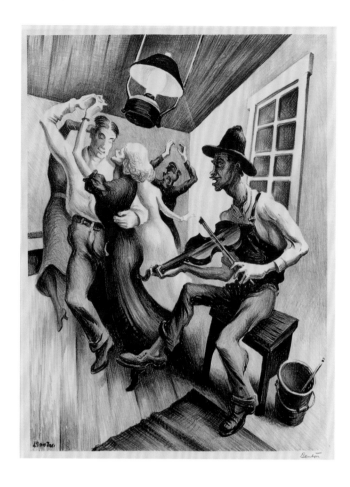

True, some artists disavowed any association with modernism. The regionalist painter Thomas Hart Benton, who spent several years (1908–12) studying various styles of modern art in Paris while in his twenties, told the art critic Thomas Craven, "I wallowed in every cockeyed ism that came along and it took me ten years to get all that modernist dirt out of my system."[23] But Benton was clearly an American modern: his multitemporal, spatially ambiguous, and wildly colorful pictures are clearly distinct from premodern styles of painting, as are his similarly animated prints. In his 1938 lithograph *I Got A Gal on Sourwood Mountain* (fig. 8), Benton employed a tilting, unstable composition to reproduce visually the "rollicking refrains" ("hay diddy ump, diddy iddy um day") of a popular Appalachian folk ballad, and conveyed the joyful, rambunctious movements of the scene's dancers and musicians on equally dynamic terms.[24] Despite his protestations, Benton's aspersion of "modernist dirt" stemmed more from personal animosity toward certain modern artists (and his own contrariness) than any antimodern bias in his own regionalist artwork.[25]

Regionalism, often grouped with social realism under the umbrella term "American Scene" painting, was one of a number of modern American art styles that flourished from the 1930s through the mid-1940s. In his best-selling book *Modern American Painting* (1939), the art magazine editor Peyton Boswell Jr. explained that "the American scene is an ever-changing total of infinite local scenes," and "American Scene painting is in reality regionalism in art, fragments of the American panorama best known to the individual native artists."[26] This collective cultural focus on Americana was not unique to the interwar era. Since the early twentieth century, anxieties about the sway of European "isms" and worries about American cultural inferiority, coupled with mounting social and political pressures to define (and most often celebrate) American nationalism, had persuaded American moderns of all types to pursue subjects and styles that might be considered distinctively native in spirit and design. As Stuart Davis announced in 1922, "Starting now I will begin a series of paintings that shall be rigorously, logically American, not French. America has had her scientists, her inventors, now she shall have her artists."[27] Critics encouraged American artists to

discover and appreciate the nation's unique cultural resources—"We have been sponging on Europe for direction instead of developing our own," Paul Rosenfeld scolded in 1924—and doing so became "a standard modernist narrative in the 1920s and 1930s," observes the art historian Wanda Corn.[28]

Exemplified in paintings like Lee Allen's *Corn Country* (1937) (fig. 36) and John Tazewell Robertson's *Sand Pits* (c. 1935) (fig. 43), and in prints produced by Benton, Curry, and Wood for the Associated American Artists, regionalism's modernist narrative centered on America's landscapes—agricultural and industrial—and peoples, often shown engaged in supposedly typical American activities: dancing to folk songs, going to the circus, baling hay on vast acres of Iowa farmland. Yet however much it focused on what Boswell called "infinite local scenes," regionalism was fundamentally national in scope; the style's visual "fragments of the American panorama" were intended to represent the nation as a diverse but unified whole. Regional details—from particular geographies to specific folk traditions—were the currency of cultural nationalism, a modernist project that melded America's multiple forms of art into a larger statement about collective national unity.

In this regard, regionalism was very much attached to the national cultural projects organized under the New Deal. As Benton observed in his 1969 autobiography, "Regionalism was . . . very largely affirmative of the social exploration of American society and resultant democratic impulses on which President Roosevelt's New Deal was based. Roosevelt's early social moves were

overwhelmingly Americanist and were concentrated on the solution of specifically American problems. This Americanism found its aesthetic expression in Regionalism."[29]

Soon after Franklin Delano Roosevelt became president in 1933, the federal government began providing nationwide emergency labor relief for the nation's artists through a variety of so-called alphabet agencies. These included the WPA (Works Progress Administration, which after 1939 was called the Work Projects Administration), FSA (Farm Security Administration), and PWAP (Public Works of Art Project). Each was housed within a different federal agency—the FSA with the Department of Agriculture, PWAP with the Treasury Department—to avoid undue political influence. The WPA sponsored multiple art, music, theater, and writing projects, including the Federal Arts Project (FAP, the visual arm of the agency, with specific divisions focused on easel painting, murals, sculpture, posters, and prints), the Federal Music Project (FMP, which offered free concerts, organized music classes, and collected traditional American folk songs), the Federal Theatre Project (FTP, which presented free performances and produced radio shows), the Federal Writers Project (FWP, which produced the "American Guide" series for most of the states in the nation), and The Index of American Design, a multivolume encyclopedia project intended to illustrate, mostly in watercolor, pre-1900 examples of American material culture. (Some eighteen thousand images were ultimately produced.) The WPA operated from 1935 to 1943, with a few projects lingering until the end of World War II.[30]

More than forty thousand American artists found employment under these New Deal cultural programs—painters such as Milton Avery, Stuart Davis, Philip Guston, Arshile Gorky, Lee Krasner, Jackson Pollock, Mark Rothko, and Ben Shahn; sculptors such as Robert Cronbach, William Edmondson, Sargent Johnson, and Louise Nevelson; printmakers Rosella Hartman, Elizabeth Olds, and Harry Sternberg; photographers Walker Evans, Dorothea Lange, and Gordon Parks; architects, musicians, actors, dancers, writers, and poets. Working on "the projects" allowed them to hone their creative skills and fostered broad public interest in American art and culture. As Nevelson later recalled, "The WPA . . . gave me a certain kind of freedom, and I think that our great artists today like Rothko, de Kooning, Franz Kline . . . had that moment of peace . . . to continue with their work. So, I feel that that was a great benefit, a great contribution to our creative people and very important in the history of art. . . . I think it's a high-light of our American history." Echoing Nevelson, Cronbach observed, "For the creative artist, the WPA/FAP was an unequaled opportunity for a serious artist to work as steadily and intensely as possible to advance the quality of his art."[31]

The New Deal's art projects were first and foremost "work relief" projects, measures aimed at employing, and keeping busy, some of the American millions (25 percent of the U.S. labor force was unemployed in 1933, for example) who might otherwise take to the streets to challenge social and political norms. But the projects also helped restore national confidence in established American social and economic patterns that were sorely tested by the destabilizing circumstances of

15

the Great Depression. Providing economic aid (typical pay was around twenty-four dollars per week) and social purpose for American artists, and emphasizing the need for public, accessible forms of American art, the federal government engaged American moderns to revitalize American national identity on generally affirmative terms.

Interest in reinvigorating American culture was extensive throughout the 1930s, manifest in popular history texts, radio shows, magazine contests, and the growth of community art centers. In his best-selling book *The Epic of America* (1931), the historian James Truslow Adams coined the phrase "American Dream," which he described as "that dream of a land in which life should be better and richer and fuller for everyone, with opportunity for each according to ability or achievement."[32] As Sharon Musher explains, Adams's basic argument was that broad national cultural reform, including investment in the arts and education, would help modern Americans "redefine their values and destiny." Adams donated the rights of *Epic of America* to the Radio Division of the WPA's Federal Theatre Project, which produced a thirteen-part radio show that, broadcast in 1937, drew two million listeners, or about 10 percent of every radio-owning American household at the time.[33]

Public enthusiasm for cultural education was astounding during the 1930s: like the AFA-sponsored radio show *Art in America*, the WPA's broadcast of *Epic of America* generated tens of thousands of letters from teachers requesting further episodes and repeated airing for classroom use. Similarly, in 1938 *American Magazine* sponsored its first American Youth Forum, offering cash awards to high school students for essays and pictures that "expressed their thoughts and feelings about themselves and the America of their hopes." The magazine received more than 231,000 entries.[34] And the WPA, which organized art classes for children and adults throughout the nation, also developed more than one hundred community arts centers. These included the Walker Art Gallery in Minneapolis, the foundation of today's Walker Art Center; the South Side Community Art Center in Chicago, which continues to offer classes in the building that Eleanor Roosevelt dedicated in 1941; and the Sioux City Art Center in Iowa, which opened in 1938 and still operates today. More than four thousand people showed up for the opening of Minneapolis's WPA-sponsored art center in January 1940, in minus-ten-degree weather.[35]

Although most New Deal art was representational in style, many modern artists with interests in nonfigurative directions also worked on "the projects." Employed with the FAP's Mural Division from 1935 to 1937, Arshile Gorky produced ten large-scale, brightly colored, cubist-inspired panels for Newark Airport titled *Aviation: Evolution of Forms under Aerodynamic Limitations.* Hired on to the projects in 1936, Mark Rothko was required to "submit an oil painting every four to six weeks (depending on size)," and used the opportunity to develop increasingly abstract canvases.[36]

The New Deal's political-cultural mandates, in other words, were neither as straightforward nor as propagandistic as one might expect, and actually fostered the stylistic pluralism of American modern art. In May of 1939, in fact, President Roosevelt dedicated the Museum of Modern Art's new building, describing it as a "citadel of civilization" and congratulating New Deal artists—"I think the WPA artist exemplifies with great force the essential place which the arts have in a democratic society such as ours"—and insisting that all communities should have "the visual chance to get to know modern art." Roosevelt especially remarked on the diversity and inventiveness of American modernism: "As in our democracy we enjoy the right to believe in different religious creeds or in none, so can American artists express themselves with complete freedom from the strictures of dead artistic tradition or political ideology. While American artists have discovered a new obligation to the society in which they live, they have no compulsion to be limited in method or manner of expression."[37] As Barr echoed in his booklet *What Is Modern Painting?* in 1943, "The greatest modern artists are pioneers just as are modern scientists, inventors and explorers. This makes modern art both more difficult and often more exciting than the art we are already used to."[38]

Notes

1. Alfred H. Barr Jr., *What Is Modern Painting?* (New York: Museum of Modern Art, 1943), 2–3.

2. Holger Cahill and Alfred H. Barr Jr., eds., *Art in America in Modern Times* (New York: Reynal & Hitchcock, 1934). In the 1920s Cahill was a curator at the Newark Museum, a leading venue for modern art, and became director of the New Deal's Federal Art Project in 1935.

3. Initiated by the General Federation of Women's Clubs, *Art in America* first aired in winter 1934, and covered American art from the colonial period through the Civil War. The program's second season aired from October 1934 to January 1935 and included seventeen broadcasts ranging from the first episode, "America after the Civil War," to closing episodes titled "The Modern House," "The Modern City," and "The Motion Picture." For more information see the Museum of Modern Art press release dated September 23, 1934, at http://www.moma.org/docs/press_archives/191/releases/MoMA_1934–35_0006.pdf?2010 (accessed April 13, 2013).

4. John Howell White, "Twentieth-Century Art Education: A Historical Perspective," in Elliot W. Eisner and Michael D. Day, eds., *Handbook of Research and Policy in Art Education* (New York: Routledge, 2004), 63. For more on art and radio during the Great Depression see Leo G. Mazow, *Thomas Hart Benton and the American Sound* (University Park: Pennsylvania State University Press, 2012), esp. chap. 4, "Regionalist Radio," 120–149.

5. Wanda M. Corn, "Coming of Age: Historical Scholarship in American Art," *Art Bulletin* 60, no. 2 (June 1988): 192–193; Robert J. Goldwater, "The Teaching of Art in the Colleges of the United States," *College Art Journal*, part 2, supplement (May 1943): 13–18.

6. Erika Doss, "Catering to Consumerism: Associated American Artists and the Marketing of Modern Art, 1934–1958," *Winterthur Portfolio, A Journal of American Material Culture* 26, nos. 2–3 (Summer–Autumn 1991): 143–167; the quoted advertisement appeared on the back cover of *Art Digest* 9, no. 7 (January 4, 1935).

7. Irving Sandler, *The Triumph of American Painting: A History of Abstract Expressionism* (New York: Praeger Publishers, 1970).

8. Peter Wollen, "Modernities and Realities," *Views from Abroad: European Perspectives on American Art* 3 (New York: Whitney Museum of American Art, 1997), 13–14; see also Erika Doss, "American Moderns and the American Scene," paper presented at the symposium "Remapping the New: Modernism and the Midwest, 1893–1945," Terra Museum of American Art, Chicago, September 18, 2004.

9. Clement Greenberg, "Review of Exhibitions of Mondrian, Kandinsky, and Pollock," *Nation* 160, no. 14 (April 7, 1945): 397; B. H. Friedman, *Jackson Pollock: Energy Made Visible* (New York: Da Capo Press, 1995), 75–76.

10. Clement Greenberg, "The Decline of Cubism," *Partisan Review* 10, no. 3 (March 1948): 369.

11. Clement Greenberg, "'American-Type' Painting," *Partisan Review* 22, no. 2 (Spring 1955): 186–187.

12. Erika Doss, *Benton, Pollock, and the Politics of Modernism: From Regionalism to Abstract Expressionism* (Chicago: University of Chicago Press, 1991), 364, 369–379; see also Serge Guilbaut, *How New York Stole the Idea of Modern Art: Abstract Expressionism, Freedom, and the Cold War* (Chicago: University of Chicago Press, 1983).

13. Clement Greenberg, "Our Period Style," *Partisan Review* 16, no. 11 (November 1949): 1138; see also Erika Doss, "Not Just a Guy's Club Anymore," *American Quarterly* 50, no. 4 (December 1998): 840–848.

14. Daniel Joseph Singal, "Towards a Definition of American Modernism," *American Quarterly* 39, no. 1 (Spring 1987): 7–26.

15. Janet Wolff, *AngloModern: Painting and Modernity in Britain and the United States* (Ithaca, NY: Cornell University Press, 2003).

16. Kiesler's publications include *Contemporary Art Applied to the Store and Its Display* (New York: Brentano, 1930).

17. R. L. Held, *Endless Innovations: Frederick Kiesler's Theory and Scenic Design* (Ann Arbor, MI: UMI Research Press, 1982), 107–108.

18. Anaïs Nin, *Diary of Anaïs Nin*, vol. 4, 1944–1947 (New York: Houghton Mifflin, 1972), 103.

19. Frederick Kiesler, "Design-Correlation: From Brush-Painted Glass Pictures of the Middle Ages to the 1920s," *Architectural Record* 81 (May 1937): 53–60; see also Linda Dalrymple Henderson, *Duchamp in Context: Science and Technology in the Large Glass and Other Works* (Princeton: Princeton University Press, 1998). Kiesler and Duchamp had a falling-out in 1947, when Kiesler wrote a "malicious letter" to Breton accusing Matta of forcing Gorky's suicide; Matta and Gorky's wife had an affair just before Gorky killed himself in 1948. See Calvin Tomkins, *Marcel Duchamp: A Biography* (New York: Henry Holt, 1996), 365–366, and Henderson, *Duchamp in Context*, 214–217.

20. Susan Davidson, ed., *Peggy Guggenheim and Frederick Kiesler: The Story of Art of This Century* (New York: DAP, 2004).

21. Frederick Kiesler, quoted in Ingrid Whitehead, "Kiesler's Unforgettable Interior: The Art of This Century Gallery," *Architectural Record* 191, no. 9 (September 2003): 103.

22. Larry Witham, *Picasso and the Chess Player: Pablo Picasso, Marcel Duchamp, and the Battle for the Soul of Modern Art* (Lebanon, NH: University Press of New England, 2013), 192.

23. Thomas Hart Benton, letter to Thomas Craven, quoted in Milton Brown, *The Story of the Armory Show* (New York: Joseph H. Hirshhorn Foundation, 1963), 26.

24. Leo G. Mazow, "Thomas Hart Benton: Painting the Song," *The Space Between: Literature and Culture, 1914–1945*, no. 1 (2011): 37.

25. Benton had long-running feuds with, for example, other American moderns such as Stuart Davis and Alfred Stieglitz; see his autobiography, first published in 1937, *An Artist in America*, 4th rev. ed. (Columbia: University of Missouri Press, 1983), 46; and Justin Wolff, *Thomas Hart Benton: A Life* (New York: Farrar, Straus and Giroux, 2012), 134–135, 162–163.

26. Peyton Boswell Jr., *Modern American Painting* (New York: Dodd, Mead, 1939), 61. Beginning in 1936, Boswell edited *Art Digest*, which his father founded in 1926. *Modern American Painting* sold 250,000 copies, making it the best-selling art book of its day.

27. Stuart Davis, journal entry, 68, as noted in Matthew Baigell, "American Art and National Identity: The 1920s," *Arts Magazine* 61, no. 6 (February 1987): 48.

28. Paul Rosenfeld, *Port of New York: Essays on Fourteen American Moderns* (New York: Harcourt Brace, 1924), 281–295; Wanda Corn, *The Great American Thing: Modern Art and National Identity, 1915–1935* (Berkeley: University of California Press, 1999), 12.

29. Thomas Hart Benton, "American Regionalism: A Personal History of the Movement," in Benton, *An American in Art: A Professional and Technical Autobiography* (Lawrence: University of Kansas Press, 1969), 192.

30. For more information on various New Deal art projects see, for example, Bruce I. Bustard, *A New Deal for the Arts* (Washington, DC: National Archives and Records Administration, 1997); Francis V. O'Connor, ed., *Art for the Millions: Essays from the 1930s by Artists and Administrators of the WPA Federal Art Project* (New York: New York Graphic Society, 1973); Richard D. McKinzie, *The New Deal for the Artists* (Princeton: Princeton University Press, 1973); Marlene Park and Gerald E. Markowitz, *Democratic Vistas: Post Offices and Public Art in the New Deal* (Philadelphia: Temple University Press, 1984); Karal Ann Marling, *Wall-to-Wall America: A Cultural History of Post Office Murals in the Great Depression* (Minneapolis: University of Minnesota Press, 1982); Barbara Melosh, *Engendering Culture: Manhood and Womanhood in New Deal Public Art and Theater* (Washington, DC: Smithsonian Institution Press, 1991); Virginia Tuttle Clayton, Elizabeth Stillinger, Erika Doss, and Deborah Chetner, *Drawing on America's Past: Folk Art, Modernism, and the Index of American Design* (Washington, DC: National Gallery of Art, 2002); A. Joan Saab, *For the Millions: American Art and Culture between the Wars* (Philadelphia: University of Pennsylvania Press, 2004); Victoria Grieve, *The Federal Art Project and the Creation of Middlebrow Culture* (Urbana: University of Illinois Press, 2009); and Sharon Ann Musher, *A New Deal for Art* (Chicago: University of Chicago Press, forthcoming).

31. Louise Nevelson, quoted in William E. Leuchtenburg, "Art in the Great Depression," in *A Modern Mosaic: Art and Modernism in the United States*, ed. Townsend Ludington (Chapel Hill: University of North Carolina Press, 2000), 252–253; Robert Cronbach, "The New Deal Sculpture Projects," in Francis V. O'Conner, ed., *New Deal Art Projects: An Anthology of Memoirs* (Washington, DC: Smithsonian Institution Press, 1972), 140.

32. James Truslow Adams, *The Epic of America* (Boston: Little, Brown, 1931).

33. Sharon Ann Musher, "A New Deal for Art" (PhD dissertation, Columbia University, 2007), 119–120.

34. John Dungan, "American Youth Forum Awards," *American Magazine* 76, no. 3 (September 1938): 14–15, 92–95; see also Erika Doss, "Sharrer's Tribute to the American Working People: Issues of Labor and Leisure in Post–World War II American Art," *American Art* 16, no. 3 (Autumn 2002): 61–62.

35. Musher, "A New Deal for Art," 200.

36. James E. B. Breslin, *Mark Rothko: A Biography* (Chicago: University of Chicago Press, 2012), 120–121.

37. Roosevelt's dedication was broadcast from the White House; for a transcript of his speech see "Radio Dedication of the Museum of Modern Art, New York City, May 10, 1939," *The American Presidency Project* at http://www.presidency.ucsb.edu/ws/?pid=15761 (accessed April 22, 2013).

38. Barr, *What Is Modern Painting?*, 3.

Modernism Ascendant

The Contested History of Modern Art at the University of Iowa

Joni L. Kinsey, PhD

Professor
School of Art and Art History
University of Iowa

Beginning in 1934 and continuing for several decades, Iowa was a hotbed of aesthetic controversy and innovation, a place where the American Scene clashed with the avant-garde in ways that were central to the ongoing national debate over the future of American art. Although sometimes viewed as a provincial outpost, the University of Iowa was uniquely positioned as an important nexus of the modern art world, with prominent individuals and events that helped define the era and set aesthetic and ideological standards for the decades that followed. Grappling with contentious regional, national, and international political and aesthetic issues, the disputes and resulting policy decisions in what was then called the Department of Graphic and Plastic Arts played an important role in helping establish modern art as the dominant mode of visual expression in the second half of the twentieth century. Equally significant were the publications that the department's artists and art historians produced, the exhibitions at the Art Building and the Iowa Memorial Union (figs. 9 and 10),

Fig. 9
Frederick Kent, *Exhibition in the Art Building*, May 1940
Frederick W. Kent Collection of Photographs, Special Collections,
University of Iowa Libraries, Iowa City, IA

Fig. 10
Frederick Kent, *Exhibition in the Iowa Memorial Union*, March 1944
Frederick W. Kent Collection of Photographs, Special Collections,
University of Iowa Libraries, Iowa City, IA

and the collections acquired for the university art collection, which would become the University of Iowa Museum of Art in 1969. The modernist controversies at the university are especially significant because Iowa was the epicenter of the regionalist art movement in the 1930s (with Grant Wood [1891–1942] as its most prominent and exemplary spokesperson) and an emerging hub of the most progressive forms and influential advocates of modern art. Figures such as Lester Longman (chair of the University of Iowa's art department, editor of the College Art Association's national art journal *Parnassus*, and a staunch proponent of international modernism), Horst W. Janson (a young émigré art history professor who emphasized modern art in his courses and who went on from the University of Iowa to establish important modern art collections in St. Louis, write the leading art history textbook of his time, and influence the acceptance of modern art in his teaching of a generation of art historians at New York University's Institute of Fine Arts), and a series of major modern artists (such as Philip Guston and Mauricio Lasansky, both of whom taught at the University of Iowa)—all worked to counteract the popular preference for regionalist or American Scene art through their

Fig. 11
Unidentified photographer, *Grant Wood*, c. 1940, Grant Wood Archive, Scrapbook 8
© Figge Art Museum, Davenport, IA

courses, art, and publications, as well as prominent exhibitions and acquisitions of avant-garde art on campus. Determined to set new standards through these activities, they ultimately succeeded in shifting the university's aesthetic emphasis toward modern art and made major contributions to the national trend away from regionalism. The avant-garde's encounter with the American Scene at Iowa had far-reaching consequences, beyond the legacy in the university museum's own collections; it helped establish perceptions of American Scene painting, regionalism, and modernism down to the present day.

The University of Iowa entered the arena of modern art in 1934. The Department of Graphic and Plastic Arts was then quite traditional, emphasizing, like most programs of the time, nineteenth-century aesthetic principles and practices that focused on close study of ancient monuments and the styles of earlier masterworks, rather than pictorial innovation or individual expression.[1] When an early New Deal program, the Public Works of Art Project (PWAP), brought Grant Wood (fig. 11) into the faculty in 1934, the smooth surfaces of his paintings, his regional subject matter, and his idiosyncratic methods (he had not been academically trained) were disconcertingly modern to his new colleagues, and he represented a challenge to the status quo even as his national reputation raised the

profile of the institution.[2] From the outset, Iowa's most celebrated artist was a controversial figure at the flagship university of his home state.

As Erika Doss points out in the preceding essay, although it is easy to characterize regionalism and modernism as antithetical (as many critics did in the 1930s and beyond), many aspects of regionalist painting *were* modern. "[Thomas Hart] Benton was clearly an American modern," she observes. "His multi-temporal, spatially ambiguous, and wildly colorful pictures are clearly distinct from pre-modern styles of painting."[3] Similarly, Wood's highly stylized and simplified forms and John Steuart Curry's more painterly effects, along with the regionalists' attention to everyday subjects that lacked the panache of high art, were hardly traditional by 1930s standards. By admitting Wood to the UI faculty in 1934, the university entered a new era.

Fig. 12
Photographer unknown, Lester Longman, c. 1938
Courtesy of Stanley Longman

The dynamics of the initial conservative/liberal polarities in the University of Iowa art department were upended quickly, however, with the arrival of a new chair in 1936, Lester D. Longman (fig. 12). Longman was a Princeton-educated art historian who immediately began transforming the program in the direction of much more radical modern art, with a new curriculum, several new faculty members, and an ambitious program of exhibitions and art acquisitions.[4] In the context of the "international modernism" that he promoted (mostly abstract art painted in a highly expressionistic style), Grant Wood's regionalism was hardly "liberal" or "modern," and the new chair considered Wood an aesthetic and political reactionary because of his emphasis on American themes painted in a manner that was highly accessible to and admired by a vast national public.[5]

A much as Longman would have liked to dismiss as inconsequential both Wood and what he represented, they presented a formidable obstacle to him, his fellow modernists, and their agenda for sweeping change in America's art, taste, and values. In the mid-1930s not only was Wood the most famous artist in Iowa, but he was also one of the best known in the United States, having painted the enormously popular *American Gothic* (Art Institute of Chicago) in 1930, along with a number of other widely reproduced and discussed regionalist works. He was then at the height of his career, extremely active nationally as the de facto spokesperson for regionalism and the most famous faculty member at the University of Iowa.[6] American Scene imagery, of which regionalism is a subset, had broad appeal with the public, and it was for all practical purposes the official style of the American

government, through numerous New Deal programs that encouraged representations of local and nationally relevant imagery through its support of thousands of artists and projects. In a period traumatized by the severe economic crisis of the Great Depression, and following a disastrous era of political and military strife in Europe, the desire to focus on familiar and often reassuring themes of home, land, and work was extremely compelling. Many, including Wood and his regionalist cohorts, saw the trends as a new and exciting beginning of an *authentic* American art that would draw its power and legitimacy from a direct response to the culture, people, and environment of the United States.[7]

Trained in the East and thoroughly attuned to the cultural history of Europe and elite intellectual issues, Lester Longman regarded these trends as provincial, isolationist, and regressive, and a serious threat to his goals for his department and the future of an American art that would transcend national interests and aesthetics and be relevant internationally. He began a concerted campaign to marginalize and discredit Wood and regionalism, both at the university and around the country, efforts that would escalate from in-house disputes over curriculum and pedagogy to diatribes in professional journals and conference presentations that reached a broad audience.[8] Simultaneously he worked to integrate modernism into the art and art history programming at the university by hiring faculty sympathetic to his views and to the larger aesthetic and ideological aims of modern art, and by ensuring that frequent exhibitions of contemporary art were a regular feature of campus life.

The vehemence with which Longman battled Wood and what he represented is both startling and significant. Far more than merely an example of university politics between two individuals with opposing aesthetic preferences and a strong dislike for each other, their ongoing dispute was part of a much larger struggle for the future, and even the soul, of American art and culture. It was an aesthetic and ideological contest charged with the fraught politics and strident rhetoric that characterized the period of the Great Depression and World War II, a tenuous era during which socialism vied with capitalism in the American public arena, and fascist and communistic forces gained ascendancy abroad.[9]

Nationalism in American art had been a widely discussed ideal throughout the nineteenth century, and many early twentieth-century modernists also self-consciously sought what Georgia O'Keeffe called "the Great American Thing," but the quest to visually represent the essence and character of the nation assumed a heightened polemical and political tenor in the 1930s and 1940s.[10] An early critique of this trend came in Samuel Koontz's *Modern American Painters* (1930), which opened with "Our more zealous chauvinists are demanding a national art . . . but there seems little gain in beseeching our painters to portray American scenes." By the middle of the war in 1943, Koontz's rhetoric had escalated to the inflammatory, damning nationalism and regionalism in the U.S. for their presumed similarity to more troubling trends abroad. The first chapter of his *New Frontiers in American Painting* (1943), for example, is "The War of Ideas," in which Koontz darkly charges, "In its bombastic philosophy

Nationalism, at its worst [and he had just cited Wood and Benton as examples], is too related for comfort to the opinionated Fascism that has itself sponsored just such local familiar narcotics."[11]

Koontz was hardly alone in diatribes. Many would take up verbal sword-rattling in the aesthetic battlefield and Lester Longman was often in the forefront. Positioned as an easterner in the heart of Grant Wood's Iowa, and faced with the preeminent proponent of regionalism on a daily basis, he took up the cause with a personal vengeance, blocking Wood's contributions to the art program in various ways, criticizing him publicly in conference presentations, and soliciting letters from carefully selected individuals in prominent positions in the art world to support his assertions about his colleague (all of which he carefully forwarded to university administrators).[12] And he had a powerful national platform as a board member of the College Art Association and as editor of *Parnassus,* the CAA's journal of art criticism. Longman opened his first issue of that magazine (1940) with an editorial titled "Better American Art" which, while not mentioning Wood or regionalism directly, called for the "defenders" of "true art . . . to attack" what he described as "reactionary" and "communazi" art, a category he associated with the popular imagery that had brought Wood and his regionalist fellows broad acclaim and commercial success. Warning of an aesthetic "fascist revolution," Longman vilified "the illustration mongers who serve us for money and fame," saying, "They are American art's fifth column, blood brothers of the exponents of the 'new order' which will be so convenient to their material prosperity."[13]

Longman's campaign was strident and unrelenting, even after Wood's untimely death from pancreatic cancer on February 12, 1942. Just weeks afterward, in early April, the chair circulated an essay about regionalism that he had written for an art dictionary, saying to the University of Iowa officials to whom he sent it, "I believe enough time has passed now (though around here the case may seem otherwise), so that one can analyze the meaning of the term without it seeming to be more a critical evaluation than a pure analysis."[14] Calling "Regionalism" a "minor American movement" of "inferior but successful artists," Longman likened its practitioners to Nazi artists, describing them as "cultural fascists" and "escapist, isolationist, and Americanist." Although the essay was purportedly written about the movement as a whole, Wood was clearly its primary target since many specifics unique to him were included, most notably the artist's preference for wearing overalls when painting and teaching, and phrases such as "Return from Bohemia" and "the only good ideas he ever had came while he was milking a cow."[15]

The university administrators were alarmed by the essay's "argumentative" and "biased" tone. After being admonished that "perhaps the Head of the Art Department where Grant Wood worked during the last years of his life should not undertake to define him and his work, out of respectful consideration on the part of those who are inclined to be respectful toward him," Longman did not publish the article, but he did go on to write others that damned regionalism as "isolationist, tribalistic, chauvinistic illustration," and that celebrated the international

Fig. 13
Horst W. Janson, ca. 1935
Reproduced from "Horst Woldemar Janson," by Lise Lotte Müller, *Zeitschrift für Kunstgeschichte* 46, no. 4 (1983).

modernism he preferred.[16] It seemed that even the death of Longman's nemesis could not lessen the threat that he and his movement had posed to the modernist agenda, and the department chair and his cohorts continued the fight even after their cause had gained the upper hand.[17]

Longman had important allies who were equally interested in the ascendancy of modernism, both at the University of Iowa and throughout the United States. Among the most significant in his home department was the art historian Horst W. Janson (fig. 13), who had moved to the United States from Germany in 1935, his immigration sponsored by Alfred Barr, director of the Museum of Modern Art. Janson came to Iowa in 1938 from Harvard University, where he was working on his doctorate, probably with the recommendation of Paul Sachs, a prominent professor of art history there with whom Longman occasionally corresponded.[18] Although Janson stayed in Iowa City for only three years (he moved

on to Washington University in St. Louis in 1941 and then to New York University's Institute of Fine Art in 1948), it was a formative period in his career and the life of the department. Longman's interests and ideas seem to have had a significant influence on the young scholar, and, conversely, Janson's seems to have, for the most part, reinforced the chair's endeavors during that time and afterward.[19]

Although trained as a historian of Italian Renaissance art, Janson took a keen interest in modernism in his teaching, curatorial activities, and research. Like Longman, he wrote articles praising contemporary art and disparaging regionalism as akin to fascism, part of a grudge he maintained against Grant Wood for supposedly getting him fired (briefly) from the University of Iowa for taking a group of students to see a Picasso exhibition in Chicago.[20] His most important contribution to the understanding of modernism, however, may have been through his 1962 *History of Art,* a sweeping survey of art history which became the standard textbook on the subject for decades, selling over four million copies and going through six editions by 2001.[21] The book makes modernism seem virtually inevitable and largely dismisses American Scene painting in favor of abstract trends, and this, along with Janson's distinguished teaching career, influenced countless individuals who went on to become artists, art history professors, and museum professionals, helping to institutionalize the dominance of modernist art in American culture.[22]

Other important hires Lester Longman made at about the same time as he worked with Janson and Grant Wood included Fletcher

Martin (1904–1979) and Philip Guston (1913–1980). Martin was Wood's replacement in 1940–41 as Wood took a sabbatical to paint in Clear Lake, Iowa, and escape the pressures of his academic position. Ironically, Martin was less well-educated academically and artistically than Wood, an unusual choice in this regard since Longman was very actively advocating academic education for artists, an emphasis on the liberal arts, in addition to studio training.[23] The chair seems to have handpicked Martin to present a virile contrast to Wood, hoping that he and other new faculty, such as printmaker Emil Ganso (1895–1941), would offer a new model for contemporary art. To make the point, Longman included in his first edition of *Parnassus* a lengthy feature article by Peyton Boswell about Martin. Acknowledging that Martin's work might appear to be American Scene painting, it emphasized that instead "there is little of regional flavor," and that he was "no popular illustrator," and finally that his new position at the University of Iowa was "another important example of a great educational institution now bringing a leading contemporary artist into its faculty."[24]

Since Wood returned to the university in the fall of 1941, Martin moved on to the Kansas City Art Institute, but before leaving he facilitated the hiring of his close friend Philip Guston, an emerging figure in the New York School of abstraction. Guston was also a high-school classmate and friend of Jackson Pollock's, and would go on to become a major modernist painter in the United States. His years at Iowa were significant both for him and the university's art program, helping to establish the school's momentum toward contemporary art.[25]

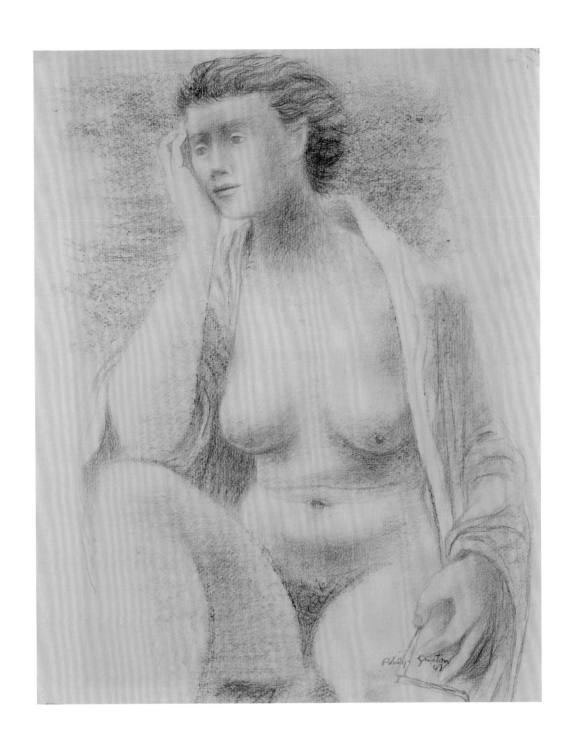

Fig. 14
Philip Guston (American, born in Canada, 1913–1980)
Untitled (figure study), c. 1941–45
Charcoal
17 x 21 in. (43.18 x 53.34 cm)
On loan from the University of Iowa School of Art and Art History
© The Estate of Philip Guston

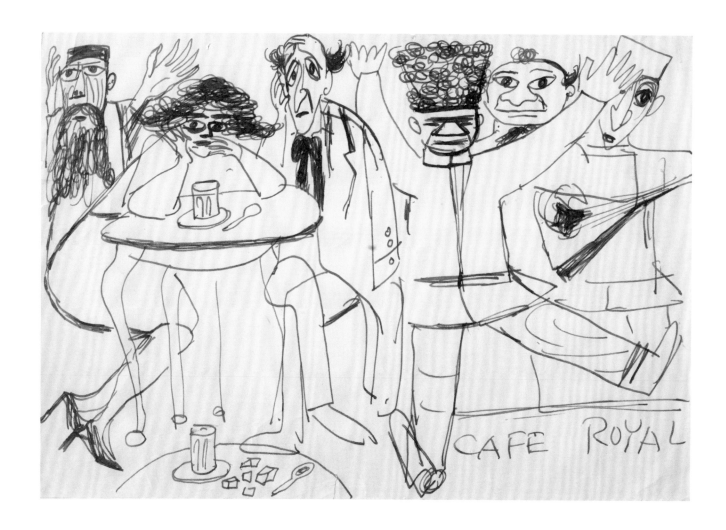

Fig. 15
Philip Guston (American, born in Canada, 1913–1980)
Café Royale, 1945
Ink
7 1/4 x 10 1/2 in. (18.42 x 26.67 cm)
Gift in memory of Lester and Florence Longman from
Stanley and Ruth Longman
© The Estate of Philip Guston

Fig. 16
Frederick Kent, *Riverview of Art Building, The University of Iowa,*
October 1936
Frederick W. Kent Collection of Photographs,
Special Collections, University of Iowa Libraries, Iowa City, IA

Guston taught at the University of Iowa throughout the war, from 1941 to 1945. Only recently an easel painter (he had done murals for the WPA in the 1930s), he focused some of his own work on portraiture during this period, sometimes using his wife and daughter as subjects (*The Young Mother,* 1944, fig. 38).[26] Another example of his art from this time is a drawing recently discovered in the files of the university's art department (fig. 14), and four drawings Guston made at Longman's home (fig. 15).[27]

Much of Guston's work in Iowa focused on support for the war effort.[28] In 1942 the art department established a "war art workshop" which had many art-related projects, from making posters for civil defense blackouts to making murals and sculptures for the servicemembers' center at Camp Dodge in Des Moines. Guston supervised the mural project.[29] He also did a series of sixteen illustrations for three articles about the war in *Fortune* magazine, for which he visited several training

and manufacturing facilities.[30] While Guston's illustrations are interesting in many ways, they are also ironic in the context of his position at the University of Iowa, since one of Longman's most persistent castigations of Grant Wood had focused on the artist's illustrations for mass-media publications. Guston's drawings for his *Fortune* illustrations were the centerpiece of his first one-person show at the Iowa Memorial Union in March 1944, at which Longman presented a lecture, calling Guston "an example of the aesthetic man, *par excellence.*"[31] Guston left Iowa City in 1945 to teach at Washington University, following Horst Janson, and then in 1947 he moved back to New York, where, like Janson, he taught at New York University. Replacing Guston at Iowa was James Lechay (1907–2001), an abstract painter who was also part of the New York avant-garde, having been a leader in the Art Union and friends with artists ranging from Milton Avery and Max Weber to Arshile Gorky and Mark Rothko.[32] Also hired that

year was Mauricio Lasansky (1914–2012), the Argentinian Guggenheim Fellow who had worked at Stanley Hayter's Atelier 17 in New York and who went on to transform the Iowa printmaking division into an internationally prominent program. All of these individuals, and many others during and after World War II, made major contributions to the development of the University of Iowa's reputation, moving it away from its former association with regionalism toward its recognition as a center for contemporary art.

A key component of this new era was the exhibition and collecting of modern art. Even though the University of Iowa Museum of Art was not formally established until 1969, exhibitions had become regular events at both the Iowa Memorial Union and the new Art Building (opened in 1936) by the mid-1930s (fig. 16).[33] During the Wood-Longman era, these displays were relatively balanced between American Scene imagery and modernism, including shows

featuring Thomas Hart Benton, Grant Wood, Marvin Cone, and Associated American Artists in 1939, for example, interspersed with exhibitions of contemporary abstract art, but Longman was obviously most interested in the latter. To celebrate the dedication of the new art building shortly after his arrival at the university, Longman wrote to several major museum directors, including Alfred Barr of New York's Museum of Modern Art, asking for a loan exhibition of "masters of the past and history-making painters of today," and he continued to arrange for such shows throughout his tenure at the university, increasingly emphasizing the contemporary.[34]

Many of the exhibitions were borrowed from the most avant-garde New York and Chicago galleries, and often showcased works by artists who, though not well known at the time, have since become canonical in the history of modern art. Le Corbusier, Max Beckmann, and Alexander Archipenko were each the focus of special exhibitions on campus in

the late 1930s, and selections from the Museum of Modern Art, the Guggenheim collection, and avant-garde New York dealers such as Midtown, Weyhe, and Downtown Galleries were also regularly featured. The exhibitions changed as often as once a month and several different groupings were usually on view at the same time. The program was extremely ambitious even by today's museum standards, but in the 1930s and 1940s in a relatively small midwestern community with no established museum, the array of notable contemporary art that was brought to campus was nothing short of extraordinary.[35]

Not all of the exhibitions were contemporary. One of the most significant displays ever mounted at the University of Iowa may have been a grouping of thirty historical masterworks from the Metropolitan Museum of Art in 1948.[36] Installed in the art building galleries and guarded by specially deputized students, the array included paintings by Fra Filippo

Lippi, Lucas Cranach, Jan Van Eyck, Pieter Brueghel, Peter Paul Rubens, Frans Hals, Rembrandt, and El Greco, as well as Rosa Bonheur's massive *Horse Fair* (1853–54). As the director of the Metropolitan, Francis Henry Taylor said, "The Metropolitan Museum of Art sends this exhibition of art to the State University of Iowa with the belief that it will stimulate an interest in the splendid work on this campus—activities which have already achieved nationwide recognition and acclaim." The exhibition was on display for three months and attracted over forty thousand visitors.[37]

This major historical show notwithstanding, most of the exhibitions at the University of Iowa in the 1940s and 1950s focused on contemporary art. Longman spent considerable time cultivating relationships in New York that would help him secure the most *au courant* work, and, recognizing that the New York art scene was relatively shuttered in the hot summer months, he and the director of the Iowa Memorial

Union, Earl Harper, inaugurated a major annual exhibition of contemporary art in 1945 as part of the university's Summer Festival of the Arts, which had begun in 1939. These special exhibitions of works from New York galleries were held every summer until at least 1963.[38] Sometimes consisting of more than 150 paintings (which included student and faculty work from the university in addition to the loans from elsewhere), and divided between galleries at the art building and the Union (fig. 17), the shows were extremely provocative by local standards.

University administrators struggled with the bewildered and often negative public reaction to the new art. Earl Harper acknowledged to a *Des Moines Register* reporter, "Not more than one or two of them [in the 1946 exhibition] are 'pretty' in the conventional sense. If they were, they would have very little significance for the modern day, for being 'pretty' simply means being conventional, something to which people are accustomed." But, he hastened to add, "The implication that these pictures are 'frightening' just cannot be taken seriously."[39] *Time* magazine reported about the same show, "Some Iowans liked what they saw; others sent letters of protest to the show's director, Lester D. Longman, who is trying to convince his fellow Iowans that there is more to art than Grant Wood ever dreamed of. Wrote Editor Don Berry of the Indianola *Record Herald and Tribune* (circ. 3,693): 'Such paintings could only come from the mentally unbalanced.'"[40] Responding to this last statement Longman retorted, "The present exhibition is *too* conservative. . . . One might reasonably conclude that the world has gone crazy. This is also the impression you get from your

newspaper. The artists themselves are barometric, not crazy."[41]

Harper was sufficiently concerned by the outcry that he called a meeting of the art department faculty, telling them that the response to the 1946 show was "99 percent adversely critical," and asking if such exhibitions were appropriate. He asked, "Is the educational objective we set up for ourselves being accomplished by this sort of show? . . . Who are we running this show for? I told Dr. Longman he is writing for the critics at the art galleries in New York. My opinion is that it [the exhibition] is for the people of Iowa."[42] James Lechay responded, echoing comments by other faculty, that he believed they should make no concessions and go forward, saying, "They condemn it because they don't understand it." President Hancher weighed in later in the summer, writing to Harper, "I must confess that the violent reaction which is created each year after the show depresses me a very great deal. From the standpoint of public relations, it seems almost the worst thing we could do." He continued, saying that he struggled to answer public complaints, and he then explained his own understanding of modern art, finishing with the suggestion, "Perhaps a partial solution might be achieved if we could have our summer shows without the reproduction of any of the paintings in *The Register* or other newspapers. However, now that such 'enjoyable' controversy is stirred up each year—enjoyable from the point of view of the newspapers—I doubt if we can hold an exhibition of art and resist their request for the reproduction of some of the more bizarre paintings in the art show."[43]

The controversies continued through the 1949 exhibition, focusing that year especially on a nude sculpture by William Zorach titled *The Embrace*. Harper suggested it should be withdrawn from the exhibition because of its explicit depiction. This caused a firestorm of protest, with Lester Longman and sculpture professor Humbert Albrizio calling Harper's suggestion censorship and likening it to "the burning of books."[44] Ultimately the show went on with Zorach's work included, but President Hancher was wary and asked for assurance that the public would find nothing objectionable about the summer show. Longman wrote him, saying, "I am unable to give such assurance," but, he added, "Now is probably the time, therefore, to let me know whether I am to be complimented for progressive leadership in art or criticized for endangering the peace and harmony of university affairs."[45] Hancher wrote back rather icily, "My opinion, which may be in error, is that the program [in the department of art] is unbalanced because most of the imponderables in the department tend to give undue importance to modern art in relation to the long history of art forms as a whole. The strength or weakness of your present position lies in how it will look twenty-five years from now. In my opinion you are in an exceedingly vulnerable position when judged by that standard."[46] The 1949 exhibition went on to receive glowing reviews in the New York press, but after Hancher's admonition the summer contemporary art exhibitions were somewhat more restrained and balanced in subsequent years.[47]

Even without a museum the University of Iowa had collected works of art since at least the late nineteenth century, but perhaps

surprisingly (or not, considering Longman's opinion of the man), the university did not acquire a painting by Grant Wood until the 1980s. Longman once said, "Certainly Wood, Benton, and Curry are no substitutes for even one good picture by Matisse or Picasso," but within weeks of his death in 1942 (and unbeknownst to Longman) the university administrators raised donations from students, alumni, and even President Hancher, accumulating two thousand dollars to purchase a work.[48] After diligent inquiries of existing owners, they were unable to find anything for sale, and the alumni director reported that "there was little enthusiasm for the purchase of other works. Indeed, one class representative suggested that their fund be added

to that of the 1942 class for the war memorial campanile if a Grant Wood picture could not be secured."[49] Two small Grant Wood drawings were donated to the university in 1947, but it would not be until 1970 that it received *A German Village* as a gift, followed in 1984 by *Plaid Sweater* (1931, fig. 18), a gift from Mel (whom the portrait depicts as a boy) and Carole Blumberg of Clinton, Iowa, supplemented with art acquisition funds.

Several other gifts of American Scene and regionalist art entered the university collections in the 1940s. In 1943, as the Fine Arts Program (FAP) of the WPA was closing, its Graphic Arts Division offered groupings of original prints to selected educational institutions.

The collection given to the University of Iowa included an array of black-and-white lithographs, color lithographs, etchings, woodcuts, and serigraphs, many by artists who had been prominent in the federal printmaking program. Typical of the FAP's emphasis, the collection is mostly American Scene imagery, but a few are more abstract, such as those by Stuart Davis and Yasuo Kuniyoshi, and although these prints have been underutilized in recent decades they represent a significant body of work representing mid-twentieth-century American art.[50]

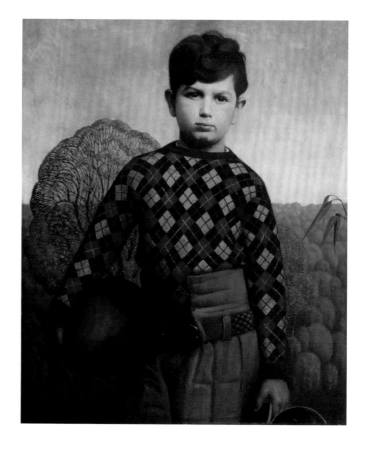

Fig. 18
Grant Wood (American, 1891–1942)
Plaid Sweater, 1931
Oil on Masonite
29 1/2 x 24 1/8 in. (74.93 x 61.28 cm)
Gift of Mel R. and Carole Blumberg and Family, and Edwin B. Green through
the University of Iowa Foundation
Art © Figge Art Museum, successors to the Estate of Nan Wood Graham/
Licensed by VAGA, New York, NY

Fig. 19
Eve Drewelowe (American, 1899–1988)
Monsieur Poinsett, 1941
Oil on canvas
39 1/2 x 32 5/8 in. (100.33 x 82.87 cm)
Gift of Eve Drewelowe
© Eve Drewelowe Collection,
School of Art and Art History,
University of Iowa

In another instance, Eve Drewelowe (1899–1989) gave three of her paintings to the university in 1944, including *Monsieur Poinsett* (fig. 19), and at the end of her life bequeathed hundreds of works to the school. Drewelowe had received the first MA in studio art at the University of Iowa in 1924 and had gone on to become a prolific painter in Colorado, varying her style and subject matter with the times. Her three paintings that arrived in 1944 were, not surprisingly, stylistically consistent with American Scene imagery, but as with all of Drewelowe's work they have a flair that is unique to the artist.[51] Other significant acquisitions during this period were two regionalist paintings by Lee Allen (1910–2006) (including *Corn Country*, fig. 36), an artist who had been one of the PWAP artists who worked with Grant Wood in 1934 and did several significant murals for post offices during the Great Depression. All of these works representing the American Scene and regionalism are significant objects in the UIMA collection today, but were not particularly well regarded by the modernists in the university's art department when they arrived on campus.

From the outset of the special summer shows of modern art in the 1940s, Lester Longman and Earl Harper envisioned buying contemporary abstract works from the exhibitions for the university's collection.[52] Longman wrote to artists, many of whom are now canonical modernists, such as Herbert Ferber, Seymour Lipton, Jose de Creeft, David Hare, George L. K. Morris, Max Beckmann, and others, inviting them to serve on the selection committees, sometimes asking for statements about their work and artistic process to help

university administrators appreciate their involvement in the process.[53]

The earliest acquisitions, from the First Summer Contemporary Art Exhibition in 1945, were four paintings by Stuart Edie, James Lechay, Bradley Walker Tomlin (fig. 48), and Karl Zerbe.[54] University administrators were careful to use privately donated funds (amounting to approximately five thousand dollars annually) rather than tax dollars. As Emily Genauer of the *New York World Telegraph* wrote,

Out in the Corn Belt, it seems they're buying caviar—or its counterpart in living American Art. The State University of Iowa has just purchased from its first summer exhibition five of the handsomest, most sophisticated pictures you could find in a season of gallery going. Among them are a Bradley Walker Tomlin abstraction; an aquatint by the surrealist Andrew Racz; James Lechay's subtle still-life, Room No. 5, and a brilliantly textured, opulently colored Karl Zerbe street scene. This in territory hitherto counted sacred to the memory of the professional "provincial," Grant Wood!

The best part of all is that these pictures are to be the nucleus of a university collection which will serve the art department and the whole college in much the same fashion that a school library does. Perhaps this is the first step in a movement which, if it spreads throughout the country, will one day see university students coming out with an awareness of fine art comparable to their knowledge of literature. Today it is shocking to realize how many well-educated,

otherwise cultivated young people know nothing about art, and appreciate it even less than that.55 Genauer was a lifelong champion of contemporary art and was obviously impressed with what was going on in Iowa.[56]

In 1946 the university bought a single picture, Max Beckmann's *Carnival* (fig. 20) from Curt Valentin of the Buchholz Gallery in New York.[57] Earl Harper wrote privately to President Hancher about the painting, saying, "The faculty in our department of art are aroused, excited and enthused . . . but I believe our average person is going to be pretty thoroughly puzzled by much of what he beholds."[58] Nevertheless, in the press release he issued, Harper said of the painting, "A museum picture in scale and educational value, it would be a notable addition to any public collection of contemporary art." In retrospect, of course, this was indeed one of the most significant purchases the university ever made; the painting is today considered one of Beckmann's masterpieces. By 1947, having suffered through the previous year's public relations fiasco in which the response to the summer exhibition had been "99 percent adversely critical," Harper's assistant cautioned Longman that the finance committee that approved the acquisition funds had nearly denied the new request based on concerns over previous purchases, but they had acquiesced with the caveat that "whatever is selected should be something which could be appreciated by Midwestern people."[59]

Fig. 20
Max Beckmann (German, 1884–1950)
Karneval (Carnival), 1943
Oil on canvas
74 7/8 x 41 3/8 in. (190.18 x 105.09 cm)
Purchase, Mark Ranney Memorial Fund
© 2013 Artists Rights Society (ARS), New York /
VG Bild-Kunst, Bonn

Fig. 21
Joan Miró (Spanish, 1893–1983)
Une Goutte de rosée tombant de l'aile d'un oiseau reveille Rosalie endormie à l'ombre d'une toile d'araignée (A Drop of Dew Falling from the Wing of a Bird Awakens Rosalie Asleep in the Shade of a Cobweb), 1939
Oil on basketweave fabric
25 3/4 x 36 9/64 in. (65.4 x 91.8 cm)
Purchase, Mark Ranney Memorial Fund
© Successió Miró / Artists Rights Society (ARS), New York / ADAGP, Paris 2013

In 1947, however, the acquisitions included works by Mitchell Siporin and Robert Gwathmey, neither of which were likely met with approval by most "Midwestern people," and in 1948 the purchase of Joan Miró's *A Drop of Dew Falling from the Wing of a Bird Awakens Rosalie Asleep in the Shade of a Cobweb*, 1939 (fig. 21) met with "statewide criticism."[60] Like the Beckmann, this painting is now among the most significant in the UIMA collection.

The University of Iowa also acquired contemporary art through gifts during this period. Impressed by the burgeoning modern art program in the "Athens of America," Peggy Guggenheim, who was closing her innovative Art of This Century Gallery in New York in 1947, gave the first of several major gifts to the university, a group of four paintings that included Jackson Pollock's *Portrait of H.M.* (fig. 40).[61] In 1951, she sent to campus C.O.D. (cash on delivery) Pollock's massive *Mural*

(fig. 22). *Mural* hung on campus in various locations and is now regarded as not only the most valuable work in the university's museum collection, but as a pivotal masterpiece in the artist's *oeuvre*.[62] Although relatively little substantive discussion about the painting's importance seems to have survived in the university archives, Pollock had already been featured in a major article in *Life* magazine under the headline "Is Jackson Pollock the Greatest Living Painter?" and Longman could have discussed the matter with James Lechay, who served on an art jury with Pollock at about the time the picture was acquired (fig. 23).[63]

Then in 1953 Guggenheim sent four more pictures, including Matta's *Like Me Like X* and Max Ernst's *The Lover* (fig. 4). Interestingly, Longman described this last grouping as "more useful as a study collection than for purposes of general exhibition," accepting them into the art department's collection rather than

sending them to Harper at the Union where the better-regarded objects in the university's collection resided.

Even more astonishing was Longman's letter to the IMU director a year later, in 1954, saying, "Enclosed is the list of paintings which it is proposed to transfer to your collection, or, in the event that you don't want them, to be disposed of."[64] Included on the attached list were *all* of the Guggenheim gifts, including Pollock's *Mural,* and even the Beckmann painting that had been purchased with such fanfare just eight years earlier. Why Longman would have decided that those objects could simply be "disposed of" is incomprehensible. In the end, most of the objects on the list were retained, including all that had been acquired through the summer shows and from Guggenheim, and those works remain some of the most significant objects in the university's art collection.[65]

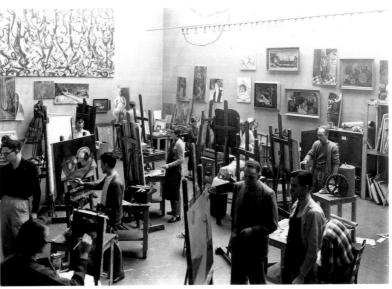

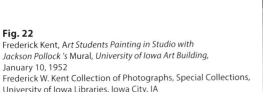

Fig. 22
Frederick Kent, *Art Students Painting in Studio with Jackson Pollock's* Mural, *University of Iowa Art Building,* January 10, 1952
Frederick W. Kent Collection of Photographs, Special Collections, University of Iowa Libraries, Iowa City, IA

Fig. 23
Photographer unknown, Jackson Pollock, Max Weber, and James Lechay
Jurors for Exhibition Momentum, Art Institute of Chicago, c. 1951

By 1963, at the twenty-fifth summer exhibition, the university could point to eighteen purchases from the summer contemporary art shows. In his history of the University of Iowa summer festival, published in the event's catalogue of that year, Earl Harper reviewed the array of achievements that had marked the program. He pointed with pride to the art acquisitions, noting that with these the university's collection now numbered "approximately three hundred today, of which approximately sixty are of major significance."[66]

Today, of course, the University of Iowa Museum of Art collection approaches fourteen thousand objects and stands with other major collegiate museums as a significant scholarly and public resource, in part due to the strength of the modern art acquired in the 1940s and 1950s. The controversies over modern art at the university have largely subsided, but still occasionally assert themselves, as when state legislators proposed selling Jackson Pollock's *Mural* to help address the economic challenges brought on by the disastrous 2008 flood in Iowa City.[67] Even as the university's School of Art and Art History has begun to acknowledge its regionalist past with the establishment of a "Grant Wood Art Colony," tensions persist between elite tastes and the public support upon which universities depend. As the University of Iowa continues to strive for a balance between these competing constituencies, the contested period when modernism was on the ascendant seems more relevant and important than ever.

Notes

1. For more on this see Evan R. Firestone, "Incursions of Modern Art in the Regionalist Heartland," *Palimpsest* 72 (Fall 1991): 148–160.

2. Grant Wood was appointed as head of the Midwest division of the PWAP in 1933 and the University of Iowa arranged to have his program, which was dedicated to painting murals for public buildings, transferred to campus early in 1934. Wood was given a faculty position at first on a short-term appointment, but it was soon converted to a conventional professorship. The tensions between his approach and that of his faculty colleagues is described as a "conflict" in a document in the University of Iowa Special Collections (Edwin Green Papers/Grant Wood folder 1934), dated June 2, 1934, which explains that "the leader of the conservatives is Professor Catherine Macartney, acting head of the department and an influential member of the Iowa Art Guild established by Professor C. A. Cumming; while the leader of the liberals is Professor Grant Wood, who has played an important part in the Iowa Artists Club." The statement explains that the document is being placed in the cornerstone of the new art building (the Special Collections version is a copy) so that "the outcome of the conflict between the conservatives and the liberals of the faculty will be known when this comes to light and can be interpreted with perspective." Unfortunately the library copy is incomplete, ending just when the "clash between the Macartney group and the Wood group" is about to be explained. The nature of the conflict may be fully understood only at some future point when the cornerstone of what is now the "old" art building on Riverside Drive is opened.

3. Doss has written extensively about Benton and modernism in her book *Benton, Pollock, and the Politics of Modernism: From Regionalism to Abstract Expressionism* (Chicago: University of Chicago Press, 1991).

4. Longman articulated his ideas and ambitions for his department soon after his arrival at the University of Iowa in a lengthy address to the College Art Association. The text was published: Lester D. Longman, "Art Education in the University, Reprinted in Full from the Session on Education at the Twenty-Fifth Anniversary Meeting of the College Art Association," *Parnassus* 8 (October 1936): 21–25.

5. In his CAA presentation in October 1936 (n. 4), Longman mentioned Wood in a relatively complimentary fashion, saying, "Original self-expression and an instructed technique may be encouraged by having on the faculty a well-known creative artist, who also knows the history of art, such as Grant Wood, Associate Professor at the University of Iowa," but this was written as Longman had just arrived on campus. His opinion of his famous colleague would change relatively quickly. Even as Longman regarded him as regressive, Grant Wood was not uninterested in modernism (although he scorned elitists—what he called "bohemians"). As a letter from Lester Longman to Dean of the College of Liberal Arts Rufus Fitzgerald, January 19, 1937, verifies, "Mrs. Wood has recently received word from the capable contemporary artist George Grosz to the effect that he would be in Chicago the latter part of February and would be glad to stop out here to see Grant Wood who wishes to meet him, and that he would send some of his pictures which we could exhibit. . . . Mr. Wood is a particular admirer of George Grosz." Longman to Fitzgerald, January 19, 1937, School of Art and Art History files/Exhibits, box 1, Special Collections, University of Iowa Libraries.

6. The scholarly literature on Grant Wood is becoming voluminous, but among the most direct discussions of Grant Wood's many activities are Wanda Corn, *Grant Wood: The Regionalist Vision* (New Haven: Yale University Press in association with the Minneapolis Institute of Arts, 1983), 43–61; and my "Cultivating Iowa: An Introduction to Grant Wood," in *Grant Wood's Studio: The Birthplace of American Gothic*, ed. Jane C. Milosch (Munich and Cedar Rapids: Prestel in association with the Cedar Rapids Art Museum, 2005), 24–27. The Grant Wood scrapbooks at the Figge Museum in Davenport, Iowa, are the best primary source for his activities, with numerous newspaper and magazine clippings that track his movements and efforts during this period. These are available online through the Iowa Digital Library, http://digital.lib.uiowa.edu/grantwood/. Wood's fame is evidenced in many ways, but Longman must have been especially irritated that, when *Life* magazine did a two-page spread on the University of Iowa's art program in 1939, Grant Wood received two photographs, one of which was over half a page in the large magazine, and Longman was not mentioned at all. "The Flowering of the Valley, Iowa Trains Creative Artists," *Life* 6 (June 5, 1939): 54–58.

7. No single survey of the regionalist movement in its larger manifestation (which would include literature, politics, economics, and other cultural history) exists, but see James M. Dennis, *Renegade Regionalists: The Modern Independence of Grant Wood, Thomas Hart Benton, and John Steuart Curry* (Madison: University of Wisconsin Press, 1998), 69–89, as well as focused studies on the individual artists, such as

Henry Adams, *Thomas Hart Benton: An American Original* (New York: Alfred A. Knopf, 1989); Patricia Junker et al., *John Steuart Curry: Inventing the Middle West* (New York: Hudson Hills Press in association with the Elvehjem Museum of Art, 1998); and M. Sue Kendall, *Rethinking Regionalism: John Steuart Curry and the Kansas Mural Controversy* (Washington: Smithsonian Institution Press, 1986).

8. I discuss Longman's efforts at the university in detail in my essay, "Cultivating Iowa," 27–32. Primary documents relating to the ongoing controversy between the two men are found in the Edwin Green Papers, Grant Wood file, Special Collections, University of Iowa Libraries.

9. For a thorough discussion of art and politics during this period, see Cécile Whiting, *Antifascism in American Art* (New Haven: Yale University Press, 1989), especially chap. 4, "American Heroes and Invading Barbarians," which specifically discusses regionalism in this context.

10. For a wide-ranging discussion of this see Wanda Corn, *The Great American Thing: Modern Art and National Identity, 1915–1935* (Berkeley: University of California Press, 1999).

11. Samuel Koontz, *Modern American Painters* (Norwood, MA: Brewer and Warren, 1930), 1; Samuel Koontz, *New Frontiers in American Painting* (New York: Hastings House, 1943), 12.

12. These are just a few of the ways in which Longman undermined Wood's standing at the university. Perhaps the most inflammatory was an investigation in the fall of 1940 by *Time* magazine into what were called "charges" against Wood—that he had been fired from the university, that he relied on photographs because he could not draw, that students painted much of his work, that they resented using his methods in their art, etc. The source of the story was never determined. Wood believed, at least at first, that it was Fletcher Martin. Martin denied it, but he had been in New York just the week before and could have approached *Time*. Even so, however, he had been in Iowa for only a little over a month and Wood was on leave; most of what he knew of Wood would likely have come from Longman. Longman facilitated the *Time* reporter's visit and the subsequent university investigation into the issue in ways that were damaging to Wood's reputation. Ultimately the *Time* article was never published. I discuss this episode in some detail in my "Cultivating Iowa," 29–31. See also, Wood to Fletcher Martin, November 26, 1940; Martin to Wood, November 21, 1940, Edwin Green Papers, Grant Wood file, Special Collections, University of Iowa Libraries.

13. Lester D. Longman, "Better American Art," *Parnassus* 12 (October 1940): 4–5. A "fifth column" is a subversive effort to undermine something from within, a term first used by in 1936 by Emile Mola, a Nationalist general in the Spanish Civil War. The term quickly acquired widespread use, including as the title of both a play and an anthology by Ernest Hemingway (1938). http://www.oed.com.proxy.lib.uiowa.edu/view/Entry/70006?redirectedFrom=fifth+column#eid. Longman disparaged American Scene painting, regionalism, and those who admired them in many different contexts, often in acerbic asides in articles about other things. He did write a review of a book about John Steuart Curry in which he criticized the author for a text "too detailed for such a subject," dismissing the artist as "minor" and "negligible." Lester D. Longman, "*John Steuart Curry's Pageant of America* by Laurence E. Schmeckebier," *College Art Journal* 5 (January 1946): 141–142.

14. Longman to Phillip Clapp, April 9, 1942. Edwin Green Papers, Grant Wood file, Special Collections, University of Iowa Libraries.

15. *Return from Bohemia* was the title of one of his self-portraits (1935) and also his unpublished biography, written with Park Rinard. Wood was regularly quoted as saying that he had gotten his best ideas while milking a cow and he often wore overalls when working, including in his studio and the classroom. See, for example, "Town Made It Fashionable," *New York Herald Tribune*, April 23, 1939, 10, from the Grant Wood scrapbooks at the Figge Art Museum, Davenport, Iowa: http://digital.lib.uiowa.edu/cdm/compoundobject/collection/grantwood/id/130/show/118/rec/10. For a discussion of his wearing of overalls, see my "Cultivating Iowa," 11, 130, n. 2.

16. Earl Harper to Lester Longman, April 4, 1942. Lester Longman Papers, Writings folder, Special Collections, University of Iowa Libraries. Longman's writings, in addition to those cited above, include "The Carnegie Survey," *Parnassus* 12 (November 1940): 4, 34; "On the Uses of Art History," *Parnassus* 12 (December 1940): 4–5; "The Responsibility to Educate," *Parnassus* 13 (January 1941): 4–5; "The Art Critic," *Parnassus* 13 (February 1941): 4–5; "Contemporary Painting," *Journal of Aesthetics and Art Criticism* 3, no. 9 (1944): 8–18; "Why Not Educate Artists in Colleges?" *College Art Journal* 4 (March 1945): 132–134; and "Contemporary Art in Historical Perspective," *College Art Journal* 8 (Autumn 1948): 3–8.

17. Wood's fellow regionalist Thomas Hart Benton later summarized, "As soon as World War II began, substituting in the public mind a world concern for the specifically American concerns which had

prevailed during our rise, Wood, Curry, and I found the bottom knocked out from under us. . . . The coteries of high-brows, of critics, college art professors, and museum boys, the tastes of which had been thoroughly conditioned by the new esthetics of twentieth-century Paris, had sustained themselves in various subsidized ivory towers and kept their grip on the journals of esthetic opinion all during the American period. These coteries, highly verbal but not notably intelligent or able to see through momentarily fashionable thought patterns, could never accommodate our populist leanings." Thomas Hart Benton, "What's Holding Back American Art?" *Saturday Review of Literature*, December 15, 1951, 10. For the larger context of fascism and the art of the 1930s see Dennis, *Renegade Regionalists*, 69–89, and Whiting, *Antifascism and American Art.*

18. The fact that Barr was Janson's immigration sponsor is found in several sources. See, for example, http://www.dictionaryofarthistorians.org/barra.htm. Janson was born in Russia, and his family subsequently moved to Finland and then Germany. Janson was a gentile, but left Germany voluntarily because of the rise of Nazism. For more on Janson's biography, see Sabine Eckmann, *H. W. Janson and the Legacy of Modern Art at Washington University* (St. Louis and New York: Washington University Gallery of Art and Salander-O'Reilly Galleries, 2002). Longman himself studied at Princeton University but by his own description did "some work with Professor Sachs at Harvard." School of Art and Art History Papers, box 3/Conferences: Dedication, attachment to letter of October 8, 1936, Special Collections, University of Iowa Libraries.

19. Janson did take issue publicly with some of Longman's ideas about training artists in colleges. See his "Letters on the Education of Artists in Colleges," *College Art Journal* 4 (May 1945): 214–216.

20. Interview with H. W. Janson by Wanda Corn, August 11, 1974. I am grateful to Professor Corn for sharing her notes of this meeting with me. Janson himself recounted the episode in a lecture at the College Art Association conference in 1974. The lecture was subsequently published; see H. W. Janson, "Artists and Art Historians," *Art Journal* 33 (Summer 1974): 334–336. Why an art history professor could or would be fired for such a field trip is unclear, and I have been unable to find any records of this incident in the University of Iowa archives. Janson was reinstated in his position with Longman's help, but according to him it was only after he told Longman that he would never have control over his department if he did not intervene.

21. See for example, H. W. Janson, "Karl Zerbe,"

Parnassus 13 (1941): 65–69; "Philip Guston," *Magazine of Art* 40 (1947): 54–58; "Max Beckmann in America," *Magazine of Art* 44 (1951): 89–92. It may not be a coincidence that the University of Iowa bought works by Zerbe, Guston, and Beckmann in the mid-1940s. Janson's articles about regionalism include "The International Aspects of Regionalism," *College Art Journal* 2 (May 1943): 110–115; "The Case of the Naked Chicken," *College Art Journal* 15 (Winter 1955): 124–127; and "Benton and Wood, Champions of Regionalism," *Magazine of Art* 39 (May 1956): 184–186, 198.

22. Janson's *History of Art* gave regionalism only one scant and rather negative paragraph that did not mention Grant Wood. This paragraph remained unchanged through six editions and was only slightly altered in the seventh (2006) and subsequent editions, in which the book was rewritten by a team of art historians.

23. Longman wrote copiously about the importance of artists having a liberal arts education, and he carefully structured the curriculum and degree requirements for art and art history majors to ensure a balance of studio art, art history, and other liberal arts subjects. This has become known since as the "Iowa Idea." See especially Longman's "Why Not Educate Artists in Colleges?" and "Art Education in the University." For the current version of the "Iowa Idea," see http://www.art.uiowa.edu/about.html. Fletcher Martin has received relatively little attention in the scholarly literature, but Longman included a feature article on him in his first issue as editor of *Parnassus*. See Peyton Boswell Jr., "Fletcher Martin: Painter of Memories," *Parnassus* 12 (October 1940): 6–13; and also H. Lester Cooke Jr., *Fletcher Martin* (New York: Harry N. Abrams, 1977).

24. One of the covert issues during this period was Grant Wood's presumed homosexuality, which underlay some of the "Grant Wood problem," as the university administrators described it. The issue was mentioned in only one extant university document, a memo of a meeting in President Virgil Hancher's office, but it seems to have been among the so-called "charges" brought against Wood in an investigation, which Longman seems to have initiated, by *Time* magazine in the fall of 1940 while Wood was on leave. For more on the issue see my "Cultivating Iowa," 29–31. The document that mentions the issue is "Notes of meeting with Virgil Hancher, Park Rinard, and Dan Dutcher, held May 7, 1941" (dated May 8, 1941), Edwin Green Papers, Grant Wood file, Special Collections, University of Iowa Libraries. Emil Ganso arrived in the fall of 1940, perhaps recommended to Longman by Ganso's dealer, Carl Zigrosser of the Weyhe Gallery in New York. The Weyhe Gallery was a frequent source for print exhibitions

at the University of Iowa during Longman's tenure. Ganso's influence on the department was cut short by his unexpected death in the spring of 1941.

25. Guston and Grant Wood were both at Iowa in 1941–42, but their contact was probably limited since Wood's illness manifested itself relatively quickly that fall and he died in early February 1942. For more on Guston's time in Iowa and his friendship with Fletcher Martin, see Michael Edward Shapiro, "Philip Guston: The War Years," *Print Collector's Newsletter* (September–October 1994): 127–132. Shapiro reports that Janson also supported Guston's hiring, and that Janson and Paul Engle, the poet who became the director of the Iowa Writers' Workshop in 1942, were among the earliest owners of Guston's works of the 1940s.

26. The painting was given to the University of Iowa in 1947 by Dr. Clarence van Epps, a physician at the University of Iowa Hospital. His gift included nineteen other works, including two small Grant Wood drawings, the first of his works to enter the university's collection.

27. Lea Rosson DeLong and I discovered the untitled figure study in a flat file in a storage room of the old art building in 2005. The Guston drawings done in Longman's home have recently been given to the University of Iowa Museum of Art by the Longman family. The document file at UIMA says, "Stanley Longman related the following to Chief Curator Kathleen A. Edwards: One Saturday afternoon Stanley was lying on the floor coloring when Guston came to his home. Upon seeing the boy coloring Guston lay on the floor next to him and made the four sketches. Later Stanley's mother wrote the artist's name and date on the back of each."

28. Shapiro reports without naming his sources that Guston was reclassified as fit to serve in the military sometime around 1943, but that Longman and others successfully argued with the War Department that Guston would contribute more to the war effort by remaining in Iowa. Shapiro, "Philip Guston: The War Years," 129.

29. "First Project of War Art Workshop Displayed," *Daily Iowan,* November 22, 1942, 3; "War Art Workshop Preparing 8 Murals for Iowa Army Post," *Daily Iowan,* November 26, 1942, 6. Shapiro discusses these murals in "Philip Guston: The War Years," 129.

30. "Brave New World, F.O.B.," August 1943, 124–127, 146, 148; "Troop Carrier Command," October 1943, 130–135, 238–240, 243, 246; and "The Air Training Program," February 1944, 146–152, 174, 176, 178, 180, 183–184, 186, 189–191, 193–194, all in *Fortune.*

31. The typewritten manuscript of Lester Longman's gallery talk, "The Art of Philip Guston," delivered at the opening of the Guston exhibition in the IMU, March 5, 1944, is in the Lester Longman Papers, Writings folder, Special Collections, University of Iowa Libraries.

32. http://www.spaniermanmodern.com/inventory/L/James-Lechay/James-Lechay_BIO.htm

33. Lists of many if not all of these exhibitions are included in the School of Art and Art History and Iowa Memorial Union Papers (in boxes under the category Exhibits), Special Collections, University of Iowa Libraries. Exhibitions at the university had preceded Longman's arrival. There was, for example, an exhibition from the NAD in 1932. School of Art and Art History files/Exhibits, box 1, Special Collections, University of Iowa Libraries.

34. Longman to Alfred Barr, Museum of Modern Art, in Art and Art History/box 3/Conferences: Dedication, attachment to letter, October 8, 1936, Special Collections, University of Iowa Libraries. Longman sent the same letter to Walter Heil of the de Young Memorial Museum, San Francisco.

35. See listings of the exhibitions in the School of Art and Art History files/Exhibits, box. 1, Special Collections, University of Iowa Libraries.

36. There is a large scrapbook of newspaper clippings about this event in the School of Art and Art History Papers, Special Collections, University of Iowa Libraries.

37. Earl Enyeart Harper, "A Short History of the Annual Fine Arts Festival of the State University of Iowa," *Twenty-Fifth Annual Fine Arts Festival: Program, History, Exhibition* (Iowa City: State University of Iowa, 1963), n.p.

38. Budgets are not included in the exhibit files for every year, but Longman wrote to Harper on February 16, 1948, that "including the summer show of contemporary painting, we should have an annual budget for exhibitions of six to eight thousand, depending on the cost of an old master show obtained through dealers. I suggest that when a proper amount is ascertained, steps be taken to assign for this purpose funds from student tuitions, as in the case of music, plays, athletics, etc. A policy of admission charges to others than students might also be considered." School of Art and Art History Papers/Exhibits, Special Collections, University of Iowa Libraries.

39. Jack O'Brien, "Art Attention Centered on Iowa City," *Daily Iowan,* June 15, 1947, 1, 4. Somewhat defensively, IMU director Earl Harper wrote to Carl Gartner of the *Des Moines Register,* June 19, 1946, replying to the letter (see the Longman Papers, Correspondence file) he had received from him which sounds like they wanted publicity for the

summer art exhibition, but would not receive it. Harper wrote, "Just now we have on our campus one of the greatest exhibitions of contemporary art which has been shown in the United States during the past year. We have pictures having a total value of $135,690 on display. These pictures are as important in the field of art as news of atomic science in the field of physics. We are anxious to share what we have here with the people of the state. And we regard this exhibition as having prime news value. . . . Of the 160 items shown in the exhibition, I have 40 hanging in the main lounge of the Iowa Union. Many of these literally blaze with color. Not more than one or two of them are 'pretty' in the conventional sense. If they were, they would have very little significance for the modern day, for being 'pretty' simply means being conventional, something to which people are accustomed. The implication that these pictures are 'frightening' just can not be taken seriously. Many of them are lovely beyond description, and if many of us could afford them we would have them hanging in our homes." Typescript copy from "School of Art Files," 06/07; File: Art Exhibits, Correspondence, etc., 1929–1957, Special Collections, University of Iowa Libraries.

40. "Moderns in the Maize," *Time*, July 29, 1946, 64.

41. Ibid.

42. 1946 Art Department Meeting Minutes (otherwise undated), School of Art and Art History Papers/Exhibits, Special Collections, University of Iowa Libraries.

43. Virgil Hancher to Earl Harper, August 5, 1946, School of Art and Art History Papers/Exhibits, Special Collections, University of Iowa Libraries.

44. Earl Harper's notes of a meeting with Lester Longman and Humbert Albrizio, May 13, 1949, School of Art and Art History Papers/Exhibits, Special Collections, University of Iowa Libraries.

45. Lester Longman to Virgil Hancher, May 13, 1949, School of Art and Art History Papers/Exhibits, Special Collections, University of Iowa Libraries.

46. Virgil Hancher to Lester Longman, May 14, 1949, Lester Longman Papers, Special Collections, University of Iowa Libraries.

47. Carlyle Burrows, "Art in Review: Iowa University Again Takes Lead in Modern Art Promotion in the West," *New York Herald Tribune*, July 17, 1949. For the 1953 show, for example, Earl Harper proposed assembling the ten paintings illustrated in a 1948 *Look* magazine article that discussed the "ten best artists painting in the United States today," based on the publication's survey of museum directors, curators, and art critics. Curt Valentin Papers, III.E.[69], Museum of Modern Art Archives, New York.

48. Lester Longman, "Letters on the Education of Artists in Colleges," *College Art Journal* 4 (May 1945): 217. For more on the campaign to purchase a Grant Wood painting, see the Edwin Green Papers, Grant Wood file, Special Collections, University of Iowa Libraries.

49. Bruce E. Mahan, alumni director, to President Hancher, August 24, 1942. Edwin Green Papers, Grant Wood file, Special Collections, University of Iowa Libraries.

50. "Department Receives 100 Art Prints," *Daily Iowan*, February 11, 1943, 3.

51. With Drewelowe's gift of over six hundred paintings, prints, sculptures, and other objects to the School of Art and Art History in 1989, the University of Iowa is the most significant repository of her work. When she gave the three paintings in 1944 she was still using her husband's name, Van Ek, but later dropped this to assert her own identity, even as she and Jacob Van Ek remained married until his death. For more on Drewelowe see *Eve Drewelowe: A Catalogue Raisonné* (Iowa City: University of Iowa School of Art and Art History, 1988); and Lindsay Shannon, "Eve Drewelowe: Feminist Identity in American Art," *Women's History Review* (2013), at http://dx.doi.org/10.1080/09612025.2012.726117.

52. As Emily Genauer noted in the *New York Herald* (and reprinted on campus), "An Iowa Fine Art Association has been founded to raise funds so the University may buy out of the exhibition paintings especially nominated by a jury of critics and artists. Under this program the University gradually will acquire a collection of contemporary art not only comparable with the best in America, but providing for its students' use and pleasure the art equivalent of a library. . . . This year the jury recommended for purchase paintings by Stuart Davis, Ferdinand Leger, Matta, Rufino Tamayo, Yves Tanguy, Max Weber, Davis Aronson, Max Beckmann, Joseph De Martini, Yasuo Kuniyoshi, Mauricio Lasansky, James Lechay. With only a few exceptions that list is entirely abstract or surrealist. Most of the other pictures in the show are of similar character." Emily Genauer, "S.U.I. Summer Art Show Hailed in New York," *University of Iowa News Bulletin*, September 1946, 2.

53. Although brief, these statements are important historically, potentially adding considerably to our understanding of these artists' ideas about their work. School of Art and Art History Papers/Exhibits, Special Collections, University of Iowa Libraries.

54. "University of Iowa to Purchase Four Pictures from Art Exhibit," *Daily Iowan*, July 7, 1945.

55. Genauer, "S.U.I. Summer Art Show Hailed in New York," 2.

56. http://www.nytimes.com/2002/08/25/

nyregion/emily-genauer-critic-and-champion-of-20th-century-art-is-dead-at-91.html.

57. The documentation about the price paid for the Beckmann painting is somewhat contradictory. A Western Union telegram from Harper to Buchholz Gallery, July 2, 1946, in the Curt Valentin Papers (III.E.[69], Museum of Modern Art Archives, says $4,000, but *Time* magazine reported it as $5,000. "Moderns in the Maize," 64. In 1945–46, while in St. Louis as professor of art history and curator of Washington University's art collection, H. W. Janson spearheaded the deaccession of more than 120 paintings and some 500 other objects, raising $40,000 with which he established a major collection of modern art. Most of these new works, like Iowa's Beckmann painting, were purchased from Valentin at Buchholz Gallery. Valentin was a German Jewish émigré, but the owner of the gallery was Karl Buchholz, a member of the Nazi party in Germany who confiscated art for the German government. Much of what he sold in his New York gallery was what the Nazis described as "degenerate art." Considering the politicized nature of both Janson's and Longman's writings, which pointedly used Nazism as a critique of American regionalists, this connection is ironic and intriguing. The information on Janson's curatorial activities, and Valentin and Buchholz, is from Eckmann, *H. W. Janson and the Legacy of Modern Art,* 15–17, 21–22. For Janson's own summary of the new collection see H. W. Janson, "The New Art Collection at Washington University," *College Art Journal* 6 (1947): 199–206.

58. Earl Harper to Virgil Hancher, School of Art and Art History Papers, box 6, Collections/General Correspondence folder, Special Collections, University of Iowa Libraries.

59. Allin Dakin, administrative dean to Earl Harper, to Lester Longman, June 20, 1947. Lester Longman Papers, Correspondence folder, Special Collections, University of Iowa Libraries.

60. May 13, 1949, minutes of meeting by Lester Longman, Humbert Albrizio, and Earl Harper, University of Iowa School of Art and Art History Papers/Exhibits, Special Collections, University of Iowa Libraries.

61. I am citing H. W. Janson here who said that the term was "bandied about a great deal in the late 1930s" in Iowa City. See Janson, "The Case of the Naked Chicken," 125. The term has, of course, been applied to and claimed by a number of towns and cities over the years.

62. Guggenheim first offered the painting to the university in 1948, but the transaction languished (on Guggenheim's side) for three years. The historical correspondence relating to this gift, as well as a thorough discussion of the painting and its history is found at http://uima.uiowa.edu/mural/.

63. "Jackson Pollock: Is He the Greatest Living Painter in the United States?" *Life*, August 8, 1949.

64. Letter from Longman to Harper, October 19, 1954, School of Art and Art History Papers, box 6, Collections/General Correspondence folder, 1953–, Special Collections, University of Iowa Libraries.

65. Lester Longman left the University of Iowa in 1958, finishing his career at the University of California, Los Angeles, in 1973. His work there was also somewhat controversial. See http://www.aaa.si.edu/collections/interviews/oral-history-interview-henry-tyler-hopkins-12844.

66. Harper, "A Short History of the Annual Fine Arts Festival."

67. For a brief summation of the issue see http://uima.uiowa.edu/our-view-on-the-pending-pollock-sale/ and "Forced Sale of Pollock Dies in Legislature," *Iowa City Press-Citizen*, February 21, 2011.

Transitional Hybrids

Exploring the Influence of Surrealism in the Iowa Collection

Kathleen A. Edwards

Chief Curator
University of Iowa Museum of Art

From its founding, the University of Iowa Museum of Art has been endowed with an exceptional collection of art created from 1934 through 1949 by artists of the United States and western Europe. This period remains a major focus of our acquisitions and research. Not easily categorized, the objects in the exhibition for which this catalogue was produced present a unique commingling or collision—a kind of hybridization—of surrealist trends with representational orientations. During this period, many western European avant-garde artists who practiced surrealist techniques immigrated to New York City to survive World War II, the Spanish Civil War, or other untenable circumstances. The city soon became a hub of transformations in Western art.

The University of Iowa was instrumental in this transformation, thanks to the story which unfolds in this exhibition; the UIMA collection includes works by many of these émigrés—among them Max Beckmann, Giorgio de Chirico, Duchamp, Max Ernst, Stanley William Hayter, Frederick Kiesler, Mauricio Lasansky, Jacques Lipchitz, Boris Margo, Roberto Sebastián Antonio Matta Echaurren (Matta), Joan Miró, André Masson, Lil Picard, Gabor Peterdi, Karl Schrag, and Kurt Seligmann.

Surrealism had originated as a 1920s French-based art movement, organized by André Breton during the interwar years, coming out of Dada, symbolism, New Objectivity, and the like. Artists were invited to join the surrealist group only if their approach met specific guidelines, about which Breton was quite demanding; intense arguments regularly occurred concerning who was in and who was out. For example, the British artist Stanley William Hayter, a member of the surrealist group from 1934 to 1939, withdrew his membership because Breton had famously decreed that Paul Eluard's poetry was not surrealist enough and kicked Eluard out of the group.[1] Some invited artists declined. In a letter to the Museum of Modern Art (MoMA) director, Alfred H. Barr, dated November 13, 1936, the artist Joseph Cornell stated, "While fervently admiring much of their work I have never been a surrealist, and I believe that surrealism has healthier possibilities than have been developed. The constructions of Marcel Duchamp, who the surrealists themselves acknowledge, bear out this thought, I believe."[2]

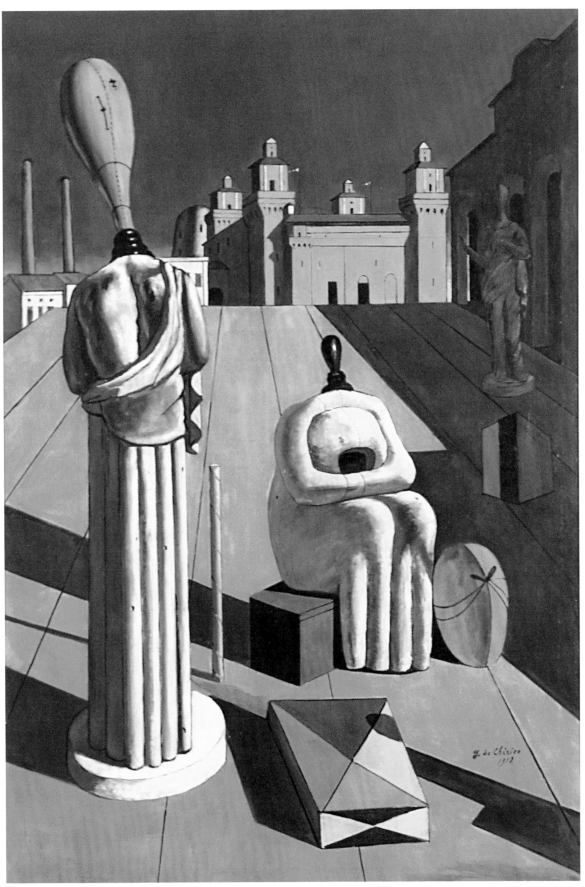

Fig. 24
Giorgio de Chirico (Italian, born in Greece, 1888–1978)
Le Muse inquietanti (The Disquieting Muses), 1947
Oil on canvas
42 1/8 x 29 15/16 in. (107 x 76.04 cm)
Gift of Owen and Leone Elliott
© 2013 Artists Rights Society (ARS), New York / SIAE, Rome

Although work by the Europeans Beckmann, de Chirico, and Miró is not included in the exhibition, these three artists are worth mentioning here in connection with the impact in the United States of western European surrealist tendencies. While Joan Miró embraced surrealist attitudes, in 1927 he severed ties to the group. Forced to flee Barcelona in late 1936, he spent the next four years in exile in France. In 1939, he left Paris for a small village: "At Varengeville-sur-Mer, in 1939, began a new stage in my work. . . . It was about the time when the war broke out. I felt a deep desire to escape. I closed myself within myself purposely. The night, music, and the stars began to play a major role in suggesting my paintings."[3] Sometime that year between August and December, Miró painted *A Drop of Dew Falling from the Wing of a Bird Awakens Rosalie Asleep in the Shade of a Cobweb* (fig. 21). Although Miró's works seem to rely on surrealist automatism, he carefully planned both his compositions and his poetic titles. He may have utilized automatic drawing, the most popular method of surrealist automatism, practiced by visual artists as a means of expressing the sub/unconscious. It was thought that this method resulted in nonrepresentational marks generated by an uninhibited state of mind, although figural forms were often suggested. In 1948, the State University of Iowa in Iowa City (now the University of Iowa) purchased *A Drop of Dew* from Pierre Matisse Gallery in New York.

Between August 1, 1942, and December 5, 1943, while exiled in Amsterdam, Max Beckmann painted *Carnival* (fig. 20), the sixth of an eventual ten triptychs (one unfinished). Each panel depicts theatrically costumed figures: Adam and Eve, a Pierrot, and Beckmann's self-portrait. Read as a narrative from left to right, Beckmann's powerful association between the biblical story of the fall of man and the realities of World War II implies a contemporary expulsion. Both surrealism and Beckmann's German expressionism were reactions against realism and naturalism. In *Carnival*, traditional narratives are conflated with scenes from different times and places. "Funny how everything grows more grotesque and more mad," Beckmann jotted in his diary on March 4, 1942, as World War II raged around him.[4] The art dealer Curt Valentin purchased the triptych directly from the artist in Amsterdam on July 16, 1946, and shortly thereafter sold it to the University of Iowa.

Considering de Chirico's painting *The Disquieting Muses* (fig. 24), viewers confront many possible interpretations of the artist's dreamlike mixture—motifs drawn from unrelated contexts with shadows of unseen objects, situated in impossible spaces with multiple vanishing points, coupled with an intense sensation of mystery and even anxiety. The compositional perspective of the painting contributes to its uneasy feeling. De Chirico's mannequins have provoked multiple identifications—mythical (Dionysus and Dante), personal (his brother Alberto Savinio), and political (Napoléon III and Count Camillo Cavour). The UIMA *Disquieting Muses* is one of eighteen versions de Chirico painted between 1924 and 1962, all based on his first, of 1917. A version of the painting was included in Alfred Barr's 1936 MoMA exhibition Fantastic Art, Dada, Surrealism. *The Disquieting Muses* was described by the artist Gordon Onslow Ford in his 1940 New York New School for Social Research lectures on surrealism as "sad, as representing degeneration and old age."[5]

The work of Beckmann and de Chirico influenced the young Philip Guston, whose painting *Mother and Child*, c. 1930, was included in the 1933 Fourteenth Annual Exhibition at the Los Angeles Municipal Museum. The painting is similar to de Chirico's work in composition and iconography. Guston followed *Mother and Child* with *The Young Mother*, 1944 (fig. 38), painted when he was an artist-in-residence at the University of Iowa (1941–45). "In the solitude of the Midwest, for the first time I was able to develop a personal imagery."[6] In *The Young Mother*, Guston presents his wife, Musa McKim, and infant daughter, Musa Jane. McKim was said to have had the quality of "dreamy inwardness" suggested in the portrait.[7] A melancholy mood and the impression of magic in the air permeates a scene that incorporates the Iowa City spire of St. Mary's Church, an otherworldly blue stuffed cat toy, and an animated string of beads. Guston's fascination with surrealism led him to portray people and settings that were at once representations of something real, and something else.

The term "American Scene" was applied to the representational art of the 1930s and included the categories of regionalism, urban scene, and social realism (via Mexico and Russia). Regionalism referred specifically to American art created in or about the Midwest and West and tended to promote cultural nationalism with largely rural themes—from bucolic farming images and ranches to quaint Main Street small towns. Most urban-scene and social-realist painters

were city-based and tended to be concerned with people's living and working conditions. During the Great Depression, American artists of all these orientations held positions in one or more of the New Deal programs, including the Federal Art Project of the Works Progress Administration (WPA). In government employ, these artists were encouraged to produce images supporting the beauty and "values" of American society, but much of their art was not reviewed for these characteristics, and artists could work in relative freedom. A spirit of innovation marked the WPA programs, especially the Graphic Arts Division, which saw the evolution of silkscreen from a commercial medium to an artist's material process, and the progression of carborundum as a grinding medium for lithography to a material used to create tone in collagraphic prints. During the transition from representation—the norm of American trompe l'oeil academic realism—subject matter for WPA printmakers often included surrealist elements, such as isolated signs and pictograms, composite figures, and imaginary landscapes, to awaken the viewer's imagination. In a selection of WPA prints on loan to the University of Iowa Museum of Art, George Constant's doll-like toddlers, Jack Markow's *Perilous Merry-Go-Round*, and Grace Rivet's *Death of an Idea* are among those that utilize surrealist strategies within a representational framework. Various artists appreciated and appropriated the revolutionary surrealist philosophies, though many principally combined surrealist techniques with semirepresentational styles. As the 1930s was largely considered the decade of regionalism and social realism in American art, and the 1940s that of the

birth of abstract expressionism, the transition from one to the next was accomplished largely via hybridized surrealist approaches.

Identified in 1930 by the term "super-realism,"[8] American modes of surrealism were also called magic realism, verist surrealism, postsurrealism, neosurrealism, and social surrealism. The Art Institute of Chicago curator Frederick Sweet saw a connection between American nineteenth-century romanticism and the new dreamlike imagery, as he noted in his catalogue for the 1947–48 exhibition Abstract and Surrealist American Art: Fifty-Eighth Annual Exhibition of American Paintings and Sculpture. In the preface Sweet stated, "Romanticism has long been such a strong element in American art that the imaginative qualities of many of our artists have easily developed into the fantastic and dreamlike imagery which may be called Surrealism."[9] Holger Cahill, head of the WPA, wrote in *American Art Today*, his 1939 introduction to the catalogue of the New York World's Fair exhibition, that "a good many of the works exhibited indicate that Surrealist ideas and techniques have been assimilated into the stream of contemporary American expression."[10]

Ordinary Americans not immersed in art world trends learned about surrealism via the mass media, especially through its appearance in advertising and fashion. The persona of Spanish surrealist Salvador Dalí (though he too was famously dismissed from the group in 1934), as well as his unexpected compositions, were popular media phenomena. Often considered bizarre, Dalí's art was nevertheless widely respected by the general public because of his attention

to detail and precision, and the smooth, finely rendered results. The conclusion was that Dalí's works were illusions, presenting recognizable imagery with playful imagination. Another populist venue providing access to surrealist practices was the American literary and art magazine *View*, published from 1940 to 1947 by Charles Henry Ford and Parker Tyler. Also exerting significant popular influence during the 1930s were the Polish artist John Graham's ideas regarding surrealism, enigma, and the occult.

The 1940 lectures on surrealism by the British artist Gordon Onslow Ford at the New School for Social Research were especially persuasive for artists with their emphasis on theory and methodology.[11] The artist Jimmy Ernst commented, "He seemed to say for the first time 'Why not?' rather than 'it has to be.' We were not getting the last word from Europe, but rather the possibility for a further horizon that implied individualism."[12] The impression Ford conveyed was that surrealism was not a style, but a challenge, and he suggested analytical strategies to assist viewers in deciphering surrealist compositions. When presenting the work of Matta, Ford bade the audience, "Check the suitcase of knowledge that you usually carry with you. Lock yourself to your chair of imagination with your shadow. Cast off the spell of impotence. Summon all your nocturnal courage. And see yourself for a few moments in the mirror of Matta." And when introducing Stanley William Hayter's 1936 engraving *Pavanne*, Ford cajoled, "Let us see if we can experience this vision for ourselves."[13]

For many artists, genuine connections existed between surrealism and the problems of the contemporary world. During the crises of the 1930s and 1940s, American artists who found it necessary to respond to the Great Depression and war discovered in surrealism an adequate approach. A number of the artists represented in the exhibition were members of the U.S. armed forces, or served other countries. Werner Drewes, Boris Margo, and Robert Riggs had fought in World War I on the Western Front, and Federico Castellon, Gabor Peterdi, William Ashby McCloy, John Pusey, and Mitchell Siporin were among those who served overseas in World War II.

Attention was given to current research in psychology by artists who used the latest techniques to both locate and express lived and revealed narratives and experiences. If not in therapy themselves, some artists recalled fruitful exchanges with such refugee psychologists and psychiatrists as Sigmund Freud, Carl Jung, Max Wertheimer, and Ernst Kris. Artists embraced dream symbolism, which, they believed, could be deciphered and understood by viewers. Jung's concept that a "collective unconscious," accessible to all humanity, dwelled in visual art was a much-discussed idea in Rothko's circle at the end of the 1930s. Academic investigations were widely pursued, as evidenced

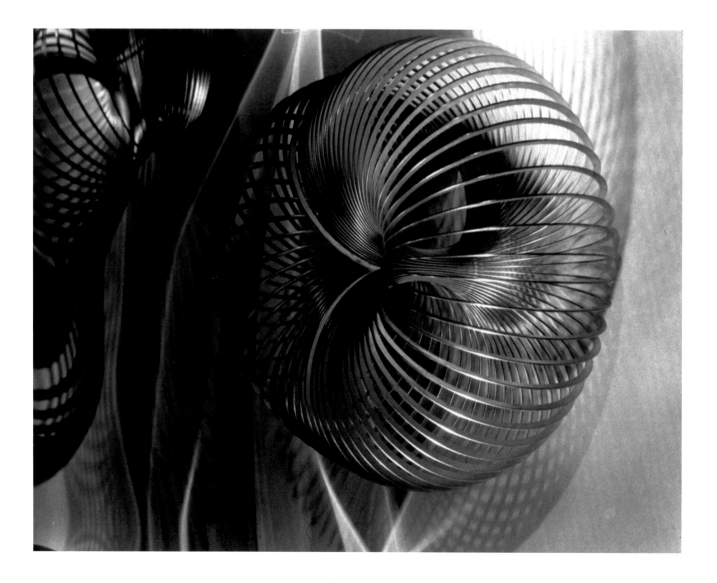

by such popular courses as Boris Margo's American University class Art and Imagination, A Psychological Approach. Other artists found in surrealism tools of expressive distortion that could merge with social realism to reveal content related to the struggle of the working classes.[14]

Although American Scene artists generally conformed to representational expectations, many had experimented with and pursued European modernist approaches to cubism and abstraction after the New York City 1913 International Exhibition of Modern Art (the "Armory Show"). By the 1930s nonobjective abstraction was a regular practice. With the addition of surrealist methods, nonobjective art acquired subjective qualities. The work of members of various groups and schools that supported nonobjectivity, like Werner Drewes and Louis Schanker of the American Abstract Artists group, and Carlotta Corpron (fig. 25) and Nathan Lerner of the New Bauhaus in Chicago, took on more extraordinary imagery. (The New Bauhaus was the successor to the German Bauhaus, which was dissolved in 1933 under pressure from the Nazi regime.) The New Bauhaus celebrated constructivist concepts, and faculty and students focused on joining form and function without ornamentation across the arts, architecture, and crafts. Formal beauty was found in commonplace objects, often incongruously juxtaposed.

Much has been written about the myriad influences of non-Western and indigenous peoples' objects and narratives on Western art, and about the appropriative strategies and recontextualization efforts of artists.[15] In the visual artist–author

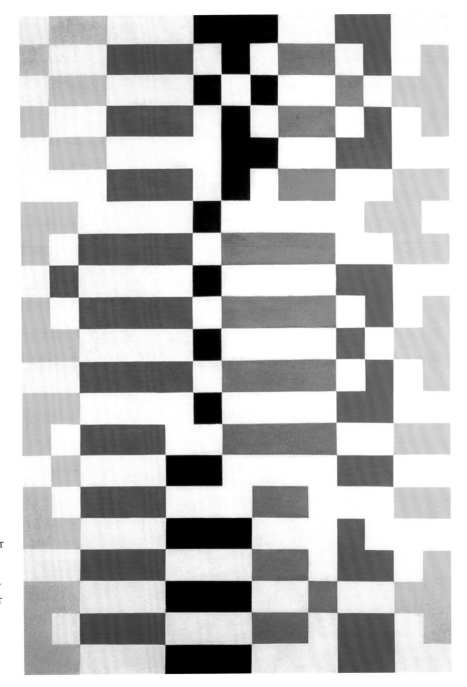

Barnett Newman's eager arguments praising non-Western objects, he related surrealist theories of the freed unconscious to his notions of the aims of indigenous American art. In his essay for the 1946 exhibition Northwest Coast Indian Painting at Betty Parsons Gallery, Newman encouraged viewers to "discard the mock heroic, the voluptuous, the superficial realism that inhibited the medium for so many European centuries.[16] In a pamphlet for a 1947

Fig. 26
Leon Polk Smith (American, 1906–1996)
Center Columns, Blue Red, 1946
Oil on panel
71 x 48 in. (180.3 x 121.9 cm)
Purchased with assistance from the Phillip D. Adler Fund, the Friends of the University of Iowa Museum of Art, and the Judith Rothschild Foundation
Courtesy Washburn Gallery, New York

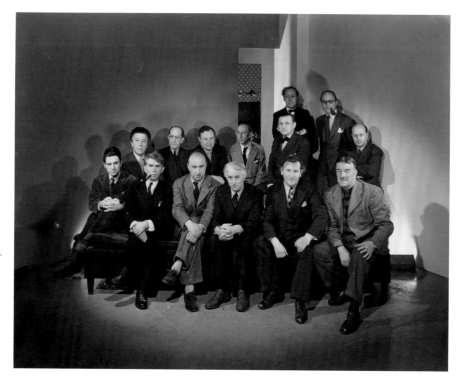

Fig. 27
From left to right, first row: Matta, Ossip Zadkine, Yves Tanguy, Max Ernst, Marc Chagall, Fernand Léger. Second row: André Breton, Piet Mondrian, André Masson, Amédée Ozenfant, Jacques Lipchitz, Pavel Tchelitchew. Third row: Kurt Seligmann, Eugene Berman.

George Platt Lynes, artists participating in the Artists in Exile exhibition at the Pierre Matisse Gallery, 1942. George Platt Lynes photographs, Archives of American Art, Smithsonian Institution/ © Estate of George Platt Lynes

Betty Parsons Gallery exhibition, The Ideographic Picture, Newman stated his belief in the significance of Kwakiutl Northwest Coast Indian "shapes" to the work of such artists as Boris Margo and Mark Rothko, stating that "there has arisen during the war years a new force in American painting that is the modern counterpart of the primitive art impulse."[17]

Museum exhibitions too reinforced the widespread effort to relate the perceived aesthetics of indigenous objects to Western artists' interest in nonobjective representation and surrealism. In New York artists could see MoMA's exhibitions Prehistoric Rock Pictures in Europe and Africa (1937), Twenty Centuries of Mexican Art (1940), and Indian Art of the United States (1941). Leon Polk Smith provides an example of a true dialogue between indigenous American family history and modernism in his painting *Center*

Columns, Blue Red, 1946 (fig. 26). Smith, born in Oklahoma in 1906, was part Cherokee and affiliated with the Choctaw and Chickasaw. Well versed in family and tribal traditions, after locating to New York City in 1936, Smith combined indigenous American weaving patterns with western European modernist compositional approaches.

In November 1931, the Wadsworth Athenaeum in Hartford, Connecticut, presented the first museum exhibition in the United States that was dedicated to surrealism, titled Newer Super-Realism. MoMA director Alfred Barr's 1937 Fantastic Art, Dada, Surrealism followed his 1935 exhibition on cubism and abstract art; Barr believed that these styles were tendencies opposing those featured in his earlier exhibition.[18] The New York art dealer Julien Levy featured the work of European surrealists in his spring 1932 show

Surréalisme (fig. 27). An exhibition of surrealist painting organized by Howard Putzel (later a curator for Guggenheim's Art of This Century Gallery) was on view at the New School for Social Research in the spring of 1941. Additional gallery exhibitions of note include First Papers of Surrealism, at the Whitelaw Reid mansion in December 1942, and the 1944 Abstract and Surrealist Art in America, organized by the collector (later art dealer) Sidney Janis for the Mortimer Brandt Gallery and the San Francisco Museum of Modern Art. Other New York galleries showing surrealist and surrealist-inspired art included Pierre Matisse Gallery, Norlyst, Nierendorf, Weyhe, Catherine Viviano, Hugo, Perls, Willard, Buchholz, Boyer, Ferergil, Iolas, Paul Elder, and East-West Gallery, among others.

When Peggy Guggenheim opened her London gallery, Guggenheim Jeune, in January 1937 (closed

in 1939), she featured work by Alexander Calder and Max Ernst, as well as prints created at Stanley William Hayter's Paris Atelier 17. Guggenheim's plan to build a museum for her private art collection, with works by European and American surrealists and modernists, became unattainable as the war expanded. Fleeing Europe for New York City, in 1940 Guggenheim opened Art of This Century Gallery (AoTC), which displayed her own collection as well as new art. The four spaces that comprised AoTC (Abstract Gallery, Surrealist Gallery, Kinetic Gallery, Daylight Gallery) were devised by the Viennese architect and designer Frederick J. Kiesler. Although Guggenheim did not want to be identified as a supporter of surrealism,[19] the Surrealist Gallery was a black corridorlike space with wavy hanging wall units that displayed the artworks. Individual spotlights randomly lit the paintings in between periods of complete darkness complemented by the threatening sound of an oncoming train. In the Kinetic Gallery a ship's wheel rotated the contents of Marcel Duchamp's *Box-in-a-Valise*. The temporary exhibitions took place in the Daylight Gallery, including the New York debuts of Robert Motherwell, Jackson Pollock, and Charles Seliger, and important early exhibitions of work by Richard Pousette-Dart and Mark Rothko.[20]

Much has been written about the influence of surrealism on Jackson Pollock, beginning with the early identification of Pollock as a surrealist by Sidney Janis in his 1944 essay for the exhibition Abstract and Surrealist Art in America. David Anfam and other scholars have discussed Jackson Pollock's obsession with the use of oppositional forces as a method for psychic transformation, such as left/right handedness, the mirror, inner/outer self, generation/regeneration, etc. Pollock's novel creative efforts related to surrealism included drawings for two psychoanalysts, meant to call up associations and thus ruminations on meaning. And Harold Rosenberg described Pollock's work as a "performance" of his unconscious.[21]

In the contract between the art dealers Betty Parsons and Peggy Guggenheim, dated May 12, 1947, Guggenheim turned her representation of Jackson Pollock over to Parsons.[22] Guggenheim had exhibited Pollock's *Portrait of H.M.*, 1945 (fig. 40), in the March 19–April 14, 1945, AoTC exhibition. In the 1947 contract, Guggenheim notes that she was to retain the painting, which she later gave to the University of Iowa along with *Mural* (fig. 1).[23]

The Chilean artist Matta arrived in New York City in November 1939 after living in France for four years. His work for the architect Le Corbusier and his friendships with Duchamp and Gordon Onslow Ford introduced him to surrealism.[24] Recalling time spent with Matta in Switzerland in 1939 prior to their compulsory emigration, Ford wrote that through their readings and discussions, "we were trying to enlarge perception. We wanted not to be limited by what we could see but to extend in time, to see through the mountains, to see the roots of a tree as it grows. The first major discovery that Matta and I made was that when you work spontaneously you express reality. Intuitively we were both in possession of knowledge about the inner world."[25] In 1942, Matta and Motherwell explored the surrealist practice of automatism,

meeting informally with Jackson Pollock and Lee Krasner, and others, to engage in the new method.[26] Motherwell believed that the beginnings of abstract expressionism could be traced to these efforts. "Nevertheless, my conviction is that, more than any other single thing, the introduction and acceptance of the theory of automatism brought about a different look in our painting."[27] *Like Me, Like X*, 1942 (fig. 28) is a classic example of Matta's "psychological morphology" or "inscapes"—terms he used to define his preoccupation with the relationship between the unconscious mind and the forms and structures found in the natural world.

Some artists were, or had been, mathematicians (Matta) or scientists (Hayter), and the latest research news was highly significant in the development of their individualized surrealist methods. Charles Seliger was introduced to the writings of Einstein, Freud, Jung, and Thoreau in books and journals on the shelves of his uncle's library. In *Homage to Erasmus Darwin*, 1945–46 (fig. 46), the primary figure refers to Charles Darwin's grandfather, Erasmus Darwin, as a physician and scientist. In 1943, Seliger adopted automatism to bring out the organic shapes he desired, later working to alter and define them. With techniques of pigment scraping and reapplication, Seliger alluded to the passing of time, a goal he pursued his entire career. *Homage to Erasmus Darwin* was included in a 1946 AoTC group exhibition and in the 1947 University of Iowa Summer Exhibition of Contemporary Art. The painting was purchased by Peggy Guggenheim from Seliger, and soon after donated to the university.

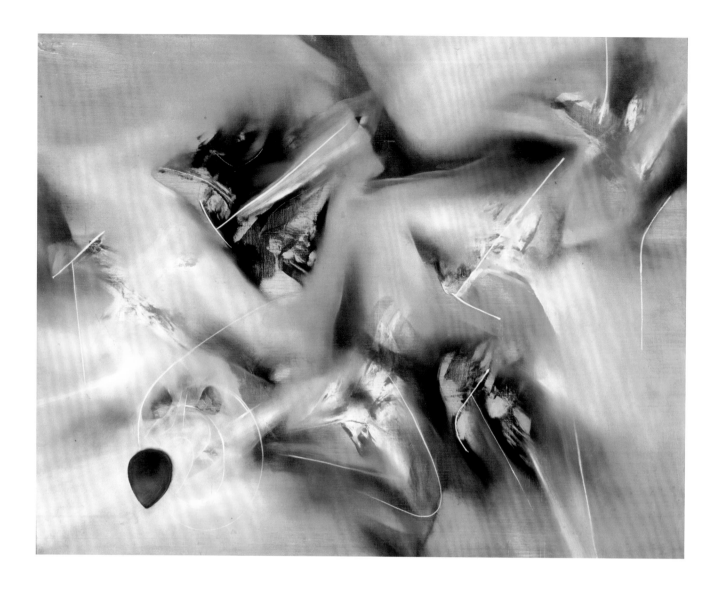

Fig. 28
Matta (French, born in Chile, 1911–2002)
Like Me, Like X, 1942
Oil on canvas
28 x 36 in. (71.12 x 91.44 cm)
Gift of Peggy Guggenheim
© 2013 Artists Rights Society (ARS), New York /
ADAGP, Paris

The often meticulous line of the intaglio print, and its centuries-old subject matter of medieval monsters and inexplicably fantastical forms, also found allegiance among artists engaged in surrealist practices. The 1937 MoMA exhibition Fantastic Art, Dada, Surrealism included prints by William Blake (British, 1757–1827), Jacques Callot (French, c. 1592–1635), and Urs Graf (German, 1485–1528). After the termination of the WPA Graphic Arts Division, and as intaglio techniques evolved through Hayter's Atelier 17, lithography found a home via the New York print publisher Associated American Artists and printers like Lynton Kistler in his Los Angles workshop. June Wayne, the 1960 Tamarind Press founder, worked with Kistler from 1947 to 1957. He rented her a lithography stone for five dollars plus a five-dollar deposit, for which he would also pull a couple of proofs. "I took the stone back to my garage studio and it was like the first shot of heroin, what a surface to draw on. How mysterious a process! Why hadn't I paid attention to Max Kahn in the 30's?"[28] Wayne's mind-bending drawings on lithography stones for her Kafka-stimulated series of human bodies, blasting guns, and barbed wire refer to the unreality of war for those coming to terms with images of the concentration camp horrors (fig. 29).

Fig. 29
June Wayne (American, 1918–2011)
Kafka Symbols, 1948
Lithograph
Image: 14 x 17 3/4 in. (35.6 x 45.1 cm); sheet: 17 3/4 x 22 5/8 in. (45.09 x 57.47 cm)
Gift of the Stone Circle Foundation
Art © The June Wayne Collection/Licensed by VAGA, New York, NY

Fig. 30
Stanley William Hayter (British, 1901–1988)
Untitled, plate 2 from "L'Apocalypse," 1931
Engraving and drypoint
Image: 13 x 9 39/64 in. (33 x 24.4 cm);
sheet: 19 1/4 x 15 in. (48.9 x 38.1 cm)
Gift of Mr. and Mrs. Peter O. Stamats
© 2013 Artists Rights Society (ARS), New York /
ADAGP, Paris

Stylistically, as many observed, the work completed at Atelier 17 was as advanced as the most highly praised contemporary American art. For those artists who rejected what they thought of as provincialism in American Scene or social-realism art, surrealism provided a key to a more international outlook. In New York, Hayter's promotion of technical experimentation, automatism, and abstraction reflected some of the most advanced tendencies in all art media.[29] His theoretical writings on automatism and the expressive abstraction of his art were formative influences on Jackson Pollock, who experimented with eleven plates at Atelier 17.[30]

The MoMA exhibition Hayter and Studio 17: New Directions in Gravure, June 17–September 17, 1944, held in the auditorium galleries, listed sixty prints, with fifty-two prints in the traveling versions.[31] MoMA curator James Johnson Sweeney introduced the show: "Its story is the story of an artist who saw the widespread neglect into which engraving as a medium of expression had fallen during the last four centuries and who realized the possibilities it offered for the exploration of those pictorial interests which most attracted twentieth century artists. . . . Hayter combines in an unusual fashion a scientist's technical interests with a plastic artist's imagination and feeling for form."[32] The significance of the Atelier 17 exhibition has been likened to that of the Armory Show.[33]

Hayter had settled in Paris in 1926, enrolled at the Académie Julian, and studied burin engraving privately with the Polish artist Joseph Hecht. By 1927, Hayter had his own students, and in 1933 named his workshop Atelier 17, after its address. The hallmark of the workshop was its egalitarian structure, which broke sharply with traditional print studios through its insistence on a cooperative approach to labor and technical discoveries. Hayter gravitated toward avant-garde artistic circles, developing relationships with Jean Arp, Alexander Calder, Miró, Yves Tanguy, and Masson. From 1934 to 1939, Hayter was in frequent contact with Pablo Picasso, periodically providing him with technical assistance.

Hayter began to exhibit his own paintings and prints with the surrealists and at the Salon des Surindépendents. His use of the surrealist juxtaposition of disparate ideas can be seen in the plates from the six-engraving set *L'Apocalypse* (fig. 30), published by Editions Jeanne Bucher in 1932. The text accompanying the set, a commentary on Hayter's compositions, was written by the poet George Hugnet.[34] Hayter's themes were often mythological, typically focused on violence, anguish, and war. Many Hayter works were inspired by the destruction and inhumanity of the war in Spain and the approaching war in Europe, foremost concerns of many. The author Anaïs Nin recalled the following from the spring of 1939: "Refugees from Spain began to slip into Paris. The laws were rigid: if one sheltered or fed them there would be a punishment of jail and a fine. These were the fighters, the wounded, and the sick. Everybody was afraid to help them. William Hayter hid them in his studio. . . .

I was busy cooking gallons of soup, which had to be brought in small containers to Hayter's studio."[35]

Atelier 17 was abandoned (with all its contents) on September 4, 1939, a day after war was declared in Europe. Hayter, a member of the British reserves, returned to England. In 1941, Rosamund Frost reported in *Art News* that Hayter is "acting advisor to the Museum of Modern Art camouflage section in their 'Britain at War' show scheduled to open late this month. He has constructed for them an apparatus which can duplicate the angle of the sun and the consequent length of cast shadows at any time of day, and day of the year, at any given latitude. This complex of turntables, discs inscribed with a scale of weeks, allowances for seasonal declination, and so on is just the kind of working mathematics he really delights in."[36]

Hayter's scientific training, mathematical ability, and lifelong interest in the natural sciences were manifested through his use of topological transformations, wave motion, and moiré field interferences in his compositions.[37] His experiments and essays on surrealist automatism and visual perception (*Line and Space of the Imagination*, 1944; *The Convention of Line*, 1945; *Interdependence of Idea and Technique in Gravure*, 1949) led to a deeper understanding of the relationships between conscious awareness and unconscious influence. An interview published in the October 15, 1940, *Art Digest* noted: "His classes at the New School, which are for advanced students and professional artists only, will stress independent experimentation with the various print media." Hayter explained, 'I want the artists to try impossible, different, unusual

methods. If they want advice or information, I'll give it. I'll teach them technique. I'm not teaching art first of all, it can't be done. Then, if I gave my ideas to anyone they'd become secondhand. That's no good. . . . The test of whether a piece of work is good or bad is whether it's dead or alive, and that you can tell by feeling."[38] In her *Art News* article, Frost suggested, "If at first glance the Hayter pupils might appear to work under too strong a domination of their master, a closer inspection will show a great number of personal trends. . . . There are no trade secrets in this workshop and the general tendency [is] toward abstraction as a language which permits maximum experiment."[39]

Unlike existing print workshops based on master-pupil relations, at Atelier 17 émigré artists mingled with young American artists, sharing techniques and stories. All were pursuing the possibilities of fresh approaches for the integration of space and object. Hayter's reintroduction of the use of burin engraving, combined with new soft-ground and aquatint techniques, was understood to be in pursuit of expanding the frontiers of expression. Hayter revived William Blake's eighteenth-century methods of engraving and relief etching (it was said that Hayter literally dreamed about innovations departing from Blake's techniques).[40] For example, in *Tropic of Cancer* (fig. 31) Hayter capitalized on the facility of the engraved line to create positive recession and a sensation of enormous space, utilizing the force of the physicality of substantial embossment on the printed surface, rather than just the illusion of design.[41] He also evolved the technique of relief-printing color from the plate surface. The toolbox

for artists working in Atelier 17 soon included embossing, engraved line, and surface printing, which in combination produced remarkable evocations of cosmological universes.

In 1943, the artist Sue Fuller went to Atelier 17 to learn how to engrave metal for jewelry. "There's a guy down at the New School teaching engraving," she was told. Fuller's background in metals "came in handy when I was into printmaking. I knew about cutting metal, tools, scraping and burnishing."[42] Fuller incorporated lace from her recently deceased mother's clothing into her prints via soft-ground etching, using the crossed threads instead

of cross-hatching. Her collage-like use of thread, silk, gauze, and net were inventive, similar to the Bauhaus approach to texture (fig. 32).[43] "Hayter really knew how to make a soft-ground etching. And that's the key to the whole thing. . . . I printed with a 'trick wipe' demonstrated by Hayter—your hand removes only one part. Take some talc and give one area of that plate a quick twist. Bill Hayter could inspire other artists. It was the energy he himself generated. He inspired others to do their best."[44] Vaseline for soft-ground and Karo syrup for aquatint were two unique material techniques shared by everyone in the workshop, including Masson, who

46/50 Hen Sue Fuller '45

Fig. 32
Sue Fuller (American, 1914–2006)
Hen, 1945
Soft-ground etching and engraving
Image: 14 3/4 x 11 5/8 in. (37.47 x 29.53 cm); sheet: 18 3/4 x 14 in. (47.63 x 35.56 cm)
Leola Bergmann Print Fund
Courtesy of the Estate of the Artist and the Susan Teller Gallery, NY, NY

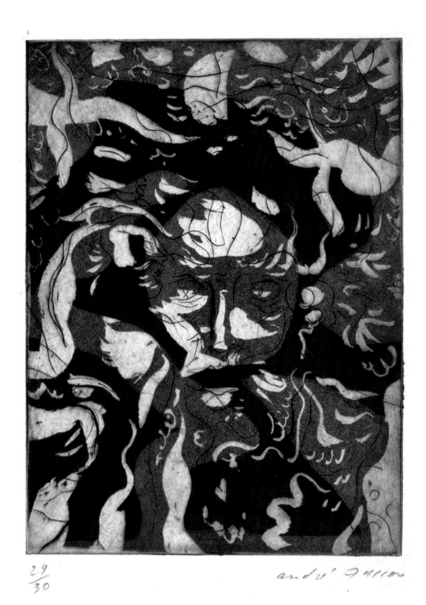

famously utilized the new methods in prints like *Improvisation*, 1945 (fig. 33). According to Fuller, Atelier 17 artists "cut the cord of that American Scene bit."[45] While Lipchitz, Chagall, Masson, and Matta produced some "erotic art," Fuller said, as Hayter's assistant she was busy editioning two plates for Chagall and one for Masson for the French publisher Curt Valentin. "Just about the same time Mauricio Lasansky turns up . . . in September of '43 at the Atelier. And from then on in Lasansky and I became great friends. He could hardly speak any English . . . was

my exact same age and to a certain extent he was my pal. Came from Cordova, Argentina. . . . Francis Henry Taylor from the Met went— saw the greatest drypoints he had seen in some years. They were quite large, you see. He immediately contacted Henry Allen Mow at the Guggenheim—you've got to give this man sight unseen a Guggenheim."[46]

Mauricio Lasansky was already an accomplished artist and teacher in Argentina when he traveled to New York in 1943 on a John Simon Guggenheim Memorial

Foundation Fellowship for Advanced Study Abroad to examine the print collection of the Metropolitan Museum of Art (figs. 34 and 35). During the next two years, while he worked at Atelier 17, his prints *Caballo*, *La Lagrima*, and *Doma* were included in the formative 1944 MoMA circulating exhibition Hayter and Studio 17: New Directions in Gravure.

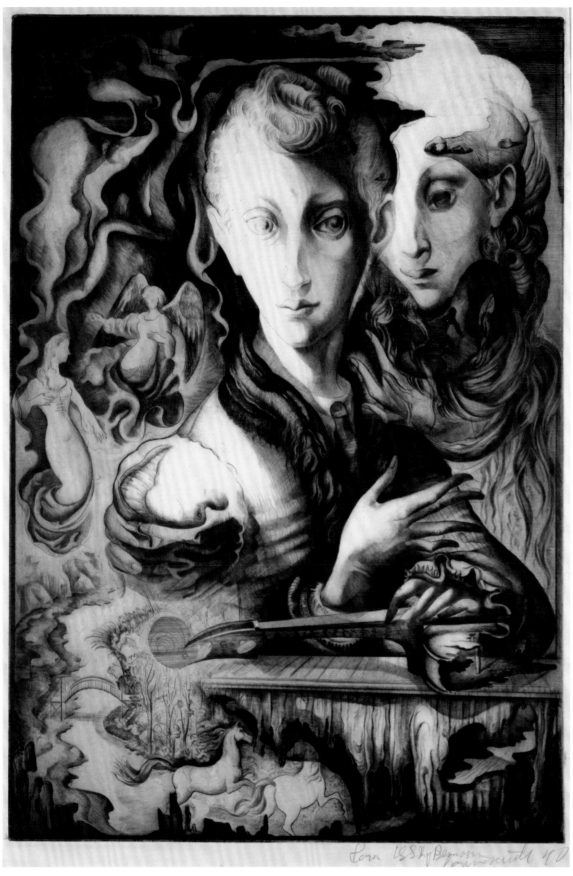

Fig. 34
Mauricio Lasansky (American, born in Argentina, 1914–2012)
El Presagio, 1940–41
Drypoint
Image: 24 1/4 x 16 3/8 in. (61.6 x 41.6 cm); sheet: 25 1/2 x 17 1/2 in. (64.77 x 44.45 cm)
Gift of Webster and Gloria Gelman
© The Lasansky Corporation

With the GI bill at the end of the war, professional artists, like Lasansky at the University of Iowa, taught the first generation of credentialed American art school graduates—students from the service—who went on to establish new departments and degree programs across the United States. Coming through New Deal programs and exposed to surrealism and modernism, the first and second generations of these professional artist-professors and their students played important and not widely enough recognized roles in the dramatic change soon seen in American printmaking.[47] Lasansky's approach to intaglio was motivated by a complex relationship between the artist, print history, the printing plate, and various techniques. He taught his students to develop compositions by combining methods related to the intrinsic properties of intaglio. Although students learned traditional skilled editioning, Lasansky was not especially concerned with that end result and encouraged experimental artist's proofs. Under Lasansky's tutelage, prints soon came "out of the portfolio and onto the wall."

In her review for the exhibition Surrealism USA, the *New York Times* art critic Roberta Smith joked, "Social realism and American scene painting, in particular, needed only slight adjustments to become strange."[48] The impact of surrealism on the artists and works represented in *New Forms* suggests that during the period covered by the exhibition, hybrid individualistic styles utilizing surrealist philosophies and techniques thrived. Combinations of illusionistic and semirepresentational subject matter are in abundant evidence, as artists manifested subtle manipulations of the ordinary into the extraordinary, absorbing surrealism and moving beyond it.

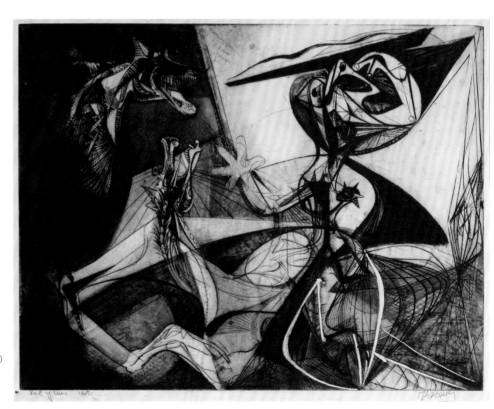

Fig. 35
Mauricio Lasansky (American, born in Argentina, 1914–2012)
Sol y Luna (Sun and Moon), 1945
Engraving, gouged-out white areas, etching, soft-ground, aquatint, scraping, burnishing
Image: 16 x 20 3/4 in. (40.6 x 52.4 cm)
sheet: 18 1/2 x 22 1/4 in. (46.99 x 56.52 cm)
Gift of Webster and Gloria Gelman
© The Lasansky Corporation

Notes

1. Graham Reynolds, "Hayter: The Years of Surrealism," in *The Renaissance of Gravure: The Art of S. W. Hayter*, ed. P. M. S. Hacker et al. (Oxford: Clarendon Press, 1988), 9–10.

2. Letter from Joseph Cornell to Alfred H. Barr Jr., Curatorial exhibition files, Exh. no. 55, *Fantastic Art, Dada, Surrealism*, December 7, 1936–January 17, 1937, Museum of Modern Art Archives, New York. See also Cornell's wooden box assemblage, *Hotel Boule d'Or*, 1955–60, in the UIMA collection.

3. Margit Rowell, ed., *Joan Miró: Selected Writings and Interviews* (New York: Da Capo Press, 1992), 209. Miró was able to return to Spain in 1940.

4. Marco Pesarese, catalogue entry for the 2007 exhibition *Max Beckmann: Exile in Amsterdam* (Amsterdam and Munich: Van Gogh Museum and Pinakothek der Moderne, 2007), 206.

5. Martica Sawin, *Gordon Onslow Ford: Paintings and Works on Paper, 1939–1951* (New York: Francis M. Naumann Fine Art, 2010), 64.

6. Guston, quoted in Thomas Albright, "A Survey of One Man's Life," *San Francisco Chronicle*, May 15, 1980.

7. Michael Shapiro, *Philip Guston: Working Through the Forties* (Iowa City: University of Iowa Museum of Art, 1997), 6.

8. James Johnson Sweeney, "A Note on Super-Realist Painting," *The Arts*, May 1930: 611–614.

9. Frederick Sweet, "The First Forty Years," in Sweet, *Abstract and Surrealist American Art* (Chicago: Art Institute of Chicago, 1947), 12.

10. Holger Cahill, *American Art Today*, New York World's Fair, National Art Society, 1939. Holger Cahill Papers, Archives of American Art, Smithsonian Institution.

11. Sawin, *Gordon Onslow Ford*. Ford gave four lectures at the New School of Social Research titled "Surrealist Painting: Adventures into Human Consciousness" (January 22, Giorgio de Chirico, in which he included a slide of a version of *The Disquieting Muses*; February 5, Max Ernst; February 19, Magritte; March 5, a survey of artists including Matta, Hayter, and Seligmann.) The transcription of Ford's longhand notes for these lectures appeared for the first time in Sawin's book. In her essay, Sawin notes that Ford practiced his talks, accompanied by slides, in the apartment of Frederick Kiesler. According to Sawin, the artists Yves Tanguy, Kurt Seligmann, Stanley William Hayter, Roberto Matta, Arshile Gorky, Jimmy Ernst, Peter Busa, William Baziotes, Robert Motherwell, and Jackson Pollock, among others, were said to be in attendance.

12. Ibid., 6.

13. Ibid., 69.

14. James Thrall Soby, *Artists in Exile* (New York: Pierre Matisse Gallery, 1942), 22.

15. For discussions of the Western concept of primitivism, see, among others, Susan Hiller, ed., *The Myth of Primitivism: Perspectives on Art* (London and New York: Routledge, 1991).

16. Lee Hall, *Betty Parsons* (New York: Harry N. Abrams, 1991), 73.

17. Barnett Newman, *The Ideographic Picture* (New York: Betty Parsons Gallery, 1947). Betty Parsons Gallery records and personal papers, Archives of American Art, Smithsonian Institution.

18. Letter to Dan Fellows Platt from Alfred H. Barr, October 15, 1936, Fantastic Art, Dada, Surrealism, December 7, 1936–January, 1937, CUR, Exh. #55, Registrar's file, MoMa Archives, NY.

19. In a letter to the editor, "Peggy Guggenheim Replies," published in *Art Digest*, June 1, 1943, Guggenheim responded to a description of Art of This Century by Klaus Mann: "As I am not the supporter of surrealism, neither am I its defender." Peggy Guggenheim Papers, Archives of American Art, Smithsonian Institution.

20. http://en.wikipedia.org/wiki/The_Art_of_This_Century_gallery

21. Harold Rosenberg, "The American Action Painters," *Art News*, December 1952:22.

22. In 1985, the Betty Parsons Foundation gifted 26 works to the UIMA. Betty Parsons was an active young artist in 1920s and '30s Paris. Shortly after her return to the U.S., first to California in 1933, then to New York City in 1936, she had an exhibition of her work at Midtown Galleries, which led to a position at the gallery. By 1937, Parsons was employed by the gallery of Mrs. Cornelius J. Sullivan until 1940, when she managed the gallery in The Wakefield Bookshop. Parsons became director of the modern division of Mortimer Brandt Gallery in 1945. She opened the Betty Parsons Gallery in the same space in 1946, adding Guggenheim's stable of artists in 1947. Among the artists represented by Parsons were Alexander Calder and Hedda Sterne, whose works are included in the exhibition. Betty Parsons Gallery Records and Personal Papers, Archives of American Art, Smithsonian Institution.

23. Ibid.

24. Colette Dartnall, Elizabeth A. T. Smith, and William Rubin, *Matta in America: Paintings and Drawings of the 1940s* (Chicago: Museum of Contemporary Art; Los Angeles: Museum of Contemporary Art, 2001), 14.

25. Sawin, 8.

26. Jeffrey Wechsler, *Surrealism and American Art, 1931–1947* (New Brunswick, NJ: Rutgers University Art Gallery, 1977), 49.

27. Sidney Simon, "Concerning the Beginning of the New School: 1939–1943: An Interview with Robert Motherwell by Sidney Simon in New York in January 1967," *Art International* 11, no. 6 (Summer 1967): 20–23.

28. June Wayne Papers, 1945–1981, Archives of American Art, Smithsonian Institution.

29. Joann Moser, *Atelier 17: A Fiftieth Anniversary Retrospective Exhibition* (Madison: Elvehjem Art Center, University of Wisconsin-Madison, 1977). Moser was curator and acting director of the UIMA from 1976 to 1986.

30. David Cohen, "Hayter: The Years of Surrealism," in *The Renaissance of Gravure, The Art of S. W. Hayter*, ed. P.M.S. Hacker et al. (Oxford: Clarendon Press, 1988), 24

31. Venues for the U.S. traveling version in later 1944 to the end of 1945 were the Cincinnati Modern Art Society, Baltimore Museum of Art, St. Paul Gallery and Art School, Detroit Institute of Art, Art Institute of Zanesville, Ohio, San Francisco MoMA, Fort Worth Art Association, Museum of Cranbrook Academy, Henry Art Gallery at the University of Washington, Museum of Fine Arts, Boston, Cornell University, and Vassar College. The exhibition was transferred to the National Gallery of Art Inter-American Office at the end of 1945 to travel for two years in South America. The exhibition may have also been on view at the Chicago gallery called Cliff Dwellers, 220 S. Michigan, in May 1945. The art review says that Lasansky is "represented by four powerful engraved abstractions." CUR, Exh. #259, *Hayter and Studio 17: New Directions in Gravure*, June 18–October 8, MoMA Archives, NY.

32. Moser, *Atelier 17: A Fiftieth Anniversary Retrospective Exhibition*, 8.

33. James Johnson Sweeney, *Bulletin of the Museum of Modern Art* 12, no. 1 (August, 1944): 3.

34. Reynolds, "Hayter: The Years of Surrealism," 12.

35. Anaïs Nin, *The Diary of Anaïs Nin*, vol. 2, 1934–1939 (New York: Harcourt, Brace and World), 332. Quoted in ateliercontrepoint.com.

36. Rosamund Frost, "Graphic Revolution: Studio 17,"*Artnews* 43, no. 10 (1944), quoted in ateliercontrepoint.com.

37. P. M. S. Hacker, *Biographical Note on S. W. Hayter*, 1992, quoted in ateliercontrepoint.com.

38. "Atelier 17 Reestablished," *Art Digest*, October 15, 1940:28, quoted in ateliercontrepoint.com.

39. Frost, "Graphic Revolution: Studio 17," quoted in ateliercontrepoint.com.

40. Hayter and Studio 17, CUR, Exh. #259, MoMA Archives, NY.

41. Ibid. From Hayter's notes: "Atelier 17 worked out a method of printing a succession of colors from the same plate (1930–31 in Paris) by superimposing relief impressions in color and the final impression in intaglio."

42. Sue Fuller, notes for the presentation "Atelier 17 and the New York Avant-Garde, 1940–1955," Pollock-Krasner House and Study Center, May 1–June 31, 1993, and Sue Fuller letters to Florence Forst, 1950–1994, Archives of American Art, Smithsonian Institution.

43. The use of collage as protest and surrogate for the unconscious is well known. Lil Picard, an underacknowledged German American visual artist and writer who immigrated in 1937 to New York City from Berlin, created unique collage-paintings and assemblages with the detritus of her life. See Edwards, lilpicard.org.

44. Fuller, notes for the presentation "Atelier 17 and the New York Avant-Garde, 1940–55."

45. Ibid.

46. Ibid.

47. "Midwest Matrix" was a University of Iowa Museum of Art and School of Art and Art History tribute to mid-twentieth-century fine art printmaking held December 1–2, 2012. The event included a symposium, world premiere film, the exhibitions *A Midwest Matrix Family Tree* and *Selections from the Iowa Print Group*, a print fair, and student demonstrations of printmaking. See midwestmatrix.info.

48. Roberta Smith, "Filling in the Many Gaps in American Surrealism," *New York Times*, March 31, 2005, 47.

Catalogue Entries

Emily A. Kerrigan

Lee Allen

Byron Browne

Philip Guston

William Ashby McCloy

Jackson Pollock

John D. Pusey

Walter Quirt

John Tazewell Robertson

Mark Rothko

Charles Seliger

Mitchell Siporin

Bradley Walker Tomlin

Max Weber

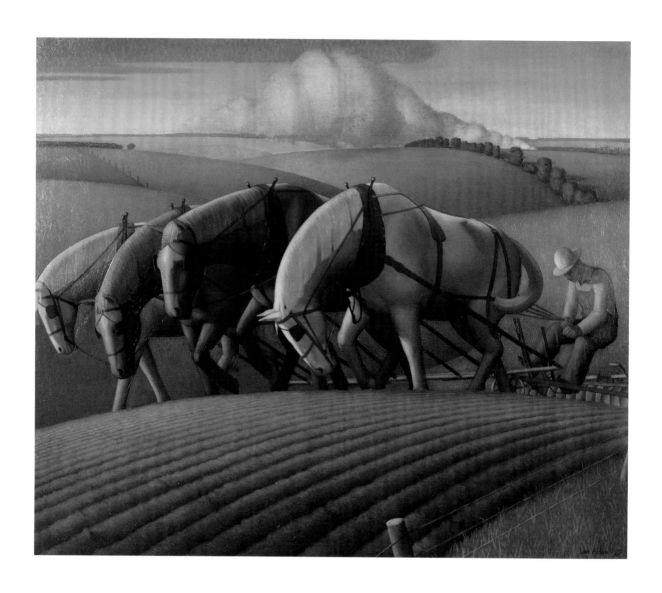

Edwin Lee Allen

Fig. 36
Lee Allen (American, 1910–2006)
Corn Country, 1937
Oil on Masonite
26 3/8 x 31 1/4 in. (66.99 x 79.38 cm)
Gift of Dr. Clarence Van Epps
Reproduced with permission of Lee Allen's
daughters, Mary Lee Hoganson and
Elizabeth Williams

Edwin Lee Allen is best known for his medical illustrations, his contributions to the field of ophthalmic photography, and his designs for implants and prosthetic eyes. Prior to his employment with the Department of Ophthalmology at the University of Iowa, however, Allen had a short but successful career as a professional artist, producing paintings, sculpture, and drawings. His university tenure left him little time for art, but he returned to painting after his retirement.

Allen was born in Muscatine, Iowa, and moved to Des Moines at age nine after the death of his mother. His interest in art developed at a young age, and intensified before he reached high school; by age sixteen he was winning awards in local shows for his paintings in both oil and watercolor. He received an informal art education as a teenager from the *Des Moines Register* when he visited its art department while working as a Western Union messenger. Although Allen's father did not approve of his son's goal to be a professional artist,

or his desire to continue his education beyond the eighth grade, his high school art teacher encouraged him to continue his artistic endeavors and to exhibit his work.[1] Allen went on to study at the Cummings School of Art in Des Moines, and he enrolled as an art student at the University of Iowa in 1929.

Allen's formal education lasted until 1933, when he went to work with the well-known regionalist Grant Wood, whom he met at the 1928 Iowa State Fair. They became lifelong friends. Allen took classes from Wood in Cedar Rapids in the early 1930s and spent time with him at the Stone City Art Colony in Stone City, Iowa, which Wood helped found.[2] In 1934 Allen began working with Wood on a Public Works of Art Project mural for the library at Iowa State University. Wood also introduced Allen to Diego Rivera.[3] After learning fresco techniques from this well-known muralist during a brief period of study in Mexico in 1935, Allen returned home to continue painting government-sponsored murals. He finished the Iowa State project, and was commissioned by the United States Treasury Department to create murals for post offices in Onawa and Emmetsburg, Iowa.[4]

Despite this productive and successful start to his life as a professional artist, Allen began a new and challenging career in 1937.[5] Faced with the responsibility of providing for his growing family, he took a position as an ophthalmic medical illustrator at the University of Iowa, and relegated his own art to his spare time. Although he accepted portrait commissions from colleagues, he ceased exhibiting his work and gave much of it away.[6] Allen had been introduced to ophthalmic medical illustration while he was still a student at the University of Iowa. Another artist, Emil G. Bethke, taught him the techniques, and Allen began making his own drawings. Despite this early experience and his artistic talent, Allen's new position proved to be difficult without medical training. To make accurate illustrations, he found, he had to study surgical procedures and attend courses with residents to learn the anatomy and common ailments of the eye. He went on to do significant work in his field, making innovations in ophthalmic photography and designing implants and artificial eyes.

Allen returned to painting after his retirement in 1976, devoting himself to capturing the local landscape and earning new accolades for his work. Later in life he noticed signs of macular degeneration in his own eyes, and he documented his changes in vision in a series of illustrations included in his book *The Hole in My Vision: An Artist's View of His Own Macular Degeneration*.[7]

Corn Country (1937) was completed in the same year that Allen became a medical illustrator. Painted in the regionalist style, it demonstrates Wood's impact on Allen's work. Wood's devotion to detail and precise brushstrokes are evident, and both artists focused on American, and often specifically Iowan, subjects. Allen frequently painted local scenes inspired by his life in Iowa City, such as *Edge of Town* and *University Bridge*, as well as depictions with national appeal, such as *Paul Bunyan and the Blue Ox*. *Corn Country* is unique in that it has the ability to relate to both local and national audiences. The rolling hills and the open sky confirm that this is an Iowa scene, yet the themes of hard work and perseverance would have resonated throughout the United States in the 1930s during the Great Depression. Allen's depiction of pristine farmland suggests that the country would recover from its economic, agricultural, and other difficulties through the power of its strong and determined citizens.

Notes

1. Don Wong and Marlene Fishman, "Lee Allen: The Man, the Legend," *Journal of Ophthalmic Photography* 12 (November 1990): 51–52.
2. Kristy Raine, "Edwin Lee Allen," in *When Tillage Begins: The Stone City Art Colony and School* (Cedar Rapids, IA: Busse Library, Mount Mercy University, 2003). http://projects.mtmercy.edu/stonecity/otherartists/allen.html. Allen assisted Wood on one mural in 1934, and on a second mural, for Iowa State, in 1936–37.
3. Emiliegh Barnes, "Renowned Illustrator Lee Allen Dies," *Daily Iowan*, May 8, 2006.
4. Allen completed *Soil Erosion and Control* for the post office in Onawa in 1938, and he completed *Conservation of Wild Life* for the post office in Emmetsburg in 1940.
5. Allen's success is evident in the many prizes he won at the Iowa Art Salon for his oil paintings and watercolors. He also exhibited his work at the Art Institute of Chicago in 1936.
6. Wong and Fishman, 53.
7. Lee Allen. *The Hole in My Vision: An Artist's View of His Own Macular Degeneration* (Iowa City: Department of Ophthalmology and Visual Sciences, University of Iowa Center for Macular Degeneration; Penfield Press, 2000).

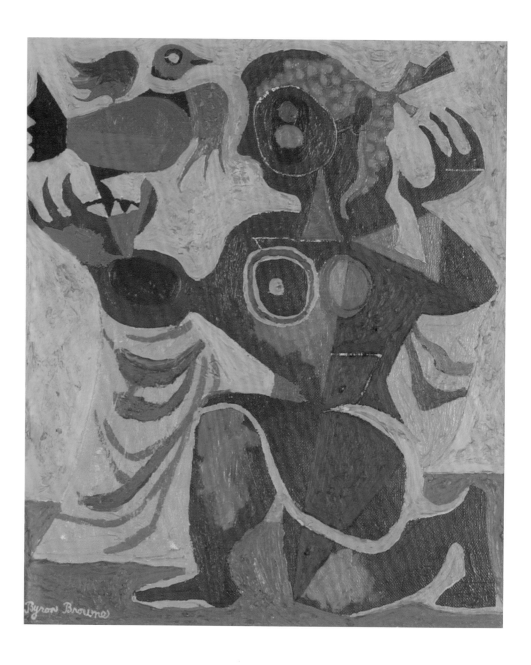

Byron Browne

Fig. 37
Byron Browne (American, 1907–1961)
Woman with Bird, 1942
Oil on canvas
12 x 14 in. (30.48 x 35.56 cm)
Gift of Mrs. Byron Browne
© Stephen B. Browne

Byron Browne, a prominent New York artist in the 1930s and 1940s, was both a modernist and a classicist. He received his initial education at the conservative National Academy of Design, but eventually abandoned his academic lessons for avant-garde techniques; he destroyed much of the representational work from his school days, and by 1930 had fully embraced abstraction. Browne was employed by the WPA beginning in the mid-1930s and became one of the first New Deal artists to create abstract murals for public buildings, helping to move this type of wall art away from its traditional focus to something freer and more original. During these same years he became a founding member of the American Abstract Artists (AAA), working for the support of abstraction even as styles such as social realism and regionalism generally held sway in the arts.[1]

Browne's dedication to modernism resulted from his introduction to the art of the cubists and that of Joan Miró and other members of the European avant-garde through the Gallery of Living Art at New York University. His education continued through copies of the art journal *Cahiers d'Art* and his brief period of study with Hans Hofmann, the famous German American teacher and modernist. Browne experimented with a variety of progressive styles throughout his career, making labels such as "abstract surrealist" inadequate.[2] As a devotee of both cubism and surrealism by the 1940s, Browne played a significant role in urging American art away from its conservative past.

Despite his dedication to abstraction, Browne believed that this mode of painting had limits and he did not want to be restricted to one style. He put experimentation and free artistic expression first, alternating between abstraction and more traditional styles. His participation in the AAA did not mean that he always followed the ideals and beliefs of the group. This is evident in his rejection of nonobjective painting, which he claimed did not exist—he believed that all art had roots in the visual world. Browne explained his continuing devotion to nature in his notebook: "When I hear the words non-objective, intra-subjective, avant-garde and such trivialities, I run. There is only visible nature, visible to the eye or visible by mechanical means, the telescope, microscope, etc."[3]

Like many modernists, Browne embraced a variety of influences, both past and present. In addition to cubism and surrealism, he had many other artistic interests and combined his fascination with Mondrian and Modigliani with his knowledge of African, medieval, Greek, Byzantine, and Assyrian art, the art of the Americas, and art from still other periods and cultures. Browne was a devoted classicist despite his respect for modernism: "I feel the tradition of art to be behind every picture I do. There cannot be a new art without a solid basis in understanding of past art. Greek, Roman, Romanesque, and Byzantine schools I find most rewarding. Here we have monumental conceptions along with human attitudes."[4]

Browne's commitment to nature and the object in his art, as well as to both modernism and classicism, is evident in *Woman with Bird* (1942). Flat and small-scale, like most of his paintings, it depicts a kneeling figure with a bird perched on her right hand. (Large figures with a bird were a common motif for Browne, one that he explored in an unfinished sculpture late in his career.[5]) In *Woman with Bird*, a thick application of paint covers the canvas and adds texture. Stylized and abstracted garments, breasts, and a hair ribbon identify the figure as a woman. Women were consistent and significant subjects in Browne's work throughout his career, and during the 1940s stylized females with bright colors, claws, bold shapes, and ringed eyes were common in his art.[6] *Woman with Bird* seems to stand somewhere between Browne's traditional depictions of figures and his abstract canvases. The bold colors and shapes betray the influence of biomorphic surrealism, while the bright colors also suggest his interest in the art of the Americas.

Despite the level of abstraction, classicism is perhaps the most important influence upon the work. Both Browne and the nineteenth-century neoclassical painter Jean-Auguste-Dominique Ingres, one of his dominant artistic influences, "presented the female figure as creation's crowning achievement."[7] The figure in *Woman with Bird*, similar to an ancient statue with its static pose, classical profile, and goddesslike appearance, may have been inspired by Browne's employment as a guard in the Greek and Roman section of the Metropolitan Museum of Art during the 1940s.

Browne never received the same attention as his New York School colleagues, in part perhaps because of his frequent changes of style. His relationship to the group was in any case somewhat tenuous. His interest in mythology and abstraction, and his circle of artist friends and acquaintances, connect Browne to the abstract expressionists, yet his devotion to nature and the figure set him apart.[8] This dichotomy also complicates his long-term significance within American art history. While he was promoted by Samuel Koontz as a true American artist in the early 1940s—one who created art that was optimistic, vibrant, and individualistic— it was not long before he was considered not American enough because of his adherence to Parisian modernism.[9] Nevertheless, decades later, despite his many influences from the great art-historical past, one scholar still argued that Browne "remains one of the most truly American artists of the century."[10]

Notes

1. Extremely political, Browne worked for artists' rights. He was a founding member of many groups, including the Federation of Modern Painters and Sculptors (along with Mark Rothko and others).

2. Paul Schimmel, "Images of Metamorphosis," in *The Interpretive Link: Abstract Surrealism into Abstract Expressionism: Works on Paper, 1938–1948*, ed. Paul Schimmel and Lawrence Alloway (Newport Beach, CA: Newport Harbor Art Museum, 1986), 17.

3. Browne, from a notebook, quoted in Gail Levin, "Byron Browne in the Context of Abstract Expressionism," *Arts Magazine* 59 (June 1985): 129.

4. Browne, 1948, quoted in Harry Rand, *Byron Browne: Paintings and Drawings from the Thirties, Forties, and Fifties* (Roslyn, NY: Nassau County Museum of Fine Art, 1987), 10.

5. Greta Berman, "Byron Browne: Builder of American Art," *Arts Magazine* 53 (December 1978): 102.

6. Works with similar subjects include *Girl with Lobster* (1942) and *Woman with Birds* (1947). Browne made many other paintings of women reading or holding a variety of items. See Betsy Severance, "Byron Browne," in Schimmel and Alloway, *The Interpretive Link*, 66.

7. April J. Paul, *Byron Browne: A Retrospective* (Naples, FL: Harmon Gallery, 1982), 7.

8. Browne tried to express optimism and happiness in his work, which led him to feel out of sync with the rest of the world. He noted, "I like the optimistic note in art, this is a cynical age. I want the human element in painting; the fashion today is anti-human." Quoted in Douglas Webster, *Byron Browne: Selected Works, 1932–1952* (Scottsdale, AZ: Yares Gallery, 1982), 17. Webster discusses Browne's tendency to be "at odds" with his colleagues, as does Berman. See Berman, 102.

9. Serge Guilbaut, *How New York Stole the Idea of Modern Art: Abstract Expressionism, Freedom, and the Cold War* (Chicago: University of Chicago Press, 1983), 71, 178–179.

10. Berman, 98.

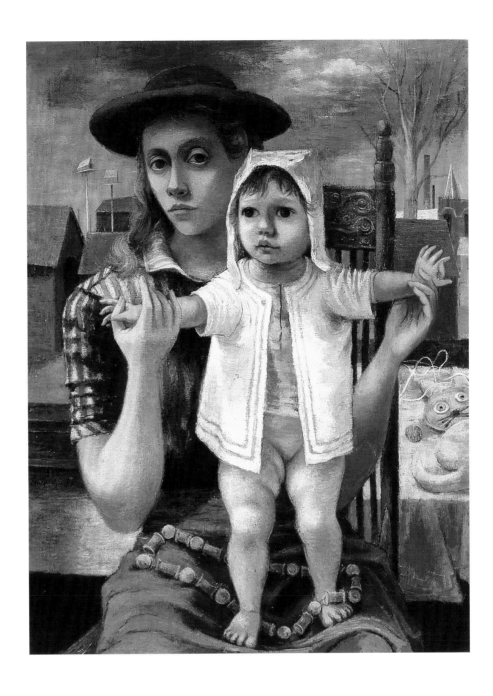

Philip Guston

Fig. 38
Philip Guston (American, born in Canada, 1913–1980)
The Young Mother, 1944
Oil on canvas
39 7/16 x 29 1/2 in. (100.17 x 74.93 cm)
Gift of Dr. Clarence Van Epps
© The Estate of Philip Guston

Philip Guston is famous for his nonobjective art—the work he created as a member of the New York School. These paintings, however, represent only one period of his career, and they were framed by years of significant figurative art that are often overlooked. Guston's work was consistently personal and reflective of its time, yet the canvases he produced in the 1940s were especially intimate and intriguing, and in many ways they foreshadowed the work that was to come. As one scholar noted, "The period of the '40s was a caldron in which many of his lifelong artistic concerns bubbled to the surface and found visual expression."[1] While Guston's friend Jackson Pollock criticized his representational work of this period as too traditional, it is clear that these canvases were true to Guston's dedication to modernism, as was his work throughout his career.

Guston, the son of Russian Jewish immigrants, was born Philip Goldstein in Montreal in 1913 and moved to Los Angeles when he was a young boy. At Manual Arts High School he received his introduction to modern art and became friends with the young Pollock. His expulsion from the school marked the end of his only formal art education; thereafter he taught himself through reading and, after he moved to New York City, museum exhibitions, copies of *Cahiers d'Art*, and conversations with members of the city's avant-garde.

During these early New York years, Guston worked as a mural painter for the Works Progress Administration's Federal Art Project and, like other muralists of the 1930s, was caught up in the social and political functions of art. In early 1941 he moved to Woodstock, New York, and then isolated himself further from the New York art scene by moving to Iowa City to teach and work as an artist-in-residence at the University of Iowa. Guston's daughter, Musa, described this change as a purposeful retreat that allowed him to work in peace and demonstrated his resistance to labels and to being identified with anything other than his own work and his own style.[2] Iowa proved to be important for Guston, who explained, "I'd gotten tired of painting public walls and having to please commissions. In the solitude of the mid-West [*sic*], for the first time I was able to develop a personal imagery."[3] He embraced the progressive atmosphere developing at the University of Iowa at the time: there was a great surge in artistic activity, and the art department, headed by Lester Longman, demonstrated a commitment to modernism. Guston's work was undergoing a transformation as well,

as he left mural painting behind and worked to develop his mature style. It was at this time that he first gained significant acclaim for his art.

Guston's transition to more personal imagery is evident in *The Young Mother* (1944). The painting depicts his wife, also named Musa, and infant daughter, in a domestic setting with a cityscape in the background. Like other works of the period, it addresses the theme of childhood that Guston became known for in works such as *Martial Memory* (1941). The young Musa stands on her mother's lap, naked from the waist down. The older Musa sits on a chair in the foreground, confronting the viewer with a direct stare. The architecture betrays their location— some of the buildings still stand in Iowa City. *The Young Mother* is one of many personal portraits Guston made during the early 1940s, when he often turned to his family, friends, and colleagues for his subjects. The intimacy of the portrait may reflect his desire to keep his family close, something Guston may have felt was necessary because of the loss he felt earlier in his life with the death of both his father and his brother.[4]

The Young Mother lets us into Guston's private life, yet it is simultaneously ambiguous in its meaning and intention. Like many of his other works, the painting is calm and contemplative. It functions as a modernized Byzantine icon with the figures close to the picture plane. The mother, while supportive of her daughter, expresses uneasiness or uncertainty through her gaze, possibly suggesting the discomfort of bringing a child into the world in the midst of World War II. It may also reflect her new role as wife and mother. Musa had worked as an artist, but she gave up her

art when the Gustons moved to Iowa and started a family. Her new responsibilities are clearly conveyed in *The Young Mother*. She is dedicated to her daughter—providing her the stability she needs as an infant— and she is surrounded by emblems of domesticity such as household furniture and children's toys.

The Young Mother may suggest Guston's nervousness as well. At a time when his career was changing rapidly, he took on the new role of father and grappled with his responsibility for providing for his family. His daughter describes her childhood as bittersweet, with a certain degree of detachment between her and her father. Guston seemed to be conflicted about fatherhood: he never wanted children, yet he felt love for his child after she was born and even wrote a letter to his wife's parents expressing his excitement about the birth.[5] His own stressful childhood may have played a role in his sense of unease. Young children engaging in practice combat is a common theme in Guston's work during this period; while it is normal for young boys to engage in play-fighting, a mysterious element in these canvases alludes to the artist's darker past. One scholar noted this when discussing Guston's *Ceremony* (1946): "Children? . . . But what sort of childhood, one wonders, could the artist have had for its memory to evoke in him such a tense, mysterious, even anguished picture?"[6] Guston himself refers to his favorite subject of the period as "melancholy children and all that."[7]

Regardless of his feelings toward his family and his own childhood, Guston was confident about the success of *The Young Mother*. He wrote in a letter that "since the first of the month I have been at work on

a large picture of Musa and the child. I am very excited about it, more than I have been for a long while. I like it better than anything I have done. Unless something happens to me I know I am going to do some ambitious painting this year."[8]

The objects within *The Young Mother*, like its overall meaning, are ambiguous as well. They have an obvious connection to family life, but the eerie effect of the toy cat's large eyes, and the prominent placement of the spool and bead necklace and the birdhouses, suggest that they may have a deeper meaning. This seems likely: Guston developed a strong interest in symbolism during his years in Iowa, when he became an avid reader of the work of the German art historian Erwin Panofsky, including his studies on iconography. The critic and art historian Dore Ashton argues that Guston's "interest in symbolism . . . required further meditation, and for this Iowa was a perfect situation, being thoroughly remote from the urgency of New York."[9]

The ambiguity of the painting can be explained yet another way: Guston wanted to express both order and mystery in his work,[10] through his simultaneous interest in surrealism and the Renaissance.[11] During his formal training in Los Angeles, Guston became fascinated by Mantegna, Michelangelo, Masaccio, Giotto, and other Renaissance masters. The influence of Piero della Francesca and other early Renaissance artists was especially apparent in his work of the early 1940s. In *The Young Mother* this is evident in the solid and static figures, the frontal view, the interest in light and space, and Guston's overall dedication to composition and organization. The mysterious mood conveyed through the ominous

sky, the strange objects interspersed throughout the composition, and Musa's gaze disrupts this sense of order, however, and betrays another major influence on Guston's work— Giorgio de Chirico, a forerunner of the surrealists, known for his use of symbolism and mystery.

The ambiguity of *The Young Mother* can also be explained by two other influences upon Guston's art: Picasso's figurative work of the 1920s and postsurrealism. Guston was familiar with Picasso's art through avant-garde art magazines and the 1939–40 retrospective exhibition at the Museum of Modern Art in New York. The sense of order and interest in classicism that Picasso turned to after World War I may have appealed to Guston. Similarities between Guston's *Young Mother* and Picasso's paintings from two decades earlier can be seen in the dominance of the figures within the composition, as well as the emphasis given to the facial features.[12] A very different influence—that of postsurrealism—is seen in Guston's painting as well, and works to counteract any sense of order. Guston's knowledge of postsurrealism was imparted through his relationship with the artist Lorser Feitelson, beginning in 1930. Feitelson developed an approach to art in which "the realization of the work now depended upon a symbolical fusion. The sum of the parts in a painting would induce a state of mind that was something other than what the objects represented by themselves."[13]

In 1942, the art historian H. W. Janson argued that American art could never truly separate itself from European art—a symbiotic relationship and undeniable link existed between them. Janson viewed Guston as an example of one of

the few artists who understood the necessity of looking to the European avant-garde as a stepping stone to the development of a personal style.[14] In Iowa, Guston was able to form his own style, using the work of Picasso and the surrealists as his guide.

Guston left representational art behind for a long phase of abstraction in the years after World War II, feeling, like many of his colleagues, that his figures could not capture the horrors of the war and that nonobjective art was therefore the best form of expression. Although he became a respected member of the avant-garde after his respite in the Midwest and abroad, figures began to reemerge slowly in his work in the late 1960s. His new figurative style, cartoonlike in appearance, upset many people in the art world and caused significant controversy. For Guston, figurative art meant "dealing with the impossible."[15] He knew that representation was not an easier path to travel. It involved identifying the key people and objects in his everyday life and portraying them on canvas, responding to the world around him in an intimate way, and drawing from disparate periods of art history. Despite the difficulty he had, his work of the early 1940s proves to be remarkable for its continuity with his later paintings, and for what it demonstrates about Guston's commitment to modernism throughout his career.

Notes

1. Michael Edward Shapiro, "Philip Guston: The War Years," *Print Collector's Newsletter*, September–October 1994:127.

2. Musa Mayer, *Night Studio: A Memoir of Philip Guston* (New York: Alfred A. Knopf, 1988), 33.

3. Guston, quoted in Thomas Albright, "A Survey of One Man's Life," *San Francisco Chronicle*, May 15, 1980. Guston also described these years in Iowa as difficult ones: "In 1941 when I didn't feel strong convictions about the kind of figuration I'd been doing for about eight years, I entered a bad, painful period when I'd lost what I'd had and had nowhere to go. I was in a state of dismantling." Although Guston viewed Iowa during the war years as "empty" and "lonely," his turn to easel painting and to working in the studio seemed to ease any regrets he felt about living in the Midwest. Dore Ashton, *A Critical Study of Philip Guston* (Berkeley and Los Angeles: University of California Press, 1976), 62–64.

4. Michael Edward Shapiro, *Philip Guston: Working Through the Forties* (Iowa City: University of Iowa Museum of Art, 1997), 6. Guston's father committed suicide when he was still young and his brother died in an automobile accident.

5. Mayer, 33–35.

6. Emily Genauer, in the New York *World-Telegram*, quoted in Mayer, 8.

7. Albright.

8. Unpublished correspondence between Guston and Alan Gruskin, Archives of American Art, Smithsonian, quoted in Shapiro, *Philip Guston: Working Through the Forties*, 6.

9. Ashton, 54, 53.

10. Shapiro, "The Early Years, 1930–1945," in Michael Auping, ed., *Philip Guston: Retrospective* (Fort Worth, TX: Modern Art Museum of Fort Worth; Thames and Hudson, 2003), 26.

11. Shapiro, *Philip Guston: Working Through the Forties*, 5.

12. Picasso's influence on Guston's work is discussed by many scholars. See, for example, H. H. Arnason, *Philip Guston* (New York: Solomon R. Guggenheim Museum, 1962).

13. Jules Langsner, "Permanence and Change in the Art of Lorser Feitelson," *Art International* 7 (September 25, 1963): 73; quoted in Alison de Lima Greene, "The Artist as Performer, Philip Guston's Early Work," *Arts Magazine* (November 1988): 55–56. Greene discusses the significance of Feitelson and postsurrealism on Guston's art.

14. H. W. Janson, "'Martial Memory' by Philip Guston and American Painting Today," *Bulletin of the City Art Museum of St. Louis* 27 (December 1942): 34–41.

15. Jan Butterfield, "A Very Anxious Fix: Philip Guston," *Images and Issues* (Summer 1980): 34.

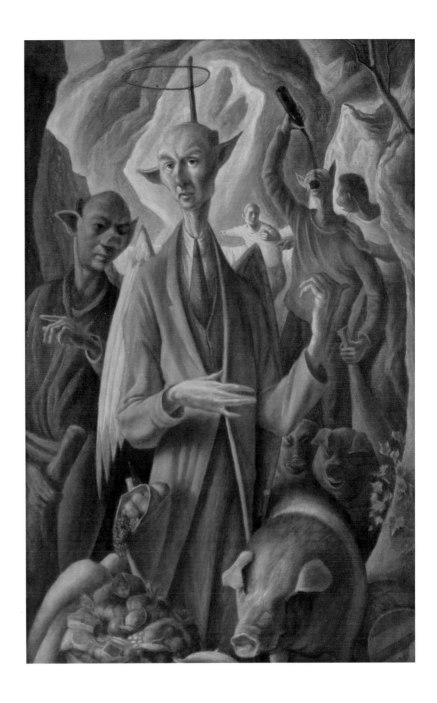

William Ashby McCloy

Fig. 39
William Ashby McCloy (American, 1913–2000)
Spirit of Self Sacrifice, 1943
Oil on Masonite
17 x 11 1/2 in. (43.18 x 29.21 cm)
Gift of the Slater Museum

William Ashby McCloy was a prolific, well-educated artist who, like many other mid-twentieth-century artists with modernist inclinations, is difficult to label. Although McCloy's work is not well known, he was the student and colleague of many famous artists. He studied printmaking with Mauricio Lasansky at the University of Iowa, shared a studio with Grant Wood for a portion of his career, and painted murals with John Steuart Curry at the University of Wisconsin, where he taught from 1939 to 1948.

McCloy's life and career were productive and fascinating. Although he was born in Maryland, he grew up in China. He returned to the United States as a teenager and pursued a thorough education in the arts. After

attending Phillips Academy Andover, he earned his BA in art from the University of Iowa in 1933 and continued his education at the Yale School of Fine Arts. McCloy returned to the University of Iowa, where he earned an MA in the psychology of art in 1936, an MFA in painting in 1949, and a PhD in art history in 1958. His high level of education led to many varied and distinguished employment opportunities: he worked as an assistant professor of art at Drake University from 1937 to 1939; as a clinical psychologist in the United States Army from 1943 to 1946; as director of the School of Art at the University of Manitoba from 1950 to 1954; and as chair of the art department at Connecticut College until his retirement in 1978.[1] McCloy's most valuable role was arguably in Manitoba, where he helped advance the university's art program with the help of other Iowa graduates, and encouraged the appreciation of contemporary art in Winnipeg.

McCloy's art proved to be exciting for his students, who appreciated his openness to a variety of media and styles.[2] He produced paintings, sculpture, prints, drawings, watercolors, and collages throughout his career. He is known for work influenced by both regionalism and surrealism, as is evident in *Spirit of Self Sacrifice* (1943). This painting shows the influence of the regionalist triumvirate: Curry, in its complicated and crowded figural arrangement and color palette; Wood, in the emphasis on symbolism and the use of precise brushstrokes; and Thomas Hart Benton, in the swirling forms in the landscape in the background. The strange, illogical subject matter, however, betrays McCloy's interest in avant-garde artistic movements. Gluttonous figures—bankers and

businessmen with hoglike features— feast on wine, fruit, and meat in an eerie cave setting. This use of symbolism and transformation/ disfiguration demonstrates McCloy's knowledge of figurative surrealism such as that of Salvador Dalí. It also led his art, along with that of some of his colleagues, to be called "the work of perverted minds" years later.[3] McCloy's approach to art is evident in his belief that "it is rather the artist's function to paint, not what he has seen but . . . what can be understood or felt only through seeing. Those who can't understand modern art, and wish to do so, must also get down to work. You will find the effort rewarding."[4] His style is rooted in tradition, yet his creativity led him to pursue a more original, modern, and personal response to art—evident in *Spirit of Self Sacrifice*—which had a lasting impact on his students and colleagues.

Notes

1. The impact he had in Manitoba is evident in the controversy he caused by exhibiting his work, which forced the community to a greater awareness of contemporary art. It is also evident in his students' opinions of him. See John C. Kacere, "Growing Pains in the Arts," *Canadian Art* 9 (1952): 127–128.

2. One student in Winnipeg noted that "McCloy had you look into your subconscious to find shapes which related to yourself, and once you discovered it there was no going back. . . . Everything was possible." Tony Tascona, interview, April 22, 1993, conducted by Dianne Scoles, in Scoles, "Printmaking in the 1950s: School Setting and Dedicated Staff Inspire 1950s Student Printmakers," Gallery One One One, School of Art, University of Manitoba, Winnipeg. http:// www.umanitoba.ca/schools/art/ content/galleryoneoneone/scoles. html. Another Winnipeg student noted that when McCloy and the other American staff arrived, "it was exciting to be around." Frank Mikuska, interview, April 26, 1993, conducted by Scoles, in Scoles.

3. Kacere, 127.

4. William A. McCloy, radio broadcast talk, in Kacere, 127, 128.

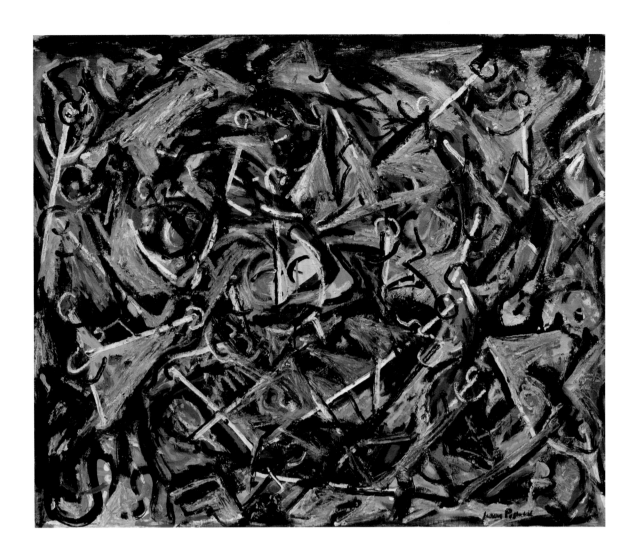

Jackson Pollock

Fig. 40
Jackson Pollock (American, 1912–1956)
Portrait of H.M., 1945
Oil on canvas
36 x 43 in. (91.44 x 109.22 cm)
Gift of Peggy Guggenheim
© 2013 The Pollock-Krasner Foundation /
Artists Rights Society (ARS), New York

Jackson Pollock, perhaps the most famous member of the New York School, is known as much for his difficult personality and the myths surrounding his life and career as for his art. His large-scale "drip" paintings made him especially well known, as did the 1949 *Life* magazine article that brought him into the homes of average Americans, intensifying his celebrity and, consequently, misperceptions about him. As more people tried to learn about the man who may have been "the greatest living painter in the United States," the more they found that Pollock was reluctant to discuss himself and his work. His art, therefore, while praised by critics such as Clement Greenberg, has remained enigmatic—and both fascinating and frustrating for scholars.

While Pollock's drip paintings, created after 1947, are notoriously difficult for the public to understand and interpret, the art he created earlier in his career, which often retained some representational and figurative elements, can be even more perplexing. His *Portrait of H.M.* (1945) is an example. While the title

indicates a portrait, the painting is highly abstract, and the scholarship on it offers few clues as to who "H.M." might be. While there are many theories regarding the subject of this painting, no scholars have discussed the issue at length, and there remains no concrete evidence to confirm H.M.'s identity.

Portrait of H.M. was painted during an important period in Pollock's career, when he first started receiving significant recognition for his work. In 1943 Peggy Guggenheim, owner of the Art of This Century Gallery, gave Pollock a contract with a monthly stipend, an opportunity for more money at the end of the year if his work sold well, a one-person show, and a commission for a painting for her townhouse.[1] By 1945 Pollock was enjoying considerable success. His contract with Guggenheim was renewed for two years, and she supported him with an increased stipend and money for a down payment on a house in Springs, Long Island. Pollock was reviewed favorably at this time. In response to his 1945 one-person show at Guggenheim's gallery, which included *Portrait of H.M.,* Greenberg declared that the exhibition "establishes him, in my opinion, as the strongest painter of his generation and perhaps the greatest one to appear since Miró . . . and he is not afraid to look ugly at first—all profoundly original art looks ugly at first."[2]

Pollock was frequently mentioned in discussions about the formation of a new artistic movement. Many critics and dealers recognized the development of a new style that they believed would be America's contribution to the art world, an original approach combining the influences of surrealism and

expressionism. The gallery owner Howard Putzel said, "Here the new 'ism' found its most effective support among American painters. . . . What counts is that the painters, however respectful, are unimpressed with any idea of becoming 'another Picasso' or 'another Miró,' and that their works indicate genuine talent, enthusiasm and originality. I believe we see real American painting beginning now."[3] Robert M. Coates also noted that "a new school of painting is developing in this country. It is small as yet, no bigger than a baby's fist, but it is noticeable if you get around the galleries much. It partakes a little of Surrealism and still more of Expressionism. . . . It is more emotional than logical in expression, and you may not like it (I don't either, entirely), but it can't escape attention."[4]

The avant-garde influences inherent in this new movement appear in *Portrait of H.M.* and Pollock's other work from the period.[5] After 1940, Pollock rejected the regionalism of his mentor, Thomas Hart Benton, and focused on symbolism and two-dimensionality, revealing the influence of the surrealists, who, along with Pablo Picasso, had the strongest impact on his art.[6] Pollock's enthusiasm for surrealism was largely connected to his interest in Carl Jung's view of myths as unifying stories that are part of the collective unconscious.[7] He was first introduced to Jung's ideas in 1934, and beginning in 1937 he underwent Jungian analysis as part of his treatment for alcoholism. Pollock's interest in myths is evident in many of his paintings, including *Male and Female* (1942–43), *The Moon Woman* (1942), and *The Guardians of the Secret* (1943). *Portrait of H.M.* was painted during a transitional period in Pollock's career when

he was embracing these disparate avant-garde sources, moving toward greater abstraction, and using all-over abstraction consistently, as seen here with the repetitive white lines and triangular shapes that fill the canvas.

Portrait of H.M. was first exhibited in Pollock's spring 1945 Art of This Century show, which left many critics perplexed. A reviewer, Maude Riley, expressed her bewilderment: About *There Were Seven in Eight* (c. 1945), she noted, "What it means, or intends, I've no idea." While she made an attempt to analyze *Totem Lesson 1* (1944) and *Totem Lesson 2* (1945), she admitted, "I really don't get what it's all about."[8] The paintings were, and still are, puzzling; as Pollock famously explained, "I choose to veil the image."[9] *Portrait of H.M.* incorporates his practice of retaining a subject but hiding or disguising it in lines, poles, or skeins of paint.

It is more than just its appearance, however, that makes *Portrait of H.M.* difficult to decipher. Pollock's titles are often ambiguous.[10] His work was not planned out ahead of time through notes and sketches; instead, Pollock, like many other New York School artists, often found his subject as he was painting, rather than before.[11] In addition, any clues, either in the painting or in the scholarship, largely make interpretations more difficult. One article that refers to the work includes the cryptic note, "The Pollock, *Portrait of H.M.* (Iowa), is an early work (1945) and of interest historically," but fails to note what that historical interest is.[12] An intriguing letter from Frank Seiberling, the director of the School of Art at the University of Iowa, to William Lieberman at the Museum of Modern Art in New York, announces, "It is exciting to

learn that you have a lead as to the identity of the mysterious H.M. involved in our small Pollock." Unfortunately, the lead he is referring to is unknown.[13] Lack of evidence has therefore led scholars to suggest numerous identities for H.M., such as Henri Matisse, Herman Melville, Helen Marot, and Herbert Matter. Another interesting possibility is that Pollock was referring to a Balthus work also titled *Portrait of H.M.*, which is a self-portrait. Most of these suggestions deserve careful consideration, as they lead the viewer toward a better though still incomplete understanding of the painting.

One possibility that scholars have not considered before is that H.M. may refer to "Her Majesty" or "His Majesty," connecting *Portrait of H.M.* to the theme of royalty found in many of Pollock's early paintings. In his 1946 show at Art of This Century, for example, Pollock exhibited *The Troubled Queen* (1945) and *The Little King* (c. 1946). Or "Her Majesty" may refer to his wife, Lee Krasner, in honor of her significance to Pollock, especially in 1945, the year they married and moved to Springs.

Another important female figure in Pollock's life, and another possible identity for H.M., is Helen Marot.[14] Marot was a mature woman in her seventies when Pollock met her, but he was apparently drawn to her compassion and intellect. Marot had left years of social activism behind to study psychology, and she encouraged Pollock's interest in psychoanalysis. He may have met Marot in 1934 when he worked as a janitor at the City and Country School, where she was a teacher, or he may have met her through Benton, a good friend of Marot's partner, Carolyn Pratt. Either way,

Marot became an important figure in his life at a time when he needed significant care and support. She was a "substitute mother figure" who was essential "for his need to give and receive feeling."[15] Pollock was known to rely on her for late-night talks, and Marot encouraged him to see the Jungian analyst Dr. Joseph Henderson, which he subsequently did for about a year and a half.[16] In 1938, under the guidance of Marot and his psychiatrist, he entered Westchester Division of New York Hospital for treatment of alcoholism. Their relationship ended with Marot's unexpected death in 1940, five years before Pollock completed *Portrait of H.M.* It should also be noted that the representational forms in the painting do not seem to refer to or resemble Marot in any way, and the larger suggestion of a face to the left of center is clearly that of a man.

A third possible identity for H.M. is Herman Melville, one of Pollock's favorite authors.[17] Pollock owned a copy of *Moby-Dick*, and he named his dog Ahab, after a character in the book. Pollock referred to *Moby-Dick* in several of his other paintings, such as the untitled work known as "Blue (Moby-Dick)" (1943), and *Pasiphaë* (1943) was originally titled *Moby-Dick*. *Guardians of the Secret* also refers to the novel, and both it and *Pasiphaë* include a whale or sea creature. In *Portrait of H.M.,* this and other direct references are lacking. Nevertheless, in her discussion of *Guardians of the Secret*, Elizabeth Lawrence Langhorn notes, "That the secret they are guarding is in fact the unconscious is indicated by the many stick-figures teeming in the central white panel."[18] These stick figures dominate in *Portrait of H.M.* as well, and maritime elements such as suggestions of anchors, triangular shapes that may be sails,

and the use of blue are apparent as well. If Pollock was referring to Melville in his painting, it would certainly confirm Greenberg's notion that the "feeling" of his art is "radically American."[19]

While his initials do not match, Thomas Hart Benton (as "His Majesty") may be a more likely identity for H.M. than is Melville. Pollock's strong relationship with Benton began in 1930 when Pollock moved to New York and began studying at the Art Students League. He took several classes from Benton and remained close to him through the spring of 1935 when Benton left New York. Their friendship continued; Pollock visited Benton on Martha's Vineyard through 1937 and in Missouri for Christmas that same year. Although they spent no significant time together after the late 1930s, they maintained contact through brief meetings, letters, and telephone calls until Pollock's death in 1956.[20]

Despite the differences in their mature styles, Pollock developed as an artist with Benton's help, and his teacher's style and methods greatly influenced his own.[21] In a 1950 interview, Pollock described the importance of Benton in his life: "Tom Benton . . . did a lot for me. He gave me the only formal instruction I ever had, he introduced me to Renaissance art and he gave me a job in the League cafeteria. I'm damn grateful to Tom."[22] Benton was a figural artist who looked to mannerist and baroque masters to create effective compositions, and he planned his work carefully, often using sketches from clay models. His final compositions were always notably curvilinear in design. Many scholars agree that these aspects of the older artist's work are evident

in *Portrait of H.M.*; Henry Adams explained that "even late in his career Pollock's paintings often retain many of the features of Benton's preliminary sketches. The little stick figures scattered over the surface of Pollock's *Portrait of H.M.*, for example, are exactly the same sort of stick figures we find in Benton's early sketches, such as his preliminary studies for *America Today*."[23]

Perhaps the most likely identity of H.M. is Herbert Matter, a graphic designer and photographer, and a close friend of Krasner and Pollock for many years.[24] Matter and Pollock were introduced through Krasner in the early 1940s. Matter and his wife, Mercedes, became very close to Pollock and Krasner, especially during the 1940s. Although the Matters lived in California for three years, from 1943 to 1946, a Christmas card Pollock made for them and the many letters they wrote show that their friendship was not strongly affected by the distance. The correspondence expresses the value they mutually placed on the friendship and the difficulty of being apart.[25] The close relationship between Pollock and Matter has been confirmed by their contemporaries. Willem de Kooning, another member of the New York School, noted that "they were taken with each other— they had a nice feeling between them. They didn't have to talk."[26]

The art historian Ellen Landau says that the artistic relationship between Pollock and Matter was as significant as their personal connection: "Neither Jackson nor Herbert needed words to feel close; as has been newly discovered, theirs was a profound dialogue enacted artistically." They greatly admired each other's work, collecting it when they could. It is undeniable,

however, that Matter's influence over Pollock's career was stronger than the reverse. Matter introduced Pollock to many important figures in the art world, including the artist Alexander Calder and the critic James Johnson Sweeney. He also arranged the interview in *Arts and Architecture* magazine in 1944. Matter's influence on Pollock's art was especially significant. The repetitive stick figures in *Portrait of H.M.*, along with the curving lines that imply motion, for example, demonstrate the influence of Matter's action photography and his use of abstracted figures.[27]

Despite the significance of the Pollock-Matter friendship, there is no confirmation that *Portrait of H.M.* refers to Matter. The most intense portion of their relationship seems to have been after the Matters returned from California in 1946, when the couples visited each other's homes in East Hampton, Matter photographed Krasner's work and the Pollock property, and Pollock and Matter collaborated on a project.[28] Nevertheless, the overall closeness between Pollock and Matter during the 1940s and beyond is undeniable.[29] Every shape and line in *Portrait of H.M.* moves around or points to the suggestion of a man's face, presumably a depiction of H.M., just off center. Was Matter important enough in Pollock's life to earn such a tribute? It seems that, both professionally and personally, he was.
There were many significant men and women in Pollock's life in the mid-1940s, making a decisive reading of *Portrait of H.M.* difficult. Adams offered a reasonable suggestion when he was deciding whether the subject could be either Melville or Marot: "Quite likely it is a tribute to both, and Pollock chose to use initials so that he could symbolically

merge the two figures."[30] While the strongest case could be made for Herbert Matter as the subject of this portrait, the overall ambiguity of Pollock's art suggests that Adams may be right—that "H.M." is not necessarily one person, but a reference to many people who made an impact on his work. This idea, while leaving the interpretation of the painting unresolved, sites *Portrait of H.M.* comfortably within Pollock's complicated *oeuvre*.

Notes

1. The work Pollock created for Guggenheim's town house was *Mural* (1943), also owned by the University of Iowa Museum of Art.

2. Clement Greenberg, "Art," *Nation* (April 7, 1945), 397.

3. Putzel, discussing "A Problem for Critics," his 1945 show of avant-garde art at 67 Gallery that included work by Pollock, Jean Arp, Joan Miró, Pablo Picasso, and Mark Rothko, among others. Edward Alden Jewell quotes Putzel's identification of a new artistic movement. Jewell, "Toward Abstract, Or Away?: 'A Problem for Critics'," *New York Times*, July 1, 1945, 22.

4. Robert M. Coates, "The Art Galleries: Water Colors and Oils," *New Yorker*, May 26, 1945, 67–68.

5. Pollock was open about the effect on American art by progressive European artists, especially those who came to the United States at the start of World War II. For the February 1944 issue of *Arts and Architecture*, he said, "I accept the fact that the important painting of the last hundred years was done in France. American painters have generally missed the point of modern painting from beginning to end. . . . Thus the fact that good European moderns are now here is very important, for they bring with them an understanding of the problems of modern painting. I am particularly impressed with their concept of the source of art being the unconscious." Pollock, in Howard Putzel and Jackson Pollock, "Jackson Pollock," *Arts and Architecture* 61 (February 1944): 14.

6. Joan Miró and many other surrealists exhibited their art in New York, and Picasso's work was well known, especially after his retrospective at the Museum of Modern Art in New York in 1940. Matta was another important surrealist influence. He held gatherings in his home in New York where artists could learn about and discuss advanced European techniques. Other influences on Pollock's work include Vasily Kandinsky, Navajo sand painting, theosophy, Taoism, shamanism, and Friedrich Nietzsche. See Barbara Novak, "Pollock and Olson: Time, Space, and the Activated Bodily Self," in *Voyages of the Self: Pairs, Parallels, and Patterns in American Art and Literature* (New York: Oxford University Press, 2007), 142–146.

7. Interest in Jung developed in the U.S. in the 1930s and 1940s when he lectured at Yale and many of his books were published in English. Many members of the New York School were drawn to Jung's ideas during this time.

8. Maude Riley, "Jackson Pollock," *Art Digest* 19 (April 1, 1945): 59.

9. Krasner, quoting Pollock; quoted in B. H. Friedman, "An Interview with Lee Krasner Pollock," in *Jackson Pollock: Black and White* (New York: Marlborough-Gerson Gallery, 1969), 7.

10. C. L. Wysuph writes that "it seems that when Pollock titles his paintings, the title reflected his interpretation of it after the fact." C. L. Wysuph, *Jackson Pollock: Psychoanalytical Drawings* (New York: Horizon Press, 1970), 25.

11. This is evident in his statement that "I'm a little representational all of the time. But when you're painting out of your unconscious, figures are bound to emerge." Pollock, from Selden Rodman, *Conversations with Artists* (New York: Devin-Adair, 1957), 82; quoted in Wysuph, 22.

12. From Henry R. Hope, "Public Museum News," *Art Journal* 33 (Spring 1974): 266.

13. University of Iowa Museum of Art, Jackson Pollock, *Portrait of H.M.*, object file.

14. B. H. Friedman believes that *Portrait of H.M.* was "probably named for his old friend Helen Marot." Friedman, *Jackson Pollock: Energy Made Visible* (New York: McGraw-Hill, 1972), 76. Steven Naifeh and Gregory White Smith call *Portrait of H.M.* "a veiled reference to Helen Marot." Naifeh and Smith, *Jackson Pollock: An American Saga* (New York: Clarkson N. Potter, 1989), 494.

15. Dr. Henderson, Pollock's analyst, quoted in Wysuph, 17. Pollock took an interest in Jung in the same year that he met Marot, so it is possible that Pollock became interested in him through her.

16. Henry Adams, *Tom and Jack: The Intertwined Lives of Thomas Hart Benton and Jackson Pollock* (New York: Bloomsbury Press, 2009), 232–233.

17. "HM refers to the great 19th century American novelist, Herman Melville, whom Pollock learned about from Benton on Martha's Vineyard." Marianne Berardi, *Thomas Hart Benton: Exhibition of Paintings* (High Falls, NY: Owen Gallery, 2000), 18.

18. See Elizabeth Lawrence Langhorne, "A Jungian Interpretation of Jackson Pollock's Art through 1946," PhD dissertation, University of Michigan; Ann Arbor, MI: University Microfilms International, 1979), 189–191, 203–204.

19. Clement Greenberg, "The Present Prospects of American Painting and Sculpture," *Horizon* (October 1947): 26.

20. O'Connor, *Jackson Pollock*, 22.

21. O'Connor notes that "Benton's teachings are at the core of Pollock's artistic craft. This is a fact which Pollock never denied." O'Connor, "The Genesis of Jackson Pollock: 1912–1943," *Artforum* 5 (May 1967): 18.

22. From "Unframed Space," *New Yorker* (August 5, 1950), 16; quoted in O'Connor, "The Genesis of Jackson Pollock: 1912–1943," 17.

23. Adams, 306. See also Berardi, *Thomas Hart Benton: Exhibition of Paintings*, 16–18.

24. Matter as the possible subject for *Portrait of H.M.* is noted in Francis V. O'Connor and Eugene V. Thaw, *Jackson Pollock: A Catalogue Raisonné of Paintings, Drawings, and Other Works*, vol. 1 (New Haven and London: Yale University Press, 1978), 124.

25. Krasner first met Mercedes Carles, Herbert Matter's future wife, in 1935, when they were both arrested for protesting WPA policies. Mercedes and Herbert Matter married in 1941, and Krasner, a good friend, attended the wedding. Pollock and Krasner started dating in 1941, and Matter met Pollock soon after that, in either 1941 or 1942. Krasner may have brought Pollock to the Matters' home for dinner in 1942, but Matter claims to have met Pollock soon after he had met Krasner, in 1941; Ellen G. Landau, "Action/Re-Action: The Artistic Friendship of Herbert Matter and Jackson Pollock," in *Pollock Matters*, ed. Ellen G. Landau and Claude Cernuschi (Chestnut Hill, MA: McMullen Museum of Art, Boston College; University of Chicago Press, 2007), 19, 21, 39.

26. De Kooning, from James T. Valliere, "De Kooning on Pollock," *Partisan Review* 34 (Fall 1967): 603–605; quoted in Landau, 19.

27. Landau, 40, 18, 25. Landau notes (22–23) the significance of the fact that Herbert Matter introduced Pollock to James Johnson Sweeney since he was one of Peggy Guggenheim's advisors. Sweeney spoke to Guggenheim about Pollock and was the first critic to promote him in print (in 1943, then again in 1944). David Anfam discusses the importance of the action photography exhibition at MOMA in 1943 for Pollock's work. See Anfam, "Pollock Drawing: The Mind's Line," in *No Limits, Just Edges: Jackson Pollock Paintings on Paper*, Susan Davidson, David Anfam, and Margaret Holben Ellis (Berlin: Deutsche Guggenheim; D.A.P, New York, 2005), 32. See Landau, 16, 29–33 for other possible ways in which Matter influenced Pollock's art.

28. See Nancy Cohen, Jeffrey Head, and Michael R. Weil Jr., "Appendix 2: Chronology of the Relationship of the Matters and Pollocks," in *Pollock Matters*, ed. Landau and Cernuschi, 171–78.

29. The closeness of their relationship was especially evident c. 1950, when Krasner had a falling-out with the Matters and Pollock insisted on spending time with them anyway. Landau, 39.

30. Adams, 233.

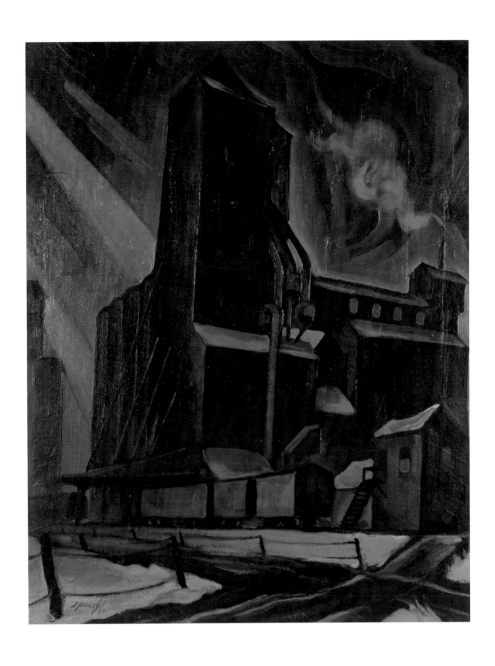

John D. Pusey

Fig. 41
John D. Pusey (American, 1905–1966)
Elevators, c. 1935
Oil on canvas
31 1/2 x 24 3/4 in. (80.01 x 62.87 cm)
On loan from the Federal Art Project of
the Works Progress Administration

John Drake Pusey had a productive and varied career, and he was good friends with the famous regionalist Grant Wood. Nevertheless, very little is known about him. In fact, even his birthplace is debated, with some claiming he was born in Council Bluffs, Iowa, and others, Omaha, Nebraska.[1] He was well educated, having studied at Northwestern University, the Art Institute of Chicago, and the Yale University School of Fine Arts. He continued his studies overseas at the Louvre, the Luxembourg Art Museum, and the Prado. In the 1930s Pusey worked for the Federal Art Project, part of the New Deal Works Progress Administration (WPA) and helped to supervise WPA artists under Wood's direction. He exhibited with the Iowa Art Salon in 1934, and he painted murals in several major cities in the state, including Council Bluffs, Cedar Rapids, Ames, and Des Moines. During this same time he

was commissioned to paint murals for the home of the biomedical researcher Eli Lilly. At the end of the decade he created murals for the San Francisco World's Fair.

Later in his career, Pusey moved to California, where he worked as an assistant art director for Universal Studios, and he designed camouflage for the Army, serving in both World War II and the Korean War. He joined the faculty at Dickinson College in Carlisle, Pennsylvania, as artist-in-residence there from 1957 until 1965, just before he retired as a lieutenant colonel. His continued devotion to the army and a nod to his early career as a mural painter are evident in his World War II mural for the Army War College library.

Like the art of John Tazewell Robertson, another artist represented in this exhibition, Pusey's work captures the American scene. And as with much 1930s art, there is a patriotic overtone to *Elevators* (c.1935)—the buildings, representing American industry, stand tall and strong despite the discouraging conditions surrounding them. *Elevators* also reveals Pusey's penchant for expressionism. He created a dramatic and unnerving mood using intense lighting effects, thick and swirling brushstrokes, and a dark palette. These characteristics, reminiscent of the work of the artist Charles Burchfield, also demonstrate Pusey's desire to break from the traditional mode of WPA painting. A reviewer of Pusey's retrospective exhibition at Dickinson College noted that "the most striking characteristic of the exhibition is that Colonel Pusey's concern for the expressionistic character of art, his methods and techniques of depicting his emotional response to the subject are extremely varied."[2] While he had,

as Grant Wood claimed, "a fresh eye for American material," Pusey also used his experiences abroad and his extensive knowledge of art to separate his work from other midcentury painters of the American scene.[3]

Notes

1. The Museum of Nebraska Art, for example, claims he was born in Omaha, while many other sources argue he was born in Council Bluffs.
2. Hillary Thomas compares him to Burchfield. See Hillary Thomas, "Variety in Expressionism Depicted in Col. Pusey Exhibit," *Dickinsonian*, November 18, 1960, 3.
3. Grant Wood to Professor Albert E. Bailey of Butler University, mid-1930s, University of Iowa Museum of Art, John D. Pusey, *Elevators*, object file.

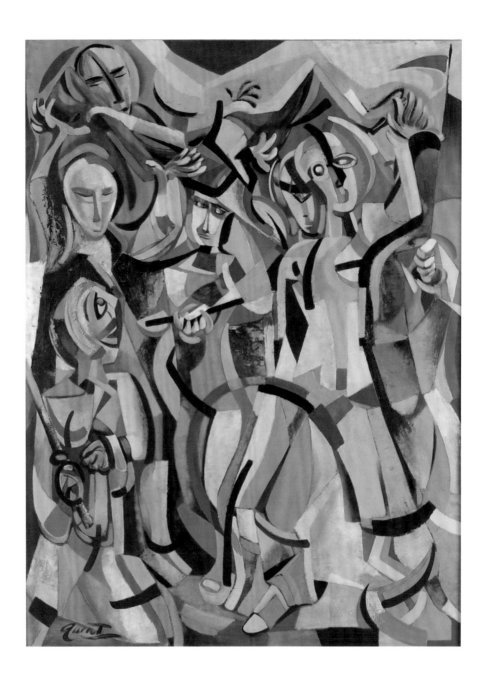

Walter Quirt

Fig. 42
Walter Quirt (American, 1902–1968)
Returned on the Shield, c. 1943
Oil on canvas
39 3/4 x 29 1/2 in. (100.97 x 74.93 cm)
Gift of Roy D. Neuberger
Reproduced with permission from
Andrew Quirt

Walter Quirt began his career as a radical artist, passionate about revealing the injustices faced by African Americans, laborers, and other undervalued members of society. His devotion to Marxist political causes lasted through the 1930s, a decade in which he produced illustrations for left-wing publications and, like many other artists of his generation, found employment with the Works Progress Administration.

Quirt worked as a social realist early in his career, but his art always differed from that of his colleagues. His friend James Guy said, "Both of us had trouble in the [John Reed] Club over the ambiguity of our images since we disagreed with the notion that a socialist or workers' art should be as obvious as a portrait of Lenin or the communist leader Earl Browder raising a clenched fist."[1]

Quirt's art is difficult to characterize in part because of his interest in surrealism. His enthusiasm for the movement began in the early 1930s, making him one of the earliest American artists to embrace its tenets. Like Jackson Pollock, he entered analysis and became fascinated by psychology. He quickly moved from social realism to work as a "social surrealist" (as did O. Louis Guglielmi and James Guy), and became a member of the New York avant-garde. Surrealism gave social-minded artists like Quirt a way to convey their ideas in the progressive manner they desired. In 1942, around the time he painted *Returned on the Shield* (c. 1943), Quirt was still consistently connected with surrealism by critics and compared to the European surrealists.[2]

Nevertheless, his social goals remained clear; as one reviewer noted, "Quirt has more of the reformer in him. He looks at the world at large . . . and if his complicated compositions with their forceful though abstracted characters are not lacking in their measure of Irish wit, his purpose is nonetheless serious. He comes right out and tells you that the world is in a mess, that it probably can be bettered."[3] Ultimately, Quirt was unable to reconcile his interest in surrealism with his social goals; eventually he criticized the movement and abandoned it for abstraction.

Quirt's frequent stylistic changes also make his work difficult to characterize. He admitted that he found it hard to settle on one style, especially in the 1940s amid the turmoil in the world, noting that "time does not exist in its former sense."[4] *Returned on the Shield* is from this turbulent period. It both comments on and rejects the tumult

and hatred of the time. Like others of Quirt's canvases of the early 1940s, it expresses his anger over World War II, evident in the swords and the mortally wounded figure at the top of the composition. The ribbons of color are also typical of his work of this period, as is its dynamism, which reflects the influences of jazz and his good friend Stuart Davis, another prominent New York artist.[5] A reviewer of Quirt's show at the Associated American Artists Gallery in 1943, which included *Returned on the Shield*, noted this transition from gloomy to hopeful in his work: "Where his pictures once were steeped in melancholy, they now bark as joyously as a happy dog."[6]

Quirt's stylistic influences went beyond the surrealists and American friends such as Davis to other members of the European avant-garde. Familiarity with Fernand Léger's figures, bright colors, overlapping geometric forms, and cubist-inspired compositions are all especially evident in *Returned on the Shield*. However, other elements of his work of the early 1940s are more personal and reveal the emergence of his unique style.[7] The curvilinear lines and forms, as well as the allover patterning across the canvas, are a signature aspect. Quirt referred to himself as a "linear artist": he believed in the importance of lines within a composition, arguing that linear expression in art could convey a great deal of information about a society.[8] One of his former students said that "in a typical canvas he would build the volumes of the figure using the simple curve, endow that figure with love and vibrant energy using the complex curve, and give that figure dynamic motion using the aggressive diagonal—all of this from a position of intellectual stability using horizontal and vertical

lines. Sometimes he made all this happen in a matter of minutes."[9] Quirt's primary goal throughout his career remained social. He strove to communicate effectively with a broad audience, using stylistic devices such as caricatures and cartoons, seen here most clearly in the figure on the far left of *Returned on the Shield*.[10] Quirt believed in the powerful relationship between art and society, a subject he wrote about frequently in a series of unpublished essays. He believed in art's ability to reflect what was happening in society and to effect change. He "taught that painting was the transmission of energy and that the energy transmitted could stand for love and was something holy that could transform the world."[11] Quirt used his figures to capture "psychological changes" in American society, and he said that "for every emotion in the people, no matter how obscure . . . there are colors, shapes, forms and art inventions to express them."[12] The power of Quirt's belief in the indelible link between art and humanity allowed him to carry his agenda through social realism to social surrealism, and ultimately to abstraction.

Notes

1. Reminiscence of James Guy, 1977, in Mary Towley Swanson, *Walter Quirt: A Retrospective* (Minneapolis: University Gallery, University of Minnesota, 1979), 12.
2. See D.B., "Three Fantasists: Masson, Quirt, Margo," *Art News* 41 (March 1–14, 1942): 29.
3. Ibid.
4. Walter Quirt, "What Are Artists Afraid Of?," unpublished manuscript, c. 1940, quoted in Swanson, 21.
5. In a review of Quirt's show at Associated American Artists in 1943, one writer noted, "Quirt composes brilliantly with flat interlacing snippets of practically every color in the rainbow. It is as exciting as boogie-woogie though often complicated." "The Passing Shows," *Art News* 42 (April 15–30, 1943): 19.
6. Helen Boswell, "Quirt on the Qui Vive," *Art Digest* 17 (April 1, 1943): 18.
7. Edith Halpert of the Downtown Gallery considered *Returned on the Shield* "an outstanding example of Quirt's work." University of Iowa Museum of Art, Walter Quirt, *Returned on the Shield*, object file.
8. Quirt, excerpt from a letter, June 1959, quoted in Robert M. Coates, *Walter Quirt* (New York: American Federation of Arts, 1960), 17.
9. Reminiscence of Gerald A. Olson, 1979, in Swanson, 14.
10. Swanson, 21.
11. Reminiscence of Eugene Larkin, 1977, in Swanson, 13.
12. Walter Quirt, unpublished manuscript, 1943, reprinted in Swanson, 23.

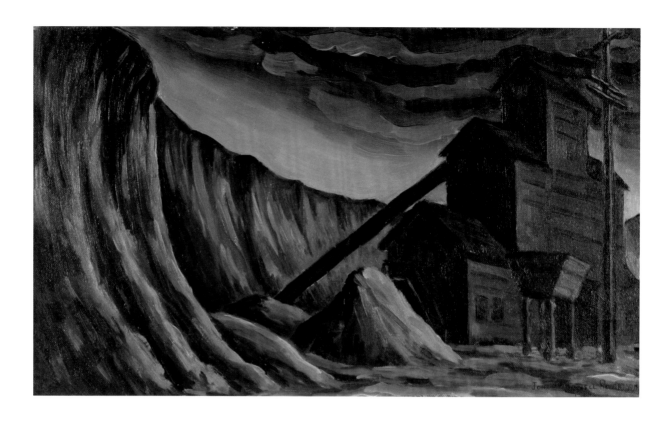

John Tazewell Robertson

Fig. 43
John Tazewell Robertson (American, 1905–1989)
Sand Pits, c. 1935
Oil on panel
12 x 20 in. (30.48 x 50.8 cm)
On loan from the Federal Art Project of the
Works Progress Administration

John Tazewell "Tod" Robertson is an important but understudied artist in the history of American regionalism.[1] Born in New York and later a resident of nearby Millington, New Jersey, Robertson studied at the Art Students League in Manhattan and became involved in the New York art world. He served as treasurer of the Art Students League of New York Club, and worked under Louis Comfort Tiffany at the Tiffany Foundation in the 1920s, receiving the Tiffany Foundation Fellowship in 1933. He was also identified as an Omaha-based artist. He was hired by the Public Works of Art Project (PWAP) in the 1930s, for which he painted murals in Kentucky, Arkansas, Tennessee, several states in the Midwest, and New York.[2] Toward the end of his life, Robertson moved to Florida, where he devoted himself to painting the local landscape.

Robertson is best known for the controversy surrounding his employment with the Nebraska PWAP in the mid-1930s, where he was supervised by the conservative artist Thomas R. Kimball. After Kimball criticized his mural studies, Robertson requested to be traded to the less-traditional PWAP program in Iowa, supervised by Grant Wood.[3] Under Wood he helped to paint murals in Iowa City as well as for the library at Ames Agricultural College. Wood's goals and theories on art proved to be more in line with Robertson's. Wood was influenced by modernist ideas,

especially in his use of simplicity, symbolism, and satire, and he believed that an American school of art was emerging through the talent of midwestern artists and the opportunities created by the PWAP. Insisting on a native expression in the 1930s and 1940s, he stated that "in time, American art will be as different from European art as is American life."[4] A review for a 1935 exhibition of work by New Yorkers at the Roerich Museum agreed with Wood when it referred to Robertson's work as "good Americana."[5]

Robertson's mural *Peach Growing* (1939), created for the Nashville, Arkansas, post office, is an example of his progressive approach to art as well as his dedicated and thorough painting process. After he was hired for the project, he wrote to the superintendent of the U.S. Treasury Department's Section of Painting and Sculpture to say that he had researched Arkansas "folk lore and romantic legend and I should very much like to do something in this vein rather than the conventional depiction of post office routine or historical battle." Robertson hoped to paint the legend of "the Arkansas Traveler" since "the other alternative of eulogizing local industry or agriculture is in my opinion too often done also." When he was asked to choose a peach industry subject instead, Robertson took the change in stride and conducted research by visiting a peach orchard and reading about the growing process.[6] His attempt to break from typical mural conventions demonstrates that, while he was a traditional painter compared to some New York artists who felt drawn to European avant-garde techniques, he pulled away from the conservatism inherent in most regionalist art.

Robertson's *Sand Pits* depicts an ordinary subject—a common site in the American landscape—yet he added visual interest through the loose brushstrokes and overall dark palette, both of which suggest the influence of the Ashcan School. The brushwork, especially in the sky and the sand pits, adds texture, and the swirling strokes in the sky suggest an approaching storm. The painting also reveals the possible influence of Charles Burchfield, a contemporary of Robertson's, through its mundane subject matter and slightly eerie quality.

Notes

1. Robertson's work is in a few public collections, including those of the Joslyn Memorial Art Museum, Omaha; Iowa State University; the University of Nebraska; and the University of Iowa.
2. He worked as an assistant to Reginald Marsh, painting murals of large ships for the Alexander Hamilton Custom House in New York in 1936–37.
3. For more on the controversy and trade, see L. Robert Puschendorf, *Nebraska's Post Office Murals: Born of the Depression, Fostered by the New Deal* (Lincoln: Nebraska Historical Society, 2012), 8–10.
4. Wood's beliefs are discussed briefly in "Omaha Artist Paints Twin 'Old Man River'," *Omaha Bee-News*, April 29, 1934, section A, 2.
5. H.D., "New Yorkers Exhibit," *New York Times*, March 14, 1935, 17.
6. "Nashville Post Office, Nashville, Howard County," Arkansas Historic Preservation Program, http://www.arkansaspreservation. com/historic-properties/_ search_nomination_popup. aspx?id=1153.

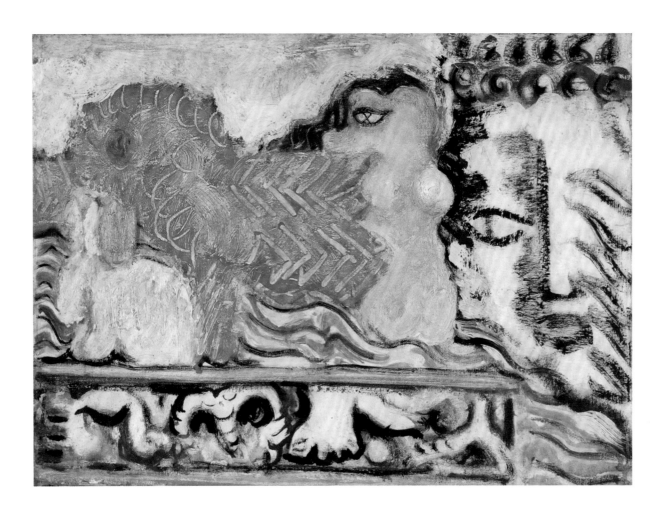

Mark Rothko

Fig. 44
Mark Rothko (American, born in Russia, 1903–1970)
Untitled, 1941–43
Oil on canvas
11 3/4 x 15 13/16 in. (29.85 x 40.164 cm)
Gift of the Mark Rothko Foundation, Inc.
© 1998 Kate Rothko Prizel & Christopher Rothko / Artists Rights Society (ARS), New York

Mark Rothko, a self-defined "myth maker," was a romantic artist devoted to expression, tragedy, and drama. These were consistent and key themes in his art and they are clearly evident in his work during World War II, when he focused on mythological subjects drawn from Greek tragedies. For Rothko, as well as for his New York School colleagues, the war years were a transitional period—each artist had to determine in what way the events of the modern world would affect his or her art and how a response to them could best be expressed through paint. As Rothko worked toward his mature abstract style, he passed through a figurative surrealist period that he believed could unite the world through its universal expression of basic human emotions.[1]

Rothko emigrated from Russia to Portland, Oregon, with his family at age ten, escaping the difficult conditions Jews faced under a czarist regime. He left the West Coast to study at Yale, but abandoned his studies before graduation to start a new life in New York. While he worked briefly with Max Weber at the Art Students League, his keen intellect (and strong interests in literature, music, psychology, and philosophy) and his independent spirit led him to pursue art largely on his own. Landscapes, cityscapes, and figure studies comprised his

early body of work, which was influenced by the simple, flat forms of the work of the artist Milton Avery. Rothko's expressive subway paintings of the 1930s reveal his disdain for regionalism and American Scene painting, the two dominant styles in American art at the time, as well as his knowledge of avant-garde techniques. By the end of the 1930s, Rothko, like many of his contemporaries, called for a new direction in American art.

Rothko's art of the early 1940s was strongly influenced by a New York School colleague, Adolph Gottlieb, by his own devotion to drama, spiritual renewal, and tragedy,

and his developing interest in surrealism.[2] Gottlieb, a close friend and collaborator, shared many of Rothko's ideas on art. They worked together to explain their art, co-writing their famous letter to Edward Alden Jewell at the *New York Times* and participating in a radio broadcast in 1943. For both artists, the subject remained the most important aspect of their art. As they explained in their letter to Jewell: "There is no such thing as good painting about nothing. We assert that the subject is crucial and only that subject matter is valid which is tragic and timeless."[3] Rothko adamantly insisted that his art was realistic, while rejecting the significance of color and form.[4]

Rothko also rejected the abstraction of European modernism, with the exception of the work of the surrealists, whose influence spread throughout the art world during the 1930s and intensified with the arrival of surrealist émigrés at the start of WWII. From 1938 to 1946, Rothko's work showed a strong interest in surrealism and a significant transition. In his hope of creating a universal art, he used surrealism's focus on myth, memories, rituals, and imagination; he and others believed that myths were common symbols uniting all humans.[5] His interest in them first appeared in *Antigone* (1938), a work that closely resembles the UIMA

untitled oil painting (1941–43). Rothko explained the significance of myths in 1943: "They are the eternal symbols upon which we must fall back to express basic psychological ideas. They are the symbols of man's primitive fears and motivations, no matter in which land or what time, changing only in detail but never in substance." "Myth," he later said, "holds us . . . because it expresses to us something real and existing in ourselves." Although he embraced Greco-Roman myths, he understood that the twentieth century was different from the ancient world and that its myths therefore needed to be modernized. He believed, however, that they remained significant in their applicability and universality—especially in their expression of base feelings such as fear, jealousy, and love. In this way, Greek tragedies, characterized by drama and violence, also served as a way to reflect the turmoil of the times.[6]

Familiar with Freud's *Interpretation of Dreams*, James George Frazer's *The Golden Bough*, and Friedrich Nietzsche's *The Birth of Tragedy*, Rothko filled his canvases of the early 1940s with both vague and obvious references to mythology and the ancient world.[7] While the iconography in the painting shown here is not entirely clear, it shares elements from other Rothko paintings from the period, such as the circular forms in the upper right and the assortment of bones, feet, and claws in the bottom left corner. All of Rothko's mythological canvases share a similar organization of space, with compartments for the shapes and forms. This stratification has been said to refer to "godly and earthly realms," divisions inherent in the modern world, geological diagrams, Rothko's interest in evolution, and "Jung's (and Freud's) concept

of the mind as metaphorically divided into horizontal layers."[8] The paintings from this period also share a similar color scheme: drawing imagery from Greek bas-reliefs and Near Eastern friezes, Rothko used white and terracotta to suggest the color of stone.[9]

Rothko's explanation of *The Omen of the Eagle* (1942) could easily apply to this untitled work as well: it addresses "the Spirit of Myth, which is generic to all myths at all times. It involves a pantheism in which man, bird, beast and tree—the known as well as the knowable—merge into a single tragic idea."[10] In Iowa's painting, strange biomorphic shapes dominate the left side of the canvas, along with a rabbit and wavy lines. A classical head presented in both frontal and profile views lines the right side, while bones and limbs in a rectangular compartment run along the bottom edge.[11] The wavy lines may refer to the sea, a common subject in Rothko's work, and the circular forms may be hair. The body parts have been called "godlike" and may watch over the image; as a compartmentalized whole, they refer to ancient friezes.[12] While most of Rothko's mythological paintings do not refer to a specific text, here the rabbit, sacred to the god Artemis, could refer to Aeschylus's *Agamemnon*, the Greek tragedy that is the subject of *The Omen of the Eagle*. In this myth the chorus tells of two eagles killing a hare (seen specifically in his *The Eagle and the Hare* from 1942). David Anfam agrees, and he suggests that the zigzag pattern on "a distorted mass" on the left signifies an eagle from Aeschylus's myth.[13]

Rothko's Iowa painting serves as an important example of his work from the 1940s. Although his art

became more abstract over time, and less rooted in myths, its subject matter and his intentions remained the same. The "exhilarated tragic experience," Rothko's "only source book for art," prevails here as in other canvases.[14] Each well-planned symbol, including the barely formed figures, suggests this theme.[15]

Notes

1. The significance of this period is emphasized in the following quotation: "To understand Rothko—to see his artistic evolution, comprehend his goals and the means he used to realize them, to live his internal struggle to manifest the human soul and chart that manifestation—one need only study the 1940s." Christopher Rothko, "The Decade," in *Mark Rothko: The Decisive Decade, 1940–1950*, ed. Bradford R. Collins (Columbia, SC: Columbia Museum of Art; Skira Rizzoli, New York, 2012), 33.

2. Rothko's interest in drama was evident throughout his life. He joined an acting company in Portland, Oregon, in the 1920s, and in the late 1940s he wrote: "I think of my pictures as dramas; the shapes in the pictures are the performers. They have been created from the need for a group of actors who are able to move dramatically without embarrassment and execute gestures without shame." Mark Rothko, "The Romantics Were Prompted," *Possibilities* (Winter 1947–48): 84.

3. Letter, 1943, written by Rothko and Gottlieb (with additional help by Barnett Newman) to Edward Alden Jewell, published in Jewell, "The Realm of Art: A New Platform and Other Matters: 'Globalism Pops into View'," *New York Times*, June 13, 1943, x9.

4. According to Stephen Polcari, his subject was "the human quest to find permanent meaning in life through spiritual renewal. For Rothko, the continual need for renewal was the tragedy of life." Stephen Polcari, "The Intellectual Roots of Abstract Expressionism: Mark Rothko," *Arts Magazine* 54 (September 1979): 124.

5. Friedrich Nietzsche was particularly influential. He emphasized the significance of myths and their unifying power.

6. Mark Rothko and Adolph Gottlieb, "The Portrait and the Modern Artist," typescript of a broadcast, "Art in New York," Radio WNYC Art, October 13, 1943, reprinted in Tate Gallery, London, *Mark Rothko, 1903–1970* (London: Tate Gallery, 1983), 80. Gottlieb expressed this sentiment (81) for both himself and Rothko in the broadcast: "In times of violence, personal predilections for niceties of color and form seem irrelevant. All primitive expression reveals the constant awareness of powerful forces, the immediate presence of terror and fear, a recognition and acceptance of the brutality of the natural world as well as the eternal insecurity of life. . . . To us an art that glosses over or evades these feelings, is superficial or meaningless."

7. Rothko wrote, in about 1940, "I stopped painting and spent nearly a year developing both in writing and in my studies my ideas concerning Myth"; from a brief note he wrote for a 1945 exhibition, in *Mark Rothko: Writings on Art*, ed. Miguel López-Remiro (New Haven and London: Yale University Press, 2006), quoted in Collins, "Beyond Pessimism: Rothko's Nietzschean Quest, 1940–49," in Collins, ed., *Mark Rothko: The Decisive Decade*, 49. See also Francis M. Celentano, "The Origins and Development of Abstract Expressionism in the United States," MA thesis, New York University, 1957, 45.

8. Dianne Waldman, *Mark Rothko in New York* (New York: Solomon R. Guggenheim Museum, 1994), n.p.; Bonnie Clearwater, *The Rothko Book* (London: Tate, 2006), 42, 44; Polcari, "The Intellectual Roots," 125, 128.

9. Clearwater, 44.

10. Rothko, 1943, written when *Omen of the Eagle* was published in Sidney Janis, *Abstract and Surrealist Art in America* (New York: Reynal and Hitchcock, 1944), 118.

11. David Anfam claims that multiple heads refer to time—past, present, and future—and refer to Titian's work of the mid-sixteenth century; David Anfam, "Rothko in the 1940s—Of Time and Tide," in Collins, ed., *Mark Rothko: The Decisive Decade*, 79. In this painting, however, there is no clear head facing toward the future.

12. Waldman, n.p.

13. David Anfam, "A Note on Rothko's 'The Syrian Bull'," *Burlington Magazine* 139 (September 1997): 630.

14. Mark Rothko, "Personal Statement," in David Porter, *A Painting Prophecy, 1950* (Washington, DC: David Porter Gallery, 1945), n.p.

15. Polcari, 128.

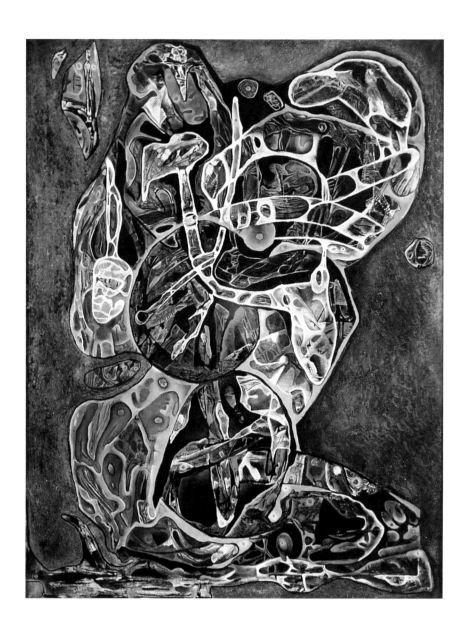

Charles Seliger

Fig. 46
Charles Seliger (American, 1926–2009)
Homage to Erasmus Darwin, 1945–46
Collage, oil on canvas
35 3/4 x 27 3/4 in. (90.81 x 70.49 cm)
Gift of Peggy Guggenheim
© Courtesy of Michael Rosenfeld Gallery
LLC, New York, NY

Charles Seliger is a forgotten member of the first generation of abstract expressionists. Although he was linked with Jackson Pollock, Mark Tobey, and other well-known artists of the period, he has never reached their level of fame, probably because he defied labels. Seliger simultaneously reflected and rejected the ideas of the New York School in his mature style, in which detail, complexity, and intimacy predominate.

Seliger began his artistic career in the late 1930s, working under the influence of impressionism. By the early 1940s he had become interested in cubism and surrealism through his exposure to books on modernism and avant-garde publications, visits to New York galleries and museums, and eventually his friendship with Jimmy Ernst, the son of the Dada and surrealist artist Max Ernst. Seliger gained the attention of the New York art world at an extremely young age, despite his lack of formal artistic training. By age sixteen he was exhibiting his work and astounding critics and dealers with his talent, and

by age twenty-two he had had his first major museum exhibition. Howard Putzel provided significant early support by including him in a group show at his 67 Gallery, encouraging Seliger's inclusion in other seminal shows, helping him get an important commission, and becoming his official dealer in 1944. By this time, Seliger was exhibiting his work alongside members of the New York School, and he became fully identified with the artists now known as the abstract expressionists. In 1945, Peggy Guggenheim, owner of Art of This Century Gallery, who called Seliger "the baby of the gallery," became his dealer and gave him his first one-person exhibition.[1]

As a resident of New Jersey rather than New York, however, Seliger maintained a distance from the artists he exhibited with—artists who were in fact at least a decade or two older. Seliger was also set apart in his style. His brushstrokes were precise, far different from the loose brushstrokes of most of the other abstract expressionists. He also departed from his colleagues in his devotion to natural forms. Most significant, Seliger worked on a small scale, which for him was the only way to create intimate and personal works of art. While his colleagues created canvases that enveloped the viewer and overwhelmed them with emotions, the effect of Seliger's paintings was intellectual; they dominated in their details rather than their size. Seliger explained that for him, being an abstract expressionist "was never an emotional statement, but a means to elicit and release forms that relate to a timelessness—as if to restate primeval beginnings and an awareness of nature's eternal structure of change and metamorphosis."[2]

Seliger's interest in surrealism set him further apart from his colleagues. His knowledge of the movement developed early when he was exposed to the writings of Jung and Freud through the volumes in his uncle's library. He adopted automatism, the surrealist technique of "automatic" writing and drawing, in 1943. While many early abstract expressionists used this technique, Seliger's interest in surrealism continued throughout his career, long after most progressive American artists had abandoned it. Seliger noted this distinction when he explained that "I wanted to examine it, I wanted to focus it, to detail it, to study its potential images. I carried the Abstract Expressionist idea into another area."[3] Automatism allowed him to develop his mature style. Through it, natural forms—similar to the organisms and organic shapes that appeared in the work of the surrealists he admired, such as Joan Miró and Roberto Matta—emerged from his canvases spontaneously. After this initial step, Seliger worked with the forms to alter and define them, and create personal artistic statements.

Seliger's method consisted of applying layers of paint with brushes, knives, or other tools. These layers were then scraped or sanded away to reveal the images and effects underneath, and then more paint was applied and lines were scraped into the surface. This time-consuming process, which often took longer than a month, resulted in thick layers of paint built up over time. Seliger noted that "in a way, I am bringing out an earlier history of the painting and an earlier memory or thought. My paintings are a form of excavation . . . like stones in the earth are a form of memory of the physical history of the earth."[4] At the end, he defined forms and added details using fine

brushes, pencils, or pens. Seliger used this building-up/scraping-down process throughout his career.

Despite the consistency of Seliger's method, every work he created is unique because of his emphasis on detail and texture. Each painting encourages close looking through its multitude of forms and lines. Contradiction also keeps his work interesting: his paintings are about structure, yet they seem to change right before the viewer's eyes; they are filled with both rich color and delicate lines; they include nonrepresentational imagery, yet often seem recognizable.[5]

Seliger's overall aim was to make visible to viewers those aspects of nature they cannot see. Rather than painting specific forms, however, Seliger depicted shapes inspired by nature, especially those elements that are not visible without a microscope: cell- and amoeba-like forms, geological fragments, and anatomical systems. He worked to organize and compartmentalize these elements, focusing on their structure and rich color. Seliger explained the purpose of his work for the important 1945 exhibition Personal Statement: Painting Prophecy, 1950: "I want to apostrophize micro-reality. I want to tear the skin from life, and, peering closely, to paint what I see. I want my brain to become a magnifying lens for the infinite minutiae forming reality. Growth is the poetry of all art."[6]

Homage to Erasmus Darwin (1945–46) demonstrates the emergence of Seliger's artistic style and philosophy during the 1940s. While the work is set apart from his mature style in several ways—the figure-ground relationship is maintained, something he'd eventually move

beyond, and it is larger than most of his other paintings—it effectively demonstrates Seliger's dedication to detail, intricacy, and abstractions derived from nature. It also highlights Seliger as an intellectual with many interests. Discussing his work of the mid-1940s, Seliger said that he "began reading the writings of great naturalists, Thoreau, John Burroughs, W. H. Hudson, J. H. Fabre, along with physicists, Einstein, Heisenberg and Schrodinger. Reading their words stirred my imagination with new images and increased meditations on nature's timelessness."[7] Erasmus Darwin was therefore a logical subject. Erasmus, the grandfather of Charles Darwin, was an English physician, a natural philosopher, physiologist, poet, and much more. Despite the level of abstraction seen in *Homage to Erasmus Darwin*, the subject is still visible in this early work. A figure with a raised hand, holding what may be a knife, and animal forms refer to Erasmus Darwin as both a physician and a scientist with a theory of biological evolution.

Despite his failure to achieve the same fame as his New York School colleagues, Seliger received recognition from many of the leading figures of the day, even winning the admiration of André Breton.[8] When *Homage to Erasmus Darwin* was included in the Art of This Century exhibit Charles Seliger, in 1946, Jean-Paul Sartre, whom Seliger had met on a bus that same year, went to view his work. Sartre told Peggy Guggenheim that he especially liked its organic, delicate qualities.[9] Seliger's paintings continue to be appealing decades later, in part because although they emerged out of a free and spontaneous act, they show evidence of laborious effort and close observation. They

demonstrate the endless adaptability of surrealism—artists like Seliger could take what they wanted from it and discard the rest. They also reveal the development of a unique style linked to, but set apart from, one of the most famous movements in American art.

Notes

1. Guggenheim, interview, April 4, 1978, quoted in Melvin Paul Lader, "Peggy Guggenheim's Art of This Century: The Surrealist Milieu and the American Avant-Garde, 1942–1947" (PhD dissertation, University of Delaware, 1981), 311.
2. Seliger's journal, November 12, 1989, quoted in Francis V. O'Connor, *Charles Seliger: Redefining Abstract Expressionism* (Manchester, VT: Windsor Books; Hudson Hills, 2002), 86. Many scholars note the differences between Seliger and the other abstract expressionists, and the artist himself emphasizes the distinctions in his personal writing.
3. Seliger, quoted in Sam Hunter, *Charles Seliger: Biomorphic Drawings, 1944–1947* (New York: Michael Rosenfeld Gallery, 1997), 3.
4. Seliger, interview with Michelle DuBois, June 20, 2007, quoted in Michelle DuBois, *Charles Seliger: Ways of Nature* (New York: Michael Rosenfeld Gallery, 2008), 11.
5. Many scholars note this visual interest; see, for instance, John Yau, "Charles Seliger and His Syncretic Abstraction," in *Charles Seliger: Chaos to Complexity* (New York: Michael Rosenfeld Gallery, 2003), 3–7. Yau (7) also discusses the significance

of surrealism. "My paintings are always concerned with the most minute relationships and structure yet always remain in flux, in a state of becoming, never (in spite of the intensity and detail) to arrive at a final and recognizable form"; Seliger's journal, December 1, 1980, quoted in Jonathan Stuhlman, *Seeing the World Within: Charles Seliger in the 1940s* (Charlotte, NC: Mint Museum of Art, 2012), 46.
6. Seliger, in David Porter, *Personal Statement: Painting Prophecy, 1950* (Washington: Gallery Press, 1945), n.p.
7. Seliger, interview with Halley K. Harrisburg in 1999, quoted in Halley K. Harrisburg, *Charles Seliger: The Nascent Image: Recent Paintings*, March 11–May 1, 1999 (New York: Michael Rosenfeld Gallery, 1999), 5.
8. Lader, 310–311.
9. O'Connor, 40.

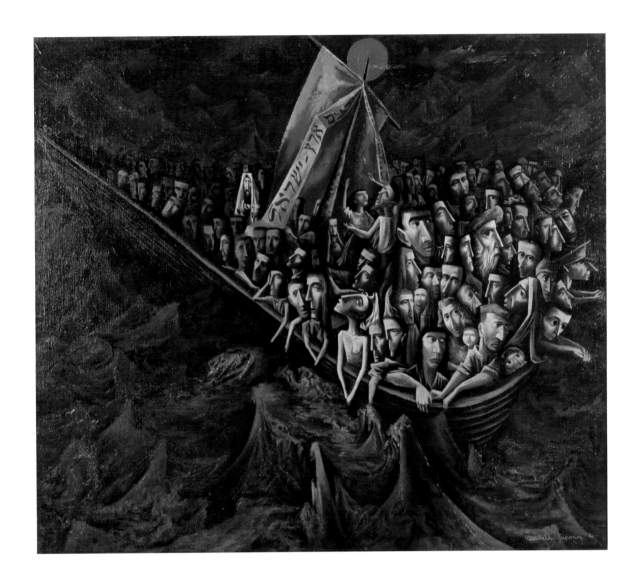

Mitchell Siporin

Fig. 47
Mitchell Siporin (American, 1910–1976)
Endless Voyage, 1946
Oil on canvas
43 3/4 x 48 3/4 in. (111.13 x 123.83 cm)
Museum purchase
Courtesy of the Estate of the Artist and
the Susan Teller Gallery, NY, NY

Endless Voyage (1946) serves as both a summation of Mitchell Siporin's career and a telling portrayal of one specific period in world history. Siporin was a Chicago-based artist, a son of immigrants, who used his past and his passion to express in his art his feelings regarding the oppressed. He was considered a radical in his day, writing for magazines such as the left-wing publication *New Masses*, and serving as a member of the John Reed Club, a Communist-affiliated organization that attracted many liberal artists and writers in the 1930s. In his early career he was best known for his series of drawings based on the Chicago Haymarket Riot of 1886, a symbol of the historical struggle for workers' rights, and for the murals he painted as an employee of the Works Progress Administration's Federal Art Project. His art was inspired by the neglected and mistreated members of society—those suffering under abusive conditions or devastated by the depression.

In the 1940s, Siporin's devotion to social themes continued, but shifted to those affected by World War II.

After he returned from serving in the army in 1945, Siporin created several works of art based on his experiences in North Africa and Italy, including *Endless Voyage*, which the artist considered one of his most important postwar paintings and one of his "strongest social expressions."[1] The Guggenheim Fellowships he won in 1945 and 1946 allowed him to reflect on his time in the war and to consider the best way to respond to the events he witnessed. Siporin concentrated on capturing the human, and specifically Jewish, experience. In *Endless Voyage* he painted Jewish refugees on a boat with a sail that reads "Land of Israel." They are most likely emigrants who were turned away from Palestine, and the scene may have been inspired by Siporin's return voyage from Italy with troops during the war.[2] His image developed an even more powerful meaning the year after the work was completed, when a refugee ship carrying Jewish Holocaust survivors from France to Palestine, known as *Exodus 1947*, was intercepted by the British, returned to France, and eventually sent to Hamburg, where the passengers were sent to camps for the displaced.[3]

While Siporin was known as a social realist in the 1930s, keeping company with other notable artists such as Ben Shahn and Jack Levine early in his career, he soon fell under the influence of modernism.[4] In *Endless Voyage*, a mass of figures—mostly men—fills a teardrop-shaped boat sailing in choppy water. The passengers are in the dark with no land in sight. The children, such as the small one at the back of the boat, and the women carrying babies add a sense of urgency. Details like the thin male passenger with exposed ribs, the faces with a sickly, greenish yellow hue, and the numbers tattooed on the refugees' arms convey this as well. The figures are expressive and their facial features exaggerated, revealing Siporin's early use of caricature. They reach out their hands as if to beg for acceptance, let their limbs and faces sag in hopelessness, and hold their hands to their faces in horror. Their bodies and the waves are angular, recalling the work of the German expressionist Ernst Ludwig Kirchner, while the faces at the front of the boat, faded, obscure, and masklike, suggest the work of Emil Nolde, another expressionist.

A famous art historian, John Baur, referred to Siporin's style as "humanistic expressionism," yet the overall eerie quality of the scene also indicates the influence of surrealism, which one critic seemed to suggest when she referred to the artist's figures as "puppets" and "paper dolls," and noted that his work is "removed from the real."[5] The figures are a strange collection of heads of various sizes, grouped together in a collagelike fashion. During the war and after, surrealism helped Siporin create bleak environments for his figures, as well as convey the effects of anti-Semitism upon them.

Refugees are a common theme in Siporin's work. Born to immigrant parents in New York, he could express his own understanding of displacement in these canvases. Bram Dijkstra emphasizes the diversity of the figures in *Endless Voyage*, yet notes that they are "all thrown together by a common fate—and united by the unreasoning hatred of others."[6] In this way, Siporin was able to capture a broad Jewish experience, including his own, during a period of strong racism and anti-Semitism in the United States. Siporin's wartime compositions are a mix of memories, personal reactions, and symbols. They are modern in their use of progressive styles, yet they stay rooted in the past in their devotion to capturing the human condition, a task so important to artists in the 1930s. An article in *Fortune* magazine devoted to *Endless Voyage* expresses the importance of the painting and its lingering power: this work "set forth not a statement but a question—a question that echoes and re-echoes in the ear of all mankind; that is wordless, but thunders."[7] The question, regarding the destiny of mankind, absorbed Siporin, occupying his art from his early days to the last decades of his career, when he became an important teacher and the founder of the Department of Fine Arts at Brandeis University.

Notes

1. Andrew Hemingway, *Artists on the Left: American Artists and the Communist Movement, 1926–1956* (New Haven and London: Yale University Press, 2002), 233; Siporin to Deborah Calkins, January 7, 1955 (AAA), quoted in Hemingway, *Artists on the Left*, 235.

2. Ibid. Siporin noted that "it took a troop ship back from Italy to make me feel what a wooden tub headed for Israel in the night would feel [like]." Quoted in Judith Hansen O'Toole, *Mitchell Siporin: The Early Years, 1930–1950* (New York: Babcock Galleries, 1990), n.p.

3. Hemingway, *Artists on the Left*, 235.

4. Siporin was nevertheless ambivalent toward modernism. Regarding the relationship between left-wing artists and modernism, Siporin noted: "We are part of this movement, and still at war with it." Hemingway, *Artists on the Left*, 160.

5. John I. H. Baur, *Revolution and Tradition in Modern American Art* (Cambridge: Harvard University Press, 1954), 45; Marion Summers, "Art Today" *Daily Worker* 23 (October 3, 1946): 11; and Marion Summers, "Art Today," *Daily Worker* 23 (May 15, 1946): 12.

6. Bram Dijkstra, *American Expressionism: Art and Social Change, 1920–1950* (New York: Abrams, 2003), 156.

7. *Fortune* 34, no. 6 (December 1946): 170.

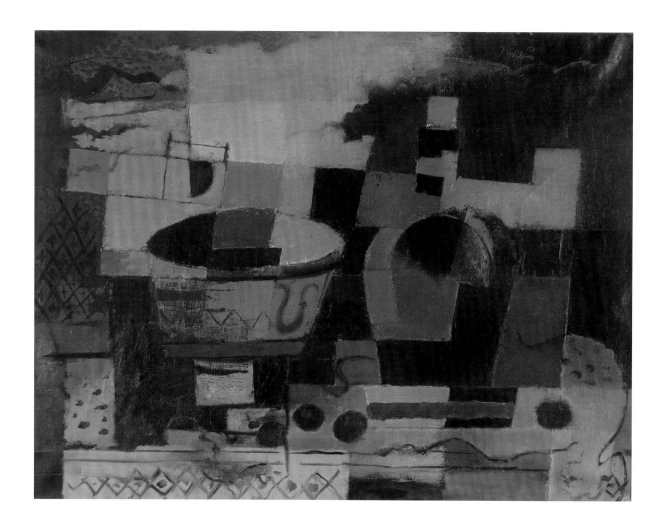

Bradley Walker Tomlin

Fig. 48
Bradley Walker Tomlin (American, 1899–1953)
Still Life, 1940
Oil on canvas
22 x 28 3/4 in. (55.88 x 73.03 cm)
Mark Ranney Memorial Fund

Bradley Walker Tomlin, a member of the New York School, is not as well known or as celebrated as his colleagues and friends such as Jackson Pollock, Adolph Gottlieb, and Robert Motherwell. While this can be explained by his relatively small body of work and his early death at age fifty-three, his lack of recognition is unfortunate. His career, exemplary of that of the American artist of the mid-twentieth century, was characterized by a devotion to experimentation, the absorption of avant-garde ideas from Europe, and a search for originality.

Tomlin demonstrated an early interest in art, and after majoring in painting at Syracuse University, he moved to New York City to pursue his career. He supported himself throughout the 1920s with private portrait commissions, commercial work, and designs for magazine covers, and furthered his education at the Louis Comfort Tiffany Foundation on Long Island. Tomlin went to Europe three times during the decade and again in 1934, spending most of his time in Paris. Like many other artists, he suffered financially during the 1930s

and, unable to sell his work, earned money by teaching at Sarah Lawrence College and two private preparatory schools in New York City.

In the late 1930s and early 1940s, Tomlin developed an interest in cubism and surrealism, moving away from his representational work toward European avant-garde styles. Sources suggest that Tomlin saw the famous Fantastic Art, Dada, Surrealism exhibition in 1936–37 at the Museum of Modern Art in New York; a friend of his claims that this show was responsible for an abrupt change in Tomlin's work during a period in which he burned many of his early, more traditional paintings.[1] The influence of cubism and surrealism on Tomlin's work culminated in the still lifes he created between 1939 and 1945, before he abandoned figuration altogether and joined the New York School artists. These paintings are all variations of a cubist grid interspersed with a strange, surrealist assortment of objects, figures, and symbols. Drawing ideas from Georges Braque and other synthetic cubists, Tomlin emphasized the two-dimensionality of the canvas and experimented with signature cubist techniques such as lettering. While he borrowed aspects of European styles, he absorbed and processed them fully in order to create something personal—what has been called "a soft elegant version" of the early twentieth-century cubist still life.[2] The early 1940s were an important period in Tomlin's career, marking both a transition in his style and, after exhibitions at several major museums, a newfound respect for his work.

The foremost Tomlin scholar, Jeanne Chenault, believes that some of the paintings from this period are "among his finest achievements."[3]

Still Life (1940) is a typical example, yet it is also set apart. While most of Tomlin's cubist still lifes maintain some representational forms, Still Life avoids them, and, with only a suggestion of a bowl-like shape, embraces greater abstraction. Symbols and patterns take precedence. John Baur argues that the formal aspects of Tomlin's cubist phase are overshadowed by the symbolism within the works, and notes that "his designs have an evanescent, melting quality, often dissolving into a dreamlike poetry."[4] While this "evanescence" is evident along the top of Still Life, Tomlin's reliance on synthetic cubism remains obvious here through his focus on rich color and the flat, decorative aspects of the geometry, diamond patterns, and dots of paint.

Tomlin's cubist still lifes were painted during World War II. While Still Life makes no direct reference to the war, others of his still lifes do.[5] Nevertheless, Tomlin's move away from figuration and the cubist grid toward complete abstraction after 1945 indicates that, like many other artists of the time, he felt the impact of the events of the 1930s and 1940s, and they eventually led to a complete departure from his previous work. Despite this final, abrupt change in direction, Tomlin remained true to his artistic process, painting slowly and mindfully and continuing to incorporate avant-garde ideas into his work.[6] Tomlin's devotion to his art through each experimental phase of his career is evident in his belief that "one can believe in paintings, as one can believe in miracles, for paintings, like miracles, possess an inner logic which is inescapable."[7]

Notes

1. Christopher B. Miller and Nancy E. Miller, "Speaking of Tomlin," *Art Journal* 39 (Winter 1979–1980): 113; and Jeanne Chenault, *Bradley Walker Tomlin: A Retrospective View* (Garden City, NY: Whaler Press, 1975): 15.

2. Chenault, *Bradley Walker Tomlin*, 16. Chenault argues that "extremely selective about what he borrowed, from 1939 on Tomlin achieved a complete assimilation of influences and originality. With the cubist-surrealist paintings of 1939–1945, his mode became both distinguished and distinctive." Jeanne Chenault, "Bradley Walker Tomlin: A Painter's Painter" *Arts Magazine* 49 (April 1975): 68.

3. Chenault, "Bradley Walker Tomlin," 67.

4. John I. H. Baur, *Bradley Walker Tomlin* (New York: Whitney Museum of American Art, 1957): 25.

5. *To the Sea* was his response to submarine sinkings during the war.

6. Many scholars have noted Tomlin's slow artistic process. One writer noted that he "paints slowly, with fidelity to a personal vision and an insistence upon the just and unified relation of all parts of his composition and a homogeneity of rhythm and mood." "Bradley Walker Tomlin," *Magazine of Art* 42 (May 1949): 184.

7. Tomlin, quoted in Baur, 15.

Max Weber

Fig. 49
Max Weber (American, 1881–1961)
Exotic Dance, 1940
Oil on canvas
30 x 40 1/4 in. (76.2 x 102.24 cm)
Gift of Mr. and Mrs. James Schramm

Max Weber, known as the "dean of American Moderns," dedicated his long career to experimentation and artistic freedom, thereby challenging the status quo. After spending several years as a young student in Paris in the first decade of the twentieth century, absorbing the avant-garde European styles popular at the time, he returned home to find the United States unprepared for these advanced ideas and techniques. As Weber explained it, "I came back to America, was kicked around for a quarter of a century."[1] He was fortunate to find the support of artistic visionaries such as Alfred Stieglitz and Hamilton Easter Field, but most critics and dealers found his work too progressive. While it took decades for his significance to be recognized by the art world, Weber always remained true to his artistic goals and philosophy, and he eventually became an important role model for many American modernists.

Weber rarely traveled outside of the United States after his early journey abroad, but the influence of advanced European styles on his work is undeniable. Henri Rousseau was a major influence—he convinced Weber to stay rooted in nature and to emphasize freedom and purity in his

work. Henri Matisse's expressive use of color, Paul Cézanne's sculptural figures, and the fragmentation and dynamism of cubism and futurism also had important and lasting impacts. Arthur Wesley Dow, Weber's instructor at the Pratt Institute in New York, supported his progressive ideas regarding color, composition, and design.

Weber maintained his own personal style throughout his career, adding, as one writer noted, "human warmth" to his unique response to advanced European artistic styles.[2] While other members of the early American avant-garde pursued nonobjective compositions, Weber's work was consistently representational. He produced landscapes, still lifes, and city scenes, but his figurative work comprised one of the largest portions of his *oeuvre*. These paintings often depict genre scenes—images of people engaged in everyday activities such as reading, studying, and playing music.

Dancing and the female nude were two other subjects that Weber explored from the beginning of his career. His female nudes, which he depicted in a variety of media, including paintings, sculpture, lithographs, and woodcuts, were portrayed both alone and in groups, often in sensual poses, fragmented or solid, active or static, traditional or abstracted—but always expressive. *Exotic Dance* (1940) demonstrates Weber's dedication to these two subjects as well as his highly personal and progressive style. This painting depicts six nude women dancing in a circle against a background of primary colors. Distorted yet graceful, their bodies are simplified and heavily abstracted, and they depart from the formerly Cezanne-esque, sculptural bodies Weber

painted early in his career. The unique qualities of this work rang true for one contemporary reviewer, who noted that "if the brutal *Exotic Dance . . .* reminds you of the Matisse *La Danse*, it is merely the compositional arabesques which are similar: the glowing, yet cruel, color and the pathos of the distorted figures make the Fauves look mild."[3]

Weber's use of primary colors in *Exotic Dance* adds intensity to the scene, and for him color was extremely personal. Weber was born in Bialystok, Russia, a textile manufacturing town where his grandfather mixed dyes for a living and his father worked as a tailor. Weber's use of color may have been influenced not only by these dyes but by the Byzantine art and religious ceremonies with colorful costumes he saw as a child in Brooklyn. As Alfred Werner wrote, "From the temple where young Max sang, some of the mysterious half-light, the red velvet and gold in which the Scrolls of the Law were draped, and the fresh blue striping of the prayer shawls found their way into the colors on his canvases."[4]

Dance allowed Weber to explore several themes in his work, including religion, popular entertainment, and human movement. His interest in painting abstracted figures in motion is evident in many paintings, such as *Hasidic Dance* (1940) and *The Acrobats* (1946), but the movement in *Exotic Dance* is especially vigorous, leading one contemporary reviewer to note that "Weber's people always move about—and usually toward you. In his *Exotic Dance*, a half-dozen Martian-looking abstract creatures speed around and around in mad ecstasy." The prominent art historian Lloyd Goodrich commented on this aspect of the work as well: "Its

content is pure motion, violent, savage, unbridled." The use of thin, black, curving lines along with painterly slashes in the background increases the dynamism of the scene. The energy dictated by the lines also suggests that the dancers may be spurred on by musical accompaniment. Weber's intent to convey vitality in *Exotic Dance* is evident in his process as well; while he often worked quickly, this canvas took several weeks of effort with significant painting and repainting to capture the effect of intense motion.[5]

Although *Exotic Dance* foreshadows Weber's style in other paintings of the 1940s, especially in its expressionist focus on color, line, motion, and emotion, it is set apart in its overall ambiguity. Unlike his religious images or depictions of figures reading, this painting leads the viewer to ask, Why are these figures dancing? What is "exotic" about the dance? These questions can be answered by considering Weber's interest in spirituality and different cultures. Spirituality was a common theme in his work, in both his images of Jewish life and his secular scenes. In *Exotic Dance*, Weber used dancing as a spiritual act, a practice common to many cultures.[6] His insistence upon learning from and honoring the artistic traditions of all cultures and societies may have inspired the "exotic" in his title, and is also reflected in the titles of works such as *Mexican Statuette* (1910), *The Egyptian Pot* (1917), and *Still Life with Chinese Pot* (1925).

Weber's interest in capturing this simple scene of nudes dancing may have been his way of responding to the war-torn period of the early 1940s. In a catalogue for a 1958 exhibition of his work at the Downtown Gallery, in which *Exotic*

Dance was included, Jerome Klein calls Weber's work from the 1940s "turbulent designs" and remarks that all of his figurative work "remains fraught with the anguish of our time."[7] Indeed, his many images of orthodox Jews and their traditions, as well as his canvases that refer to war and persecution, show that Weber had a strong reaction to world events. Percy North wrote that *Exotic Dance* serves as a "symbol of the freedom of the spirit."[8] The themes of freedom addressed in this painting would have been especially significant during World War II, when the mistreatment of and restrictions against humanity were particularly pervasive.

Notes

1. Max Weber, "An Artist Must Be a Practical Dreamer," *Friday*, May 2, 1941, 20.

2. Doris Brian, "Last Word on Weber," *Art News* 42 (February 1–14, 1944): 19.

3. Doris Brian, "E Pluribus Weber," *Art News* 40 (February 15–28, 1941): 38.

4. Alfred Werner, *Max Weber* (New York: Harry N. Abrams, 1975): 26, 29.

5. Elizabeth Sacaratoff, "Max Weber's Show Is Important and Moving," *PM's Weekly*, February 16, 1941. Lloyd Goodrich, *Max Weber: Retrospective Exhibition* (New York: Whitney Museum of American Art, 1949), 51, 54.

6. Weber's belief in the spiritual aspect of art is evident in his statement that "art has a higher purpose than the mere imitation of nature. It transcends the earthly and measurable. It has its own scale and destiny. It is concerned with the informing spirit that emanates only from spiritual and mystical realms, from the nether and astral. A work may be ever so anatomically incorrect or 'distorted' and still be endowed with the miraculous and indescribable element of beauty that thrills the discerning spectator." Max Weber, "Distortion in Modern Art," *The League (Art Students League)* 6, no. 2, New York, 1934, n.p.; quoted in Avram Kampf, *Chagall to Kitaj: Jewish Experience in Twentieth Century Art* (New York: Praeger Publishers, 1990; in association with Barbican Art Gallery, London), 142, 144.

7. Jerome Klein, *Max Weber: The Figure in Retrospect, 1906–1958* (New York: Downtown Gallery, 1958), n.p.

8. Percy North, *Max Weber: American Modern* (New York: Jewish Museum, 1982), 42.

Exhibition List

Ansel Adams

Ivan Le Lorraine Albright

Lee Allen

Milton Avery

Sally Michel Avery

Will Barnet

Thomas Hart Benton

P. L. (Leon) Bibel

Byron Browne

Paul Cadmus

Alexander Calder

Federico Castellon

George Z. Constant

Carlotta Corpron

Richard V. Correll

John Steuart Curry

Stuart Davis

John S. De Martelly

Stevan Dohanos

Eve Drewelowe

Werner Drewes

Marcel Duchamp

Mabel Dwight

Matta

Fritz Eichenberg

Max Ernst

Walker Evans

Ralph Fabri

Sue Fuller

Minetta Good

Philip Guston

Robert Gwathmey

Amelia Hammer

Hananiah Harari

Rosella Hartman

Stanley William Hayter

Albert W. Heckman

John P. Heins

Alexandre Hogue

Frederick Kiesler

Yasuo Kuniyoshi

Mauricio Lasansky

Joseph Leboit

Nathan Lerner

Helen Levitt

Russell Limbach

Jacques Lipchitz

George Platt Lynes

Loren MacIver

Boris Margo

Kyra Markham

Jack Markow

André Masson

William Ashby McCloy

Elizabeth Olds

Irene Rice Pereira

Gabor Peterdi

Genoi Pettit

Lil Picard

Jackson Pollock

John D. Pusey

Walter Quirt

Mildred Rackley

Robert Riggs

Grace Rivet (Clements)

John Tazewell Robertson

Theodore Roszak

Mark Rothko

Anne Ryan

Louis Schanker

Karl Schrag

Charles Seliger

Kurt Seligmann

Mitchell Siporin

G. Ralph Smith

Theodoros Stamos

Ralph Steiner

Harry Sternberg

Hedda Sterne

Bradley Walker Tomlin

Herman Roderick Volz

Hyman Warsager

June Wayne

Max Weber

Grant Wood

Ansel Adams (American, 1902–1984)
The Tetons and the Snake River, Grand Teton National Park, Wyoming, 1942
Gelatin silver
15 1/2 x 19 1/4 in. (39.37 x 48.9 cm)
Museum purchase

Ivan Le Lorraine Albright (American, 1897–1983)
Self-Portrait: 55 Division Street, 1947
Lithograph
Image: 14 1/4 x 10 1/4 in. (36.2 x 26 cm)
Sheet: 16 3/4 x 13 1/4 in. (42.55 x 33.66 cm)
Museum purchase

Lee Allen (American, 1910–2006)
Corn Country, 1937
Oil on Masonite
26 3/8 x 31 1/4 in. (66.99 x 79.38 cm)
Gift of Dr. Clarence Van Epps

Milton Avery (American, 1885–1965)
My Wife Sally, 1934
Drypoint
Image: 5 1/2 x 8 1/4 in. (14 x 21 cm)
Sheet: 13 x 15 in. (33 x 38.1 cm)
Museum purchase

Sally Michel Avery (American, 1903–2003)
Harbor (Gaspé Peninsula), 1938
Watercolor
18 x 24 in. (45.72 x 60.96 cm)
Museum purchase

Will Barnet (American, 1911–2012)
August, 1940
Etching
Image: 9 7/8 x 8 in. (25.1 x 20.3 cm)
Sheet: 15 1/4 x 11 1/2 in. (38.74 x 29.21 cm)
Gift of Mrs. Karl Mattern

Thomas Hart Benton (American, 1889–1975)
I Got a Gal on Sourwood Mountain, 1938
Lithograph
Image: 12 1/2 x 9 1/4 in. (31.8 x 23.5 cm)
Sheet: 16 x 12 in. (40.64 x 30.48 cm)
Gift of F. Arnold Daum

P. L. (Leon) Bibel (American, 1913–1995)
Dancers, 1939
Silkscreen
Image: 14 x 11 in. (35.56 x 27.94 cm)
Sheet: 18 x 12 in. (45.72 x 30.48)
On loan from the Federal Art Project of the Works Progress Administration

Byron Browne (American, 1907–1961)
Woman with Bird, 1942
Oil on canvas
12 x 14 in. (30.48 x 35.56 cm)
Gift of Mrs. Byron Browne

Paul Cadmus (American, 1904–1999)
Coney Island, 1934
Etching
Image: 9 1/4 x 10 1/4 in. (23.6 x 26 cm)
Sheet: 12 3/8 x 13 5/8 in. (31.43 x 34.61 cm)
Museum purchase

Alexander Calder (American, 1898–1976)
Untitled, 1948
Watercolor and pencil
15 1/4 x 23 in. (38.74 x 58.42 cm)
Gift of the Betty Parsons Foundation

Federico Castellon (American, 1914–1971)
By the Arks, 1941
Lithograph
Image: 9 x 12 in. (22.9 x 30.5 cm)
Sheet: 11 3/4 x 16 1/4 in. (29.85 x 41.28 cm)
Edwin. B. Green American Art Acquisition Endowment

George Z. Constant (American, born in Greece, 1892–1978)
Planting Flowers, c. 1937
Etching
Image: 12 x 14 3/4 in. (30.5 x 37.5 cm)
Sheet: 14 5/8 x 17 7/8 in. (37.15 x 45.4 cm)
Gift of the Estate of James Lechay

Carlotta Corpron (American, 1901–1988)
Four Eggs and Hand Sculpture, 1948
Gelatin silver
Image: 13 3/4 x 10 1/2 in. (34.9 x 26.7 cm)
Sheet: 14 x 11 in. (35.56 x 27.94 cm)
Gift of Judith and Stephen Wertheimer

Slinkies, 1945
Gelatin silver
Image: 10 1/2 x 13 3/4 in. (26.7 x 34.9 cm)
Sheet: 11 x 14 in. (27.94 x 35.56 cm)
Gift of Judith and Stephen Wertheimer

Richard V. Correll (American, 1904–1990)
Grazing, 1938
Wood engraving
Image: 8 1/2 x 10 1/2 in. (21.59 x 26.67 cm)
Sheet: 11 15/16 x 15 3/4 in. (30.32 x 40 cm)
On loan from the Federal Art Project of the Works Progress Administration

John Steuart Curry (American, 1897–1946)
Circus Elephants, 1936
Lithograph
Image: 9 x 12 3/4 in. (22.9 x 32.4 cm)
Sheet: 11 7/8 x 16 1/8 in. (30.2 x 40.9 cm)
Museum purchase and partial gift of Dr. and
Mrs. George Cooper IV

Stuart Davis (American, 1892–1964)
Harbor Landscape (Funnel and Smoke), 1939
Lithograph
Image: 9 1/4 x 12 in. (23.50 x 30.48 cm)
Sheet: 12 1/2 x 16 in. (30.16 x 40.96 cm)
On loan from the Federal Art Project of the Works
Progress Administration

John S. De Martelly (American, 1903–1979)
The Evangelist, 1941
Lithograph
Image: 13 1/2 x 9 7/8 in. (34.3 x 25.1 cm)
Sheet: 16 x 11 1/2 in. (40.6 x 29.2 cm)
Edwin. B. Green American Art Acquisition Endowment

Stevan Dohanos (American, 1907–1994)
State Fair, 1948
Wood engraving
Image: 12 3/4 x 9 in. (32.4 x 22.9 cm)
Sheet: 17 1/4 x 13 in. (43.82 x 33.02 cm)
Gift of Mrs. Moselle Meals in honor of Ulfert Wilke

Eve Drewelowe (American, 1899–1988)
Monsieur Poinsett, 1941
Oil on canvas
39 1/2 x 32 5/8 in. (100.33 x 82.87 cm)
Gift of Eve Drewelowe

Red Plush Passengers, 1938
Oil on canvas
22 1/8 x 20 5/32 in. (56.20 x 51.18 cm)
On loan from the School of Art and Art History,
University of Iowa

Werner Drewes (American, 1899–1985)
Scorpion, 1946
Woodcut
Image: 12 1/4 x 18 in. (31.12 x 45.72 cm)
Sheet: 16 1/8 x 20 3/4 in. (40.96 x 52.71 cm)
Edwin. B. Green American Art Acquisition Endowment

Marcel Duchamp (French, 1887–1968)
Boîte-en-Valise (de ou par Marcel Duchamp ou Rrose Sélavy) (Box-in-a-Valise), 1941/1966
Replicas and reproductions of 80 works encased in
red leather box
15 1/8 x 16 1/4 x 3 5/8 in. (38.42 x 41.275 x 9.21 cm)
Museum purchase with funds from the Philip D. Adler
Fund

Mabel Dwight (American, 1876–1955)
Danse Macabre, 1934
Lithograph
Image: 9 1/2 x 13 3/4 in. (24.1 x 34.9 cm)
Sheet: 11 5/8 x 15 3/4 in. (29.53 x 40 cm)
Museum purchase

**Roberto Sebastián Antonio Matta Echaurren
(Matta)** (French, born in Chile, 1911–2002)
Like Me, Like X, 1942
Oil on canvas
28 x 36 in. (71.12 x 91.44 cm)
Gift of Peggy Guggenheim

Fritz Eichenberg (American, 1901–1990)
April, 1937
Wood engraving
Image: 7 3/4 x 6 in. (19.69 x 15.24 cm)
Sheet: 11 1/4 x 8 5/8 in. (28.58 x 21.91 cm)
On loan from the Federal Art Project of the Works
Progress Administration

Max Ernst (German, 1891–1976)
L'Amoureux (The Lover), 1934
Collage
5 x 3 3/4 in. (12.7 x 9.53 cm)
University acquisition

Walker Evans (American, 1903–1975)
Tuscaloosa Wrecking Co., 1935/printed c. 1950
Gelatin silver
7 x 9 in. (17.78 x 22.86 cm)
Museum purchase

Ralph Fabri (American, 1894–1975)
The Race, 1945
Etching
Image: 6 7/8 x 9 in. (17.5 x 22.9 cm)
Sheet: 10 7/8 x 13 1/2 in. (27.62 x 34.29 cm)
Gift of Alan and Ann January

Sue Fuller (American, 1914–2006)
Hen, 1945
Soft-ground etching and engraving
Image: 14 3/4 x 11 5/8 in. (37.47 x 29.53 cm)
Sheet: 18 3/4 x 14 in. (47.63 x 35.56 cm)
Leola Bergmann Print Fund

Minetta Good (American, 1895–1946)
Columbia Heights, 1939
Lithograph
Image: 14 1/8 x 9 1/4 in. (35.88 x 23.5 cm)
Sheet: 19 3/4 x 13 1/4 in. (50.17 x 33.66 cm)
On loan from the Federal Art Project of the Works
Progress Administration

Philip Guston (American, born in Canada, 1913–1980)
Any French Restaurant, 1945
Ink
10 7/8 x 7 1/4 in. (27.62 x 18.42 cm)
Gift in memory of Lester and Florence Longman from
Stanley and Ruth Longman

Café Royale, 1945
Ink
7 1/4 x 10 1/2 in. (18.42 x 26.67 cm)
Gift in memory of Lester and Florence Longman from
Stanley and Ruth Longman

John's, 1945
Ink
7 1/4 x 5 1/2 in. (18.42 x 13.97 cm)
Gift in memory of Lester and Florence Longman from
Stanley and Ruth Longman

Lon Fong, 1945
Ink
7 1/4 x 5 1/4 in. (18.42 x 13.34 cm)
Gift in memory of Lester and Florence Longman from
Stanley and Ruth Longman

The Young Mother, 1944
Oil on canvas
39 7/16 x 29 1/2 in. (100.17 x 74.93 cm)
Gift of Dr. Clarence Van Epps

Untitled (figure study), c. 1941–45
Charcoal
17 x 21 in. (43.18 x 53.34 cm)
On loan from the School of Art and Art History,
University of Iowa

Robert Gwathmey (American, 1903–1988)
Field Flowers, 1946
Silkscreen on canvas
Image: 29 3/8 x 19 7/8 in. (74.6 x 50.5 cm)
Sheet: 38 1/4 x 29 in. (97.16 x 73.66 cm)
Museum purchase

Amelia Hammer (American, dates unknown)
Sideshow, n.d.
Silkscreen
Image: 17 1/2 x 20 1/2 in. (44.45 x 52.07 cm)
Sheet: 17 7/8 x 20 13/16 in. (45.40 x 52.86 cm)
On loan from the Federal Art Project of the Works
Progress Administration

Hananiah Harari (American, 1912–2000)
Divers, 1939
Silkscreen
Image: 9 3/4 x 13 1/8 in. (24.77 x 33.34 cm)
Sheet: 11 3/8 x 17 1/2 in. (28.89 x 44.45 cm)
On loan from the Federal Art Project of the Works
Progress Administration

Rosella Hartman (American, 1894–1984)
Screeching Bob-Cat, 1939
Lithograph
Image: 10 3/4 x 13 3/4 in. (27.31 x 34.93 cm)
Sheet: 14 1/2 x 18 1/8 in. (36.83 x 46.04 cm)
On loan from the Federal Art Project of the Works
Progress Administration

Stanley William Hayter (British, 1901–1988)
Tropic of Cancer, 1949
Engraving, soft-ground etching
Image: 21 3/4 x 27 1/2 in. (60.3 x 69.9 cm)
Sheet: 27 1/4 x 33 1/4 in. (69.2 x 84.5 cm)
Museum purchase

Untitled, plate 2 from "L'Apocalypse," 1931
Engraving and drypoint
Image: 13 x 9 5/8 in. (33 x 24.4 cm)
Sheet: 19 1/4 x 15 in. (48.9 x 38.1 cm)
Gift of Mr. and Mrs. Peter O. Stamats

Albert W. Heckman (American, 1893–1971)
Industrial, 1940
Lithograph
Image: 12 x 16 3/4 in. (30.5 x 42.5 cm)
Sheet: 16 x 22 in. (40.64 x 55.88 cm)
Gift of Mr. and Mrs. Gustave von Groschwitz

John P. Heins (American, 1896–1969)
Still Life, c. 1937
Wood engraving
Image: 10 x 7 7/8 in. (25.4 x 20 cm)
Sheet: 17 1/2 x 11 1/4 in. (44.45 x 28.58 cm)
Gift of the Estate of James Lechay

Alexandre Hogue (American, 1898–1994)
Liberators, 1943
Lithograph
11 1/2 x 15 1/4 in. (29.21 x 38.74 cm)
Edwin. B. Green American Art Acquisition Endowment

Frederick Kiesler (American, born in Austria, 1890–1965)
Unidentified scenic design (Statue of Liberty), c. 1934
Collage, pencil, ink
14 3/4 x 11 in. (37.47 x 27.94 cm)
Gift of Maryette Charlton Collection in honor of Shannon B. and Etna Barr Charlton; Owen and Leone Elliott; Robert Hobbs, UIMA director (1983–86); and Stephen S. Prokopoff, UIMA director (1992–99)

Yasuo Kuniyoshi (American, born in Japan, 1893–1953)
Carnival, 1949
Lithograph
Image: 15 3/4 x 9 3/4 in. (40 x 24.8 cm)
Sheet: 17 5/8 x 11 1/2 in. (44.77 x 29.21 cm)
Edwin. B. Green American Art Acquisition Endowment

Mauricio Lasansky (American, born in Argentina, 1914–2012)
El Presagio (The Omen), 1940–41
Drypoint
Image: 24 1/4 x 16 3/8 in. (61.6 x 41.6 cm)
Sheet: 25 1/2 x 17 1/2 in. (64.77 x 44.45 cm)
Gift of Webster and Gloria Gelman

Sol y Luna (Sun and Moon), 1945
Engraving, gouged-out white areas, etching, soft-ground, aquatint, scraping, burnishing
Image: 16 x 20 3/4 in. (40.6 x 52.4 cm)
Sheet: 18 1/2 x 22 1/4 in. (46.99 x 56.52 cm)
Gift of Webster and Gloria Gelman

Joseph Leboit (American, 1907–2002)
Swimming Hole, 1937
Lithograph
Image: 16 1/2 x 12 7/8 in. (41.91 x 32.7 cm)
Sheet: 20 3/8 x 14 7/8 in. (51.75 x 37.78 cm)
On loan from the Federal Art Project of the Works Progress Administration

Nathan Lerner (American, 1913–1997)
Eye on String, 1937
Gelatin silver
Image: 15 x 18 3/4 in. (38.1 x 47.6 cm)
Sheet: 16 x 20 in. (40.64 x 50.8 cm)
Gift of Stephen Prokopoff and Lois Craig

Quality Folks, Depression, 1937
Gelatin silver
Image: 8 3/8 x 12 7/8 in. (21.3 x 32.7 cm)
Sheet: 11 x 14 in. (27.94 x 35.56 cm)
Gift of Nathan Lerner Living Trust and Kiyoko Lerner

Helen Levitt (American, 1913–2009)
New York (Cops and Robbers), c. 1942
Gelatin silver
Image: 6 1/4 x 8 3/4 in. (15.9 x 22.2 cm)
Sheet: 10 3/4 x 13 3/4 in. (27.31 x 34.93 cm)
Edwin. B. Green American Art Acquisition Endowment

Russell Limbach (American, 1904–1971)
Elephants, 1939
Lithograph
Image: 8 7/8 x 17 3/8 in. (22.54 x 44.13 cm)
Sheet: 11 1/2 x 20 7/8 in. (29.21 x 53 cm)
On loan from the Federal Art Project of the Works Progress Administration

Jacques Lipchitz (American, born in Lithuania, 1891–1973)
Sacrifice, 1947
Bronze
18 3/4 x 10 x 10 3/4 in. (47.63 x 25.4 x 27.31 cm)
Mark Ranney Memorial Fund

George Platt Lynes (American, 1907–1955)
Nicholas Magallanes and Francisco Moncion in Orpheus, c. 1948
Gelatin silver
8 3/4 x 7 1/2 in. (22.23 x 19.05 cm)
Edwin. B. Green American Art Acquisition Endowment

Loren MacIver (American, 1909–1998)
Untitled, from "Early Sketches," c. 1935
Pencil and colored pencil
11 x 9 in. (27.94 x 22.86 cm)
Gift of Maryette Charlton Collection in honor of Shannon B. and Etna Barr Charlton; Owen and Leone Elliott; Robert Hobbs, UIMA director (1983–86); and Stephen S. Prokopoff, UIMA director (1992–99)

Boris Margo (American, born in Russia, 1902–1995)
Shoreline, 1945
Etching
Image: 7 x 9 in. (17.8 x 22.9 cm)
Sheet: 9 3/4 x 12 in. (24.77 x 30.48 cm)
Gift of the Betty Parsons Foundation

Kyra Markham (American, 1891–1967)
Lapse of Time—Idiot's Delight, 1936
Lithograph
Image: 13 x 9 3/8 in. (33 x 23.8 cm)
Sheet: 15 7/8 x 11 1/2 in. (40.32 x 29.21 cm)
Edwin. B. Green American Art Acquisition Endowment

Jack Markow (American, 1905–1983)
Perilous Merry-Go-Round, 1937
Lithograph
Image: 12 1/4 x 8 3/4 in. (31.12 x 22.23 cm)
Sheet: 15 1/8 x 11 in. (38.42 x 27.94 cm)
On loan from the Federal Art Project of the Works
Progress Administration

André Masson (French, 1896–1987)
Improvisation, 1945
Etching, aquatint, and lift-ground
Image: 7 7/8 x 6 in. (20 x 15.2 cm)
Sheet: 12 5/8 x 10 in. (32.1 x 25.4 cm)
Museum purchase

William Ashby McCloy (American, 1913–2000)
Spirit of Self Sacrifice, 1943
Oil on Masonite
17 x 11 1/2 in. (43.18 x 29.21 cm)
Gift of the Slater Museum

Elizabeth Olds (American, 1896–1991)
Winter Soldiers, c. 1940
Silkscreen
Image: 13 5/8 x 18 1/8 in. (34.61 x 46.04 cm)
Sheet: 17 x 21 1/2 in. (43.18 x 54.61 cm)
On loan from the Federal Art Project of the Works
Progress Administration

Irene Rice Pereira (American, 1902–1971)
Eight Oblongs, 1943
Encaustic on parchment
19 x 25 in. (48.26 x 63.5 cm)
Gift of Peggy Guggenheim

Gabor Peterdi (American, born in Hungary,
1915–2001)
Combat, 1939
Engraving
Image: 11 3/4 x 15 1/2 in. (29.8 x 39.4 cm)
Sheet: 16 3/8 x 20 1/8 in. (41.59 x 51.12 cm)
Gift of Jerry Torn

Genoi Pettit (American, 1894–1982)
By the Sea, 1939
Silkscreen
Image: 11 x 14 in. (27.94 x 35.56 cm)
Sheet: 12 1/2 x 16 3/8 in. (31.75 x 41.59 cm)
On loan from the Federal Art Project of the Works
Progress Administration

Lil Picard (American, born in Germany, 1899–1994)
Crossing, 1947
Oil on canvas with collaged elements
32 x 36 in. (81.28 x 91.44 cm)
Lil Picard Collection

Jackson Pollock (American, 1912–1956)
Portrait of H.M., 1945
Oil on canvas
36 x 43 in. (91.44 x 109.22 cm)
Gift of Peggy Guggenheim

John D. Pusey (American, 1905–1966)
Elevators, c. 1935
Oil on canvas
31 1/2 x 24 3/4 in. (80.01 x 62.87 cm)
On loan from the Federal Art Project of the Works
Progress Administration

Walter Quirt (American, 1902–1968)
Returned on the Shield, c. 1943
Oil on canvas
39 3/4 x 29 1/2 in. (100.97 x 74.93 cm)
Gift of Roy D. Neuberger

Mildred Rackley (American, 1906–1992)
Boogie Woogie, c. 1940
Wood engraving
Image: 6 1/8 x 5 in. (15.6 x 12.7 cm)
Sheet: 12 x 5 in. (30.48 x 12.7 cm)
Gift of the Estate of James Lechay

Robert Riggs (American, 1896–1970)
Shadow Boxer, 1934
Lithograph
Image: 14 3/4 x 20 1/4 in. (37.5 x 51.4 cm)
Sheet: 17 1/2 x 22 3/4 in. (44.45 x 57.79 cm)
Museum purchase

Grace Rivet (Clements) (American, 1905–1969)
Death of an Idea, 1937
Lithograph
Image: 9 1/4 x 13 in. (23.5 x 33.02 cm)
Sheet: 14 1/4 x 17 3/4 in. (36.20 x 45.09 cm)
On loan from the Federal Art Project of the Works
Progress Administration

John Tazewell Robertson (American, 1905–1989)
Sand Pits, c. 1935
Oil on panel
12 x 20 in. (30.48 x 50.8 cm)
On loan from the Federal Art Project of the Works
Progress Administration

Theodore Roszak (American, born in Prussia,
1907–1981)
Scavenge, 1946–47
Steel, stone
14 x 18 x 12 in. (35.56 x 45.72 x 30.48 cm)
Gift of Dorothy Schramm

Study for Night Bloom, 1948
Ink
14 x 10 in. (35.56 x 25.4 cm)
Museum purchase

Mark Rothko (American, born in Russia, 1903–1970)
Untitled, 1941–43
Oil on canvas
11 3/4 x 15 13/16 in. (29.85 x 40.16 cm)
Gift of the Mark Rothko Foundation, Inc.

Untitled, 1944–46
Watercolor and ink on paper
30 1/2 x 21 1/2 in. (77.47 x 54.61 cm)
Gift of the Mark Rothko Foundation, Inc.

Anne Ryan (American, 1889–1954)
Puerto, 1947
Woodcut on black paper
Image: 20 1/2 x 11 1/2 in. (52.1 x 29.2 cm)
Sheet: 23 x 16 in. (58.4 x 40.6 cm)
Museum purchase

Untitled, n.d.
Collage
7 x 5 in. (17.78 x 12.7 cm)
Gift of James H. Burke

Louis Schanker (American, 1903–1981)
Dictator's Dream, 1937
Woodcut
Image: 9 1/8 x 13 1/4 in. (23.2 x 33.7 cm)
Sheet: 10 3/4 x 14 5/8 in. (27.31 x 37.15 cm)
Museum purchase

Karl Schrag (American, born in Germany, 1912–1995)
Rainclouds and Sea, 1948
Engraving
Image: 14 7/8 x 17 1/2 in. (37.78 x 44.45 cm)
Sheet: 19 x 21 in. (48.26 x 53.34 cm)
Museum purchase

Charles Seliger (American, 1926–2009)
Homage to Erasmus Darwin, 1945–46
Collage, oil on canvas
35 3/4 x 27 3/4 in. (90.81 x 70.49 cm)
Gift of Peggy Guggenheim

Kurt Seligmann (Swiss, 1900–1962)
Le Chiffonier (The Cupboard), plate 6 from "Les
Vagabondages
Heraldiques," 1934
Etching
Image: 13 3/4 x 10 1/4 in. (34.9 x 26 cm)
Sheet: 19 1/2 x 15 in. (49.5 x 38.1 cm)
Museum purchase

Mitchell Siporin (American, 1910–1976)
Endless Voyage, 1946
Oil on canvas
34 1/2 x 39 3/8 in. (87.63 x 100 cm)
Museum purchase

G. Ralph Smith (American, 1907–2007)
Election Night, 1936
Lithograph
Image: 10 3/4 x 14 3/4 in. (27.3 x 37.5 cm)
Sheet: 13 1/2 x 18 1/2 in. (34.29 x 46.99 cm)
Edwin. B. Green American Art Acquisition Endowment

Theodoros Stamos (American, 1922–1997)
Prehistoric Phase, 1947
Oil on Masonite
20 x 23 7/8 in. (50.8 x 60.64 cm)
Museum purchase from the purchase fund 4550;
anonymous gift for development of the fine arts program

Ralph Steiner (American, 1899–1986)
Ham and Eggs, c. 1934
Gelatin silver
Image: 7 1/2 x 9 1/2 in. (19.1 x 24.1 cm)
Sheet: 8 x 10 in. (20.32 x 25.4 cm)
Purchased with the aid of funds from the National
Endowment for the Arts and matching funds from
Mr. and Mrs. Herbert Lyman and Elizabeth A. Hale

Harry Sternberg (American, 1904–2001)
Steel, 1937
Silkscreen
Image: 12 3/4 x 22 3/4 in. (32.39 x 57.79 cm)
Sheet: 16 1/8 x 24 15/16 in. (40.96 x 63.34 cm)
On loan from the Federal Art Project of the Works
Progress Administration

Hedda Sterne (American, 1910–2011)
Untitled, n.d.
Watercolor
12 x 14 7/8 in. (30.48 x 37.78 cm)
Gift of the Betty Parsons Foundation

Bradley Walker Tomlin (American, 1899–1953)
Still Life, 1940
Oil on canvas
22 x 28 3/4 in. (55.88 x 73.03 cm)
Mark Ranney Memorial Fund

Herman Roderick Volz (American, born in
Switzerland, 1904–1990)
Scab, 1938
Lithograph
Image: 14 x 9 7/8 in. (35.56 x 25.08 cm)
Sheet: 17 3/8 x 12 in. (44.13 x 30.48 cm)
On loan from the Federal Art Project of the Works
Progress Administration

Hyman Warsager (American, 1909–1974)
Sea Wall, 1941
Woodcut
Image: 13 7/8 x 18 in. (35.24 x 45.72 cm)
Sheet: 16 1/2 x 24 1/4 in. (41.91 x 61.60 cm)
On loan from the Federal Art Project of the Works
Progress Administration

June Wayne (American, 1918–2011)
Kafka Symbols, 1948
Lithograph
Image: 14 x 17 3/4 in. (35.6 x 45.1 cm)
Sheet: 17 3/4 x 22 5/8 in. (45.09 x 57.47 cm)
Gift of the Stone Circle Foundation

Max Weber (American, 1881–1961)
Exotic Dance, 1940
Oil on canvas
30 x 40 1/4 in. (76.2 x 102.24 cm)
Gift of Mr. and Mrs. James Schramm

Grant Wood (American, 1891–1942)
Approaching Storm, 1940
Lithograph
Image: 12 x 9 in. (30.5 x 22.9 cm)
Sheet: 16 1/8 x 12 in. (40.96 x 30.48 cm)
Gift of Edwin. B. Green